Art and...

General Editor: Chris Townsend

The first premise of the *Art and...* series is that art matters. By this I mean that art is not a futile game played by a few cognoscenti in a vacuum. Rather our assumption in selecting titles for the series is that contemporary art is crucial to our understanding of, and relationship to, the world in which we live. Often the first response to art, especially in the popular press, is to stress its seeming frivolity, its surface shock, rather than trying to draw out the deeper issues at stake within it. Yet art still has the capacity to challenge and to change us. Without pasting up slogans, artists have important things to say about the conditions of our times and, directly or indirectly, they have chosen to take on some of the biggest issues in the world today. In producing this series we have deliberately aligned 'art' and those perennial issues such as death and sex which trouble generation after generation. And we have deliberately sought out particular contemporary issues: scientific advances, advertising and celebrity. Books published in the *Art and...* series will be accessible, but intelligent. Serious and often difficult art need not equate to difficult writing – rather it demands clarity, and this is the second premise of the series. Above all *Art and...* aims to connect art back to the world.

Published and forthcoming:

Art and Advertising	Joan Gibbons
Art and Death	Chris Townsend
Art and Fame	Jean Wainwright
Art and Home	Nigel Prince
Art and Invention	Jaime Stapleton
Art and Laughter	Sheri Klein
Art and Obscenity	Kerstin Mey
Art and Science	Siân Ede
Art and Sex	Gray Watson
Art and Surveillance	Denna Jones
Art and War	Laura Brandon

Art and Advertising

Joan Gibbons

I.B. TAURIS

LONDON · NEW YORK

Published in 2005 by I.B.Tauris & Co Ltd
6 Salem Road, London W2 4BU
175 Fifth Avenue, New York NY 10010
www.ibtauris.com

In the United States of America and in Canada distributed by
Palgrave Macmillan, a division of St Martin's Press
175 Fifth Avenue, New York NY 10010

ISBN 1 85043 585 5 hardback
EAN 978 1 85043 585 3 hardback

ISBN 1 85043 586 3 paperback
EAN 978 1 85043 586 0 paperback

A full CIP record for this book is available from the British Library
A full CIP record for this book is available from the Library of Congress

Library of Congress catalog card: available

Typeset in Agfa Rotis by Steve Tribe, Andover
Printed and bound in Great Britain by MPG Books Ltd, Bodmin

Contents

Acknowledgements

There are a number of people that I would like to thank for helping me get this book off the ground. In the early stages of my research, several people from the advertising industry generously gave their time and helped me to find my bearings in relation to attitudes and approaches in contemporary advertising. These include: Kate Stanners (Saatchi & Saatchi), David Beverley (Leo Burnett), Jerry Ketel (Leopold Ketel & Partners), Mikhal Reich (Mad Dogs and Englishmen), Mike Byrne, Eric Johnson and Strom Tharp (all Wieden+Kennedy) and Natalie Clark (Gerngross and Clark). Equally helpful were the meetings I had with individuals and organisations whose work, in one way or another, connects with the advertising world: Tony Kaye (independent advertising creative, film-maker and artist), Milton Glaser (Milton Glaser Inc.), Victoria Fry (Portland Institute of Contemporary Art) and Catherine Coleman of the American Advertising Museum, Portland.

At this point, my thanks must also go to the Arts and Humanities Research Board for the award of a bursary in their small grants for the creative and performing arts scheme, which enabled me to travel to the USA to conduct some of the above meetings. As far as the writing of the book is concerned, I am most grateful to my editor, Susan Lawson, for saving me from myself on more than one occasion and for her good-natured support throughout. Closer to home, my thanks go to the library staff at Birmingham Institute of

Art and Design (University of Central England), who have been sensitive to my needs and deadlines, and to Boris Barker and Steve Bulcock who have provided me with invaluable IT support. Not least, thanks are also due to my immediate colleagues at UCE, Bob Jardine, Kevin Harley, Nigel Prince and Peter Grego, who have kept me going (and smiling) on a day-to-day basis, as, indeed, have my family.

Introduction

Still frequently misunderstood and often ridiculed, contemporary art has, nonetheless, become a significant force in popular culture, largely because of its sensationalism and media friendliness. Among the voices of popular criticism, UK critic Brian Sewell's strident views show the way that contemporary art has achieved media-worthy status in the culture while often remaining an estranging or alienating phenomenon. A profound allegiance to and nostalgia for the world-view of the liberal humanist can be detected in his opinions; his notion of art is partially conditioned by the notion of individual craftsmanship, and his appreciation of art is conditioned by ideas of good form. Jenny Saville's work, for instance, does not qualify as good art, because her nudes exhibit a formlessness. Sewell's understanding of art is also affected by his prejudices for or against particular media and materials. Bill Viola, for example, makes the mistake of adopting the 'wrong' medium for the art gallery: video, for Sewell, is an almost 'homeless' hybrid.[1] Obviously this position is only tenable when it is believed that knowledge, including the sort of knowledge that art constitutes, is something that can be fixed, universally validated and transcendent.

In these postmodern times, however, it has become increasingly difficult for this position to be maintained, underpinned as it is by attitudes that were

formed during the Enlightenment. In the mid to late eighteenth century, knowledge seemed to promise a perfection of human culture and society that has not in fact happened – witness the breakdown of civilisation in the Holocaust, or the failure of science or medicine to cure AIDS. Nevertheless, that culture and society maintains a legacy in the rather Romantic beliefs which see art as part of such a project. This position fits into the idealist framework set out by Immanuel Kant (1724–1804), one of the most influential philosophers of the Enlightenment period, who notably argued for a 'disinterested' or autonomous art, an art which had an intrinsic aesthetic rightness, a sense of 'purposiveness without a purpose'. This sort of art does not depend on the viewer's tastes but on the viewer's 'common sense', or shared cognitive ability to respond to the appropriateness of the form of the work, as Kant puts it, to its 'finality'.[2]

Yet the model put forward in the 'Analytic of the Beautiful' was not the only aesthetic paradigm offered by Kant in his *Critique of Judgement*. He also recognised, in the sublime, a realm beyond the beautiful that allowed him to develop an insight into the limitations of knowledge that has a relevance for contemporary art. In the accompanying 'Analytic of the Sublime', Kant argues that, faced with the unquantifiable magnitude and force of nature, the human subject undergoes an experience of self-knowledge that constitutes the sublime. It is not, in the end, pain or fear that is experienced at not being able to conceive of nature's 'totality' or 'finality' but great pleasure, the pleasure of insight into one's own limitations, what is often now referred to as reflexive knowledge. As a state of mind or being in which the subject comes to realise his or her own intellectual limitations, the sublime serves not to reduce humanity in relation to nature but to rescue it. To have this capacity for self-knowledge and self-reflexivity, to be able to conceive of not being able to conceive things beyond the reach of the human mind is what, for Kant, distinguishes humanity.[3]

Placed in relation to this sort of a framework, it now seems appropriate that contemporary art should be such a highly contested field, often full of overwhelming uncertainties and contradictions. The estranging and disturbing aspects of contemporary art may disrupt and alienate, but they also challenge and test the viewer. We are no longer asked to evaluate according to 'common sense', but to recognise the absence of such universal values. As has been argued by Nicolas Bourriaud, much of what is offered in contemporary art

belongs to a set of relational aesthetics where 'the role of artworks is no longer to form imaginary and utopian realities, but to actually be ways of living and models of action within the real.'[4]

It would be misleading, however, to suggest that, in all of its variety and for all of its contradictions and contentiousness, contemporary art is received without any method of classification. Although much contemporary art requires an act of faith of an extremely tall order, it also has a replacement for the sort of consensus concerning good form that Kant saw as the result of common sense. This replacement, as Arthur Danto has shown, exists in the form of the art world, its critics and its institutions.[5] For Danto, Warhol's *Brillo Boxes* (1964) finally signalled the end of the Kantian legacy by demonstrating that the artwork can be so close to the real object as to undermine any higher aesthetic claims concerning form and content. Because there was little to distinguish Warhol's simulated boxes from the real thing, Danto was able to claim that art is defined not by the artist's work, claims or intentions but by the way that it is received, promoted and contextualised by the art world. In other words, it is the social and cultural conditions surrounding the production and reception of the work that allow it to be named as art. Contemporary artworks exist in 'an atmosphere of artistic theory, a knowledge of the history of art, an art world'.[6] This is a similar position to that taken up by George Dickie, who has also argued that art is defined by its institutional framework rather than by any governing aesthetic criteria. According to Dickie, an artefact (including natural objects) becomes classified as art when, at least in some of its aspects, it has been seen as a candidate for appreciation by some person or persons acting on behalf of a certain social institution (the art world).[7]

While this method of categorisation does not solve the problem of understanding the meaning of an artwork or of how to value it, it does show that – as long as there is an art world to support it and in spite of all of the challenges to high culture that have been issued over the last century – the notion of art as a special and separate form of culture persists. This notion endures in the face of all of the anti-institutional efforts of early twentieth-century avant-garde movements such as Dada, and the efforts of those working in the Dada tradition in contemporary art to undermine the hierarchies that separate fine art from popular culture. It endures regardless of the substantial amount of academic work done to query the difference in status between high and low art and despite the significant changes that

have occurred in the policies and practices of museums to make them fit with the visitor's consumer habits. And it endures even though the fact that the commercially compromised nature of the art world has become more apparent of late, particularly through the relationship that Charles Saatchi has with contemporary art and through the increasing commercial sponsorship of exhibitions.

Despite (or perhaps because of) its lower status, most people feel more at home with the idea of advertising than with art, even when they are unhappy about its moral probity. For many, advertising constitutes a more readily understood category of representation, more attainable because of its status as a mass medium and more definable because, no matter how unconventional some of its practices are, its function can always be reduced to matters of promotion and persuasion, making it easy to categorise. Like so many other forms of mass media, advertising infiltrates and becomes part of popular culture by virtue of its volume and gratuitous distribution, creating an illusion of common ownership and attainability although, as Jean Baudrillard suggests, the social cohesion that advertising inspires is largely offset by the lack of critical distance that this communality brings: 'Each advertising image prescribes a consensus among all those individuals potentially summoned to decipher it: which is to say, in decoding the message, to automatically conform to the code in which the image has been encoded.'[8] A general desire to stay within the accustomed codes of advertising has been illustrated by the responses elicited by Benetton's now infamous campaign *The Shock of Reality* (1991–1992). As the media debates showed, and as complaints to the Advertising Standards Authority (ASA) confirmed, a significant number of people were outraged by the way that Benetton advertisements transgressed the conventional codes of advertising by employing outrageously shocking imagery for commercial purposes, the appropriation of the award-winning documentary image of a dying AIDS sufferer, David Kirby, for example.[9] Yet, while there was a general inability to cope with the use of the 'wrong' sort of imagery in the advertisements in the *Shock of Reality* campaign, it could nevertheless be argued that the commercial success of the campaign, which brought a substantial increase in Benetton's sales, showed that advertising no longer has to conform to set codes to be effective, nor does it necessarily have to presume an uncritical viewer.[10] In effect, the Benetton campaign shows that cutting-edge advertising has at least ceased to be the cohesive set of

practices that is implied by Baudrillard. Like contemporary art, contemporary advertising is a mixture of practices that elicits a mixture of responses.[11]

To be fair, Baudrillard's comment on the conventional codings of advertising was voiced in 1970, well before the changes wrought by Benetton had occurred, when such a generalisation could be more easily supported and at a time when the viewing habits of the consumer were less knowing than they are today.[12] It is also important to recognise that Baudrillard's attitude towards and insights into advertising are by no means as simplistic as the type of advertisement that he observed in the late 1960s and that he has, in fact, contributed significantly to the idea that advertising serves predominantly 'aesthetic' rather than practical purposes for the consumer.[13] Most significantly, while noting the uncritical production and reception of advertising, Baudrillard does not make a case for the kind of functionalism that is supposed to result in the purchase of a product. Baudrillard is keen to shed this reductive image of advertising as persuasion in favour of advertising as an autonomous realm of signs, 'a show, a game, a *mise-en-scène*'. In this scenario, advertising first and foremost provides the viewer with a simulatory experience; it is 'not the shortest way to the object, merely the shortest way to another image'.[14] From this point of view, advertising can be said to function aesthetically, if the aesthetic is taken in the Kantian sense of a sort of playground for the emotions, imagination and intellect.[15] In this respect, advertising approaches what is often thought to be the more autonomous or disinterested status of art (although it has to be recognised that in both cases the desire for ownership, whether of the artwork or the product, is far from Kant's paradigm of disinterestedness).

In short, the differences between art and advertising are not so much a matter of the intrinsic properties of each field of representation; they are more a matter of classification brought about largely by the institutional organisation of culture in the West.[16] This means that it is difficult not only to find hard and fast coordinates when mapping out the interior terrain of either art or advertising, but also to trace connections and divisions between each realm of practice. However, such difficulties can bring their own reward, and I have found that the openness and elasticity of these fields facilitates a greater play in interpretation, allowing the examination of the relationship between art and advertising from a broader critical base and permitting more complex conceptualisations. Indeed, the last thing I wanted to do in writing

this book was to attempt the impossible and try to produce a definitive account or an all-encompassing, seamless survey. Instead, I have picked out a number of key aspects and points of exchange, encounter, convergence and crossover that together demonstrate the richness and breadth of the relationship between art and advertising, but which emphatically do not serve to reduce or over-simplify it.

The comparisons of art and advertising that I make only touch upon moral or ethical distinctions or correspondences between the two types or contexts of practice. The consumer advertising that forms much of the content of this book is often seen as a *bête noir* that feeds off or exploits people's needs and insecurities purely in the interest of making money, and that may be the bottom line. However, this perception assumes that the consumer is a passive victim which is perhaps only really the case with the more vulnerable groups in society such as children. It also forgets that most countries in the West have enforceable advertising guidelines that are often industry- or media-led, and that, within the apparently inescapable framework of capitalism, advertising is also capable of providing real guidance and of supplying pleasures that enrich people's daily lives. In effect, advertising is the product of a system that the majority of people readily collude with and, as long as that collusion lasts, advertising is likely to thrive. Art, on the other hand, is often seen as able to stand outside of or even above the system and take up a critical stance towards it. Yet, art in its own way is as implicated in the economics of the system as much as advertising. What is more, art is generally far more exclusive and elitist and far less democratic and accessible than advertising. Only the most ephemeral or temporary of artworks, or those produced for the public realm or in community art, are likely to avoid incorporation into the market economy that the art world ultimately constitutes. On these grounds, therefore, I feel reluctant to set one above the other, regardless of what my personal feelings about the politics of the system and its products in either art or advertising might be.

Chapter 1

Wordplay

Although art and advertising are both seen primarily as visual arts, I want, initially, to explore an area of convergence that is as much about linguistic practices as it is about visual correspondences and exchanges. I am both captivated by the way that words acquire plasticity and become an ambient medium when co-opted by the visual arts and intrigued by correspondences that occur at the level of language forms, with a shared preference in both instances for particular types of shorthand, such as truisms, clichés and commonplaces. The term 'ambient' is already used in a specialised way in relation to advertising, referring to works that appear on surfaces beyond the hoarding or the magazine insert. In such cases, the encounter with an advertisement is often more unexpected and its presence more insinuative. For example, advertisements on the hanging straps of London Underground trains demand that you actually touch them; an advertisement placed at the bottom of a golf hole speaks directly to a captive, one-to-one audience. Of course, novel forms of contact such as these are not actually a defining feature of ambience, which is traditionally created in works of art or advertising through the choice and arrangement of forms, as with the emotive use of colour or, indeed, the emotive deployment of words. With this more conventional sense of ambience in mind, what I offer in this chapter is a discussion of

how, through their incorporation into the visual arts, words have gained a purchase of a different order in the culture. I will do this by looking at the ways in which words have mutated in both art and advertising: ways that not only demonstrate a relationship between the two fields of practice, but which have also made important, although quite different, contributions to the development of words as a visual art form.

Although words have long constituted the stuff of advertising, they are no longer central to its practices, displaced by the introduction of new printing methods in the second half of the nineteenth century; most importantly, chromo-lithography in posters facilitated the bulk production of large-scale coloured images that could emulate the sensual effects of oil paint. Such is the overriding power of the image that advertising has since then been perceived as primarily a visual medium, its visually seductive messages and pleasures further enhanced by the mass-reproducibility of photography, film and television. This preconception of advertising as a visual medium persists despite the continued relevance of strap-lines and short pieces of body copy, and has been strengthened by the emergence of several major campaigns in the late twentieth century that operated successfully without words.[1] Art, on the other hand, has become increasingly conceptual, with a significant number of artists readily presenting their work through the medium of words, despite the continued need to render their conceptualisations plastic in some way. The move into sometimes purely verbal works of art has been aided by a purposeful recuperation of the word in art over the last century.

The appropriation of words and syntax from the mass media, including advertising, by Cubist artists is exemplified by Picasso's *Still Life 'Au Bon Marché'* (1913), which features the department store Bon Marché's logo as well as a fragment of a newspaper advertisement for a rival store, Samaritaine. A number of examples are also found in Dadaism, especially in the work of Duchamp, such as *Apolinère Enameled* (1916–1917), in which the words in an advertisement for enamel paint have been altered to form a tribute to the poet Apollinaire.[2] The appropriations from the mass media found in Cubist collage and Duchamp's consistent interest in wordplay have been of particular importance for the use of words in Pop and Conceptual Art and their legacy in the art of our own time. Richard Hamilton's seminal work of Pop Art, *Just What Is It that Makes Today's Homes So Different, So Appealing?* (1956) is in the spirit of Picasso's Cubist collages and constitutes a mixture of source

materials from different aspects of popular culture, advertising, film, comic books, labour-saving devices, magazines and processed foods. It may also be that the tin of ham prominently displayed to the right of the female pin-up is a Duchamp-like pun on Hamilton's name, connecting to the colloquial expression hamming it up, which is what the two figures in Hamilton's collage appear to be doing. While Duchamp is an acknowledged influence on Hamilton, he has also been of immense importance for the development of Conceptual Art by retreating from what he termed 'retinal' artworks, which represented the appearances of things, to pieces based on the actuality of found objects and found language. For instance, works such as Joseph Kosuth's *Titled (Art as Idea (as Idea))* (1967), an appropriation of a dictionary definition, owe a direct debt to Duchamp's proto-conceptualism. Similarly, it is difficult to conceive of a work such as Bruce Nauman's *One Hundred Live and Die* (1984) without the precedent set by Duchamp's numerous puns.

What emerged with the incorporation of words into art in all of these major movements was a fusion of the verbal and the visual that has made it possible to speak of words in terms of their visual presence as well as their linguistic content. The ways in which words can add to the signification of the work has been crucial from the early days of their incorporation into modern art. The introduction of printed letters into early twentieth-century avant-garde art, for example, has been seen not only as a critique of the institutional boundaries between art and the mass media, but also as a subversion of the power relations between them.[3] Typographic appropriations in contemporary art have also followed suit, falling into two camps, as J. Abbott Miller, writing for *Eye* magazine, has noted. The first of these factions is occupied by those who make a limited use of 'professional' or 'designer' typography, Barbara Kruger, for instance; the second by those who persistently employ 'anonymous, ready-made, vernacular, non-designerly type', such as Lawrence Weiner or Joseph Kosuth.[4] While this is generally the case, a notable exception is Ed Ruscha, who has 'transcribed' a wide variety of letterforms and typographic styles into his word paintings since the late 1960s.

What Kruger, Weiner, Ruscha and other word artists all share with advertising is not only the ability to give words a visual plasticity, but a tendency to adopt certain types of linguistic forms that, although frequently banal, have an indisputable hold on the unconscious. These forms are often (although by no means always) short and economic, and include clichés, commonplaces,

aphorisms, maxims or epigrams. Indeed, the words and word combinations used in art, like the words and word combinations used in advertising, are frequently idiomatic, terse and loaded with suggestion and implication. Moreover, they are word forms that often belong to the vernacular and the popular and, as such, can be readily taken as extensions of the general ambience of everyday life. American artist Lawrence Weiner's *Many coloured objects placed side by side to form a row of many coloured objects*, exhibited outdoors on the façade of the Fridericianum at the Documenta 7 exhibition in 1982, provided an example of the ways that words in art can create a particular ambience through a combination of the nature of the language employed and the spaces upon which it is deployed. Although the message itself was disingenuously simple, it held the potential to prompt complex thoughts concerning the nature of art exhibitions, in the way that advertising slogans often provide access to deeper levels of subliminal thought. Despite their apparent modesty, the words achieved a monumental presence through their presentation in plain sans serif upper-case lettering on a neo-classical building. The contrast between form and subliminal content not only helped complexify the ways in which the piece could be read, but also altered the ambience of the conditions in which it was shown.[5] In 1986, Weiner received the support of Artangel to present a poster campaign to the public, in conjunction this time with an exhibition at the AIR gallery. The 'copy' on these posters, 'we are ships at sea not ducks on a pond', was presented in a flyer-like format in far less formal spaces than the Fridericianum, fostering viewing conditions of a very different nature. These are just two of several examples of Weiner's outdoor works. In a more recent project, for instance, he has co-opted a number of manhole covers in New York (fig. 1.), striking the same sort of relationship with the viewer as is effected by the ambient advertising referred to at the start of this chapter. As already noted, Weiner preferred utilitarian typefaces – such as Franklin Gothic or even just stencilled lettering – in a deliberate attempt to avoid the issue of style and signature and to develop a neutral voice. This choice was not just a way to avoid what Weiner saw as the 'excesses' of late modernist typography and a middle-class preoccupation with style, it also helped bring out the enigmatic nature of the words themselves.[6] Indeed, it is often through the use of simple and familiar word forms expressing complex and ambiguous thoughts that Weiner achieves a critical purchase in his work.

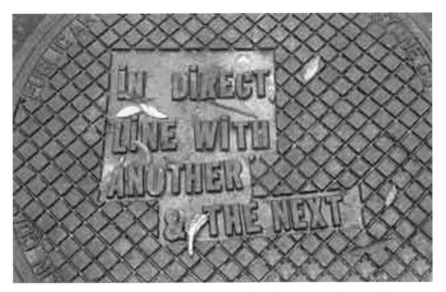

1. Lawrence Weiner, *NYC Manhole Covers* (2000). Cast iron, 19 manhole covers installed throughout lower Manhatten. A project of the Public Art Fund. Photo: Richard Griggs.

While a number of artists such as Weiner, Ruscha and Kosuth employ an ambiguous and condensed use of words in art and have displayed works both in and out of doors, it is artists such as Les Levine, Kruger and Jenny Holzer who have used such approaches more consistently in the actual spaces of advertising. This constitutes a significant development with regard to the issue of words and their ambient effects, since the viewing conditions of advertising that often form part of the flow of daily life have offered a more ambient relationship between the work of art and viewer than that offered by the gallery. I will address the implications of taking art into the spaces of advertising at some length in Chapter 2; however, for the present I want to confine my discussion to the comparison of language forms in art and advertising and to the way that they are given visual form.

From the point of view of linguistic comparisons, Jenny Holzer's work is of particular interest. The similarities to or connections with advertising are perhaps less immediate in her work, despite it having been dubbed 'The political alternative to advertising'.[7] As with Weiner's work, Holzer has presented messages in the form of truisms and epigrams, although perhaps

focusing more on their hackneyed and platitudinous nature. This is not to say that Holzer's work is limited in visual expression, since her choice of support for the words is often iconographically rich and important in terms of the plasticity that her words assume and for the ambience they create. Examples of such richly plastic and ambient surfaces include the granite, onyx and marble sarcophagi of the installation *The Laments* at the Dia Art Foundation in New York (1989–1990), or the skin in the photographs that make up the *Lustmord* project (1993).[8] Furthermore, although Holzer often uses verbal shorthand similar to that commonly used in advertisements to make subliminally suggestive statements in the actual sites of advertising, her work as a whole has a particularly strong rapport with the literary. Like that of Bruce Nauman, Holzer's work is significant because it illustrates a historically more complex relationship between art and advertising, a relationship that incorporates both avant-garde art and literature.

In effect, it is possible to trace Holzer's use of suggestion back to strategies found in the approaches of the late nineteenth- and early twentieth-century Symbolists, whose emphasis in both literature and art was also on subjectivity and the evocative. This becomes especially relevant when it is remembered that the use of suggestion and association in advertising stems equally from the evocative strategies of Symbolist artists, whose use of colour and form was meant to work subliminally to produce analogous emotions. Indeed, subliminal methodologies were first incorporated into advertising through the commercial poster work of late nineteenth-century Symbolist artists such as Alphonse Mucha and Fernand Khnopff.[9] It is also through Symbolism and its predecessors, Romanticism and Impressionism, that artists in the West first made a significant break with the so-called 'ocularcentrism' of works of art in the classical tradition that were constructed and viewed in a more detached and objective manner.[10] For example, the coordinates of perspective were undermined in favour of atmospherics, in the case of Impressionism, and in favour of mood and the creation of a psychological ambience for the viewer, in the case of Romanticism and Symbolism. These developments, of course, were to be of seminal importance for opening up and extending the viewing conditions of the work of art in a variety of ways in the twentieth century. As I will also show later, Symbolism and its influence was as seminal to the development of a new form of subjectivity in late twentieth-century graphic design and advertising.

Interestingly, it was literary Symbolism in particular that anticipated the way that language has developed as an visual art form, not only because the poet Stephan Mallarmé produced important pioneering work that addressed the plasticity of words on a page, but also because language orthodoxies were being challenged by other members of the movement. For example, the literary Symbolist Remy de Gourmont's championing of the commonplace comes to mind when discussing Holzer's frequent parodying of everyday platitudes. Referring to the commonplace as a recurring device in religious sermons (*loci communes sermonis*), de Gourmont saw it as a means by which durable essences or abstract ideas could be represented to the congregation. Its brevity makes it accessible and its repetition in the mass chanting of simply understood phrases unites its audience. Importantly, the commonplace worked on two levels, the banal and the universal:

> The commonplace is at once more and less than a banality: it is
> a banality, but one that is sometimes ineluctable; it is a banality,
> but one that is so universally accepted that it takes on the name
> of truth... The secret purpose of the commonplace, as it is being
> formed, is... to express a truth. Isolated ideas only represent facts or
> abstractions – to generate an ordinary truth requires that one have
> two elements a fact and an abstraction. Almost all commonplaces
> come down to these two elements.[11]

For de Gourmont, the banality of the commonplace becomes its redeeming feature, allowing for the expression of the sort of basic everyday truths that people depend on in the way that they depend on bread and wine for sustenance. Holzer's *Truisms* (begun in 1977) provides a clear example of the way in which the commonplace is used to do exactly this, succinctly presenting what appear to be banal and simple truths that, in effect, refer the reader on to larger and more abstract chains of thought:

ABUSE OF POWER COMES AS NO SURPRISE
A LITTLE KNOWLEDGE GOES A LONG WAY
BEING HAPPY IS MORE IMPORTANT THAN ANYTHING ELSE
BEING JUDGMENTAL IS A SIGN OF LIFE

CRIME AGAINST PROPERTY IS RELATIVELY UNIMPORTANT
GUILT AND SELF LACERATION ARE INDULGENCES
HUMANISM IS OBSOLETE
IT'S NOT GOOD TO OPERATE ON CREDIT
LACK OF CHARISMA CAN BE FATAL
SALVATION CAN'T BE BOUGHT AND SOLD
YOU ARE A VICTIM OF THE RULES YOU LIVE BY[12]

In effect, the highly suggestible character of Holzer's use of words and her deployment of terse forms, such as the cliché or the truism, emulates the shorthand route to the unconscious that is at the heart of consumer advertising, which, with its wider distribution and constant repetitions, also replicates the effects of *loci communes sermonis.* Moreover, in their reliance on the suggestibility of the viewer and shorthand methods of representation, Holzer's texts can be seen as the inverse of the copy-free advertisements that are to be discussed in Chapter 3, such as Saatchi's Silk Cut campaign (which is also traceable to Symbolism through the influence of that movement on Surrealism). By using words cryptically and forming them into generalisations, Holzer not only asks that the viewer read longer and more deeply into the meaning of the work, but also asks that they work harder at the resolution of meaning. Silk Cut advertisements, while consistent in the use of key shorthand motifs of silk and cuts, present an ongoing blend of decontextualised imagery which is also designed to make the viewer work at constructing the meaning. This aside, what is of more immediate significance in the genealogy of Holzer's work and its relation to advertising is that it incorporates a highly important literary influence in the writings of Samuel Beckett that forms a connection with the work of James Joyce, returning us to the sort of fragmentation and reconfiguration of language already noted in Cubism and Dadaism.

For Jennifer Wicke, author of *Advertising Fictions: Literature Advertisement and Social Readings* (1988), advertising in the early twentieth century was a 'new and crucial literature' that enabled James Joyce to register 'mass, modern culture's inroads into language and thought'.[13] Although Wicke possibly overstates the importance of language forms that Joyce appropriated from advertising in relation to similar appropriations from other forms of popular culture – such as newspapers, magazines and popular songs – there is no

doubt that one of the two central characters, Leopold Bloom, is substantially dependent upon advertising clichés to carry out his interior monologues.[14] As Wicke notes, words in advertising are capable of an openness and dynamism that is the product of the mixing of spoken, rhetorical and literary forms and as such suited Joyce's purposes perfectly.[15]

Wicke also points out that the language of advertising, like other language forms from popular culture that Joyce employs, inserts itself into the 'stream of consciousness', demonstrating the mutability of the self and the extent to which human subjects are constructed through language.[16] Moreover, the literary critic Colin MacCabe has shown that the coherency of language is subverted in Joyce's major work, *Ulysses*, not only by the breaking up of the continuity of the text, but also by the alteration of the appearance of the words.[17] Joyce's recurrent coining of hybrid words sets up a visual interplay of letters and words that destabilises the context (page) and means that words are defined not in terms of their flow but in terms of their visual differences, 'the different letters that go to make it up, the different words that surround it'.[18]

This visual 'deconstruction' of words had its counterpart in Dadaist and Futurist typography, in which words were liberated from the normal rules of typesetting. In both Dadaist and Futurist typography there is a pot-pourri of typefaces, the scale of letters and words is varied in an almost random way; there is a mixture of upper and lower case, and italics and roman text are intermingled and often deployed randomly on the page. As I will show, all of these features were to re-emerge in late twentieth-century typography through the work and influence of a number of cutting-edge designers and design groups.

As in the work of Joyce, the cliché and the commonplace are also characteristic of Samuel Beckett's writing. Indeed, Beckett not only maintained a long-standing friendship with Joyce but continued to be influenced by him throughout his career as a writer.[19] The cliché is a form of prefabricated, hackneyed language that is obtained not only from the repertory of 'available words, but also of available set phrases, combined strings, syntactic and narrative chains, cultural character types and mythemes et cetera'.[20] An example of this is in the words spoken by Winnie, the female protagonist of Beckett's 1961 play *Happy Days*, who, buried to her waist in a growing mound of scorched grass, issues a stream of clichés from advertising and popular songs

while excavating the contents of her handbag. Following Joyce's methods in the appropriation and distortion of 'found' language, Beckett also turns his parodies of commonplace language into near misrecitals, allowing for slips that access the unconscious, subjective world of the character, a world that is lacking in self-certainty.[21]

The recognition of a sense of lack and self-certainty, whether conscious or unconscious, is of course central to the successful practice of mainstream advertising, where the promise is ostensibly one of fulfilment and affirmation. In advertisements of this sort, the consumer's sense of lack and self-certainty is compensated for, as Judith Williamson has shown, by the device of 'mirroring'. Here, Williamson invokes Jacques Lacan's theory of the mirror stage in the development of the human subject where coherency of identity is ascertained through the reflected gaze of the other, principally the parent in the early years of infancy, but by less immediate figures as life expands and diversifies.[22] Such figures act as ego ideals, providing both behavioural models and checks and giving the illusion of a cohesive ego. Conventional advertising provides such illusions of coherency over and over again; although the identity of the consumer may be said to shift according to the characteristics of the product's identity, temporary coherencies are continually on offer. In Beckett, however, the platitudes and clichés of advertising and other forms of popular language only seem to trap the human subject irredeemably in an existential sense of lack, marooned in a world made up of both difference and indifference.

The influence of Joyce and Beckett's appropriations from popular language forms, including advertising, has also impacted on the use of words in the work of two quite different artists, Bruce Nauman and Tracey Emin. Nauman and Emin have both 'played' with commonplace forms of language and, significantly for the relationship between art and advertising, both have rendered their words particularly ambient by the use of a very specialised medium – neon. Nauman cites both Beckett and Wittgenstein as key to his understanding and employment of words. This is born out in an early piece, *A Rose Has No Teeth* (1966), where the words are taken directly from Wittgenstein's *Philosophical Investigations*, and reflect Wittgenstein's preoccupation with the failure of grammar to separate plausible statements from implausible statements, inviting the reader to think about the difference between the phrases 'a rose has no teeth' and 'a baby has no teeth'.[23]

Nauman follows Beckett not only in the way that he plays with the cliché, but also in the way that he inverts the meaning of words and plays them off against one another through slippage. As Vincent Labaume puts it: 'It is as if Nauman begins by provoking a kind of faux pas, or Freudian slip, and then tries to correct it, to make up for and erase it as best he can.'[24] Here, Labaume is speaking of *Neon Sign* (1970), which places the phrases 'none sing' and 'neon sign' next to each other (NONE SING/NEON SIGN) and in which a simple shuffling around of the letters calls attention to the contingent nature of words and the ease with which small slips or shifts can alter the meaning of a word or even the whole sense of a phrase. Moreover, as is also the case with Holzer's use of electronic signage, there is a sort of familial relationship with the language of advertising that can be stretched to incorporate the medium that carries the words. Here, the choice of neon as a preferred medium is of key importance, since neon lighting is perhaps only secondary to the billboard in its significance as a medium for outdoor advertising.

An earlier neon piece, *The True Artist Helps the World by Revealing Mystic Truths (Window or Wall Sign)* (1967; fig. 2), was in fact prompted by a shop window sign advertising beer. It is symptomatic of Nauman's desire to circumvent traditional media and forms in favour of those which belong to mass culture, as in his use of sound, video and television. Significantly, this piece is often placed at the entrance to Nauman's exhibitions, as if to advertise that which is to be encountered within, functioning, as the title indicates, as an actual sign rather than an artwork. As a sign, the work advertises Nauman's exhibitions by successfully exploiting the theatricality of neon, grabbing further attention by the way the blue neon words follow a pink neon spiral outwards in a dynamic movement towards the viewer. While the work successfully creates an ambient relationship of one sort with the viewer by virtue of the theatricality of a highly seductive visual medium, it also creates another layer of ambience through the commonplace form that the words take. Even the plausibility of the statement is questioned by encasing it in neon, a medium largely associated with commerce and popular culture. The irony of this misalignment of form and content is strengthened by the pretentiousness of the statement that elevates the artist as a true and gifted individual while expressing this elevation in the form of a cliché and by the reinforcement of the cliché through the vulgar and commonplace nature of the medium. This is not to say that the work is by any means simplistic in

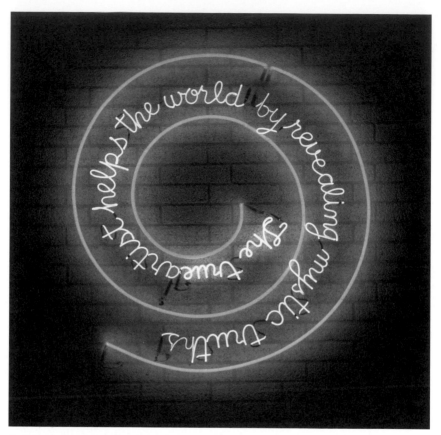

2. Bruce Nauman, *The True Artist Helps the World by Revealing Mystic Truths (Window or Wall Sign)* (1967). Neon. Collection Kröller-Müller Museum, Otterlo, the Netherlands.

intention. Huge cultural and philosophical issues concerning the nature of art and its producers are begged by the sort of clichéd and dubious truism that Nauman presents. The words allude to the notion that art is somehow the bearer of deep truths and implies that there are 'genuine' artists (as opposed, one assumes, to inauthentic artists) who reveal these truths – a notion that has been challenged and overturned by a raft of postmodern theory that questions authorship, authenticity and the certainty of knowledge.[25] Again, in the use or misuse of the cliché, Nauman is in the territory paved out by Beckett and Joyce before him.

The strategies that were developed and the issues that were raised in *Neon Sign* and *The True Artist Helps the World by Revealing Mystic Truths (Window or Wall Sign)* were brought together in a major piece first shown at the Leo Castelli Gallery in New York in 1984, *One Hundred Live and Die*. Again in neon, this piece also invokes advertising by virtue of its billboard size: when all four panels are put together, it occupies a wall-space of approximately 40 x 11 ft. The theatricality of neon is again exploited and the ambience of the work is shored up, this time by the use of a 'winking' programme which turns different sections of the text on and off randomly until the end of the sequence when the whole surface is lit before going completely dark.[26] Again, there is a sense of a message to be delivered and received that should be accessible through the vulgarity of the medium and through the conciseness of the words. But, this, as Robert Storr puts it, is Nauman's way of playing dumb by focusing on words that smart, as for example in another piece which pairs the word 'Eros' with 'Sore'.[27] In *One Hundred Live and Die*, the keywords 'Live' and 'Die' are incorporated into three-word phrases which all share the same grammatical structure but which all betray the contingency of syntax through the substitution of different words in the same very simple grammatical structure. For example, one column runs from the top as follows:

LIVE AND DIE

DIE AND DIE

SHIT AND DIE

PISS AND DIE

EAT AND DIE

SLEEP AND DIE

LOVE AND DIE

HATE AND DIE

FUCK AND DIE

LIE AND DIE

HEAR AND DIE

CRY AND DIE

KISS AND DIE

RAGE AND DIE

LAUGH AND DIE

TOUCH AND DIE

FEEL AND DIE

FEAR AND DIE

SICK AND DIE

WELL AND DIE

BLACK AND DIE

WHITE AND DIE

RED AND DIE

YELLOW AND DIE

The next column repeats the same words in the same order, linking them to 'Live' instead of 'Die'. For example:

LIVE AND LIVE

DIE AND LIVE

SHIT AND LIVE

PISS AND LIVE

EAT AND LIVE

SLEEP AND LIVE

LOVE AND LIVE

... and so on.

Thematically and iconographically, this work relates to a precedent offered by American Pop artist Robert Indiana, whose *The Demuth American Dream # 5 (Die, Eat, Hug, Err)* (1963) can be seen as tribute to an earlier proto-Pop, American Scene painter, Charles Demuth. Interestingly, from the point of view of art and advertising, both Indiana and Nauman reference commercial signage in the presentation of their work, the former by mimicking posters and the latter through the medium of neon. In Nauman's *One Hundred Live and Die*, the word constructions all have an instructional tone that has often been adopted in advertising, although, as with Joyce and Beckett, their

relationships to one another are pushed to the stage where meaning starts to collide and collapse to a point where, as Nauman himself has put it, 'poetry and art occurs'.[28] What Nauman also touches on in his work is the plasticity of words, their visual and tangible capabilities. In the above examples, this is obtained specifically through neon, a medium that signifies both the spectacle and tawdriness of modern life, a duality that is expressed in the way that glass and gas combine to produce a light-form that is simultaneously immaterial and material. In Nauman's case, the use of neon may be seen as ironic, frequently contrasting with a deeply existential tone, as in *One Hundred Live and Die*, where the contingency of being is signalled by the numerous permutations that are constructed around the two essential states of being and non-being, life and death.

There is a similar degree of irony in the way that neon is employed in the work of Tracey Emin. Although very different in nature from the work of Nauman, Emin's practice also extends across a range of materials and forms that frequently incorporate words and, on a number of occasions, these words are expressed in neon. While Nauman's word art tends to dwells on universals that are expressed in phrases that are seemingly less historically and culturally specific, Emin's words are vividly resonant of her personal history. Nevertheless, the irony in Emin's use of neon also stems from the gap between medium and message. In her case, the conventional commercial role of neon is at times poignantly subverted in shorthand allusions to a personal narrative. Emin's narrative frequently harks back to her experiences of childhood and adolescence in the seaside resort of Margate in Kent.[29] Indeed, the appropriateness of neon to the relating of these experiences has been noted by Neal Brown who writes expressively about the way that:

> the use of pure candyfloss coloured light and molten autography
> creates an emphatic exhilaration of Emin's text. For those coming
> from an English seaside town such as Margate, as Emin does, neon
> may be the seaside font of the soul, the light by which feelings are
> illuminated.[30]

Emin's neon pieces emulate hand-script, combining her frequently personalised comments or messages with the 'loudness' of neon. As Adrian Searle has noted, the boundary between private revelation and publicity is

undermined in Emin's use of neon or, as Charles Darwent put it, you see both 'the story of Tracey and an ad for Tracey'.[31] In works such as *Is Anal Sex Legal?* (1998) and *Every Part of Me's Bleeding* (1999), Emin simultaneously exploits a potentially prurient appetite for knowledge of her abused childhood and sexual history and frees herself of the burdens of such histories. Alternatively, Emin simultaneously feeds this appetite with works that celebrate her more recent sexual history and its potential for healing as, for example, in *Kiss me Kiss me Cover my Body in Love* (1996) or *Fantastic To Feel Beautiful Again* (1997; fig. 3). In exposing her personal history through the medium of neon,

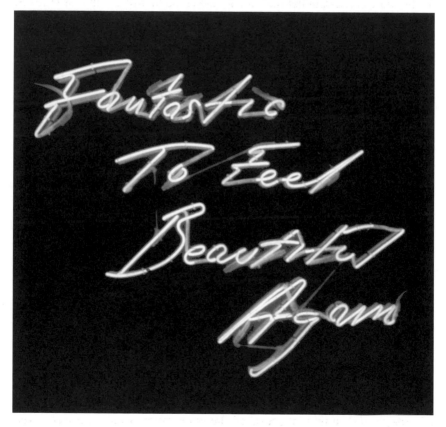

3. Tracey Emin, *Fantastic to Feel Beautiful Again* (1997). Neon, 42 x 50 x 4 in (106.8 x 127 x 10 cm). Photo: Stephen White. Courtesy: Jay Jopling/White Cube (London) © the artist.

Emin's work has entered what might be termed a familial relationship with advertising; in the use of clichés, she has, wittingly or unwittingly, entered a familial relationship with Joyce and Beckett, touching at times, even, on the bleakness of Beckett.

While the rendering of text in neon shores up the plasticity of words and phrases and exploits the ambience of thrills and anticipation that is signalled by neon, the medium is nevertheless rather intractable. Both Nauman and Emin tend to use styles of lettering that are again serviceable, either straight-talking, commanding upper case, as in Nauman's *One Hundred Live and Die* or the more conversational but equally direct 'hand-written' mix of cases in Emin's *Fantastic to Feel Beautiful Again*. Here, words function as an equivalent to the strap-lines or copy of traditional advertising, needing to be legible and to be read and understood according to their syntactical arrangement.

This is almost the exact opposite of the stress placed on the visual arrangement of words on a surface by cutting-edge graphic designers over the past twenty years. Moving away from the detachment and objectivity of modernist graphics, an ethos of subjectivity and individual creativity has developed amongst contemporary graphic designers that some have carried over into their advertising work. Leaders in this shift away from modernism include members of the Cranbrook Academy in Detroit, West Coast designers April Grieman and David Carson, British typographers Peter Saville and Neville Brody, and more recently formed British design groups or agencies such as Tomato, Fuel and Why Not Associates.

In the 1970s, a seminal embrace of subjectivity took place at Cranbrook with the appointment in 1971 of Katherine and Michael McCoy as co-chairs of the design department. This was a time when graphic design was led internationally by Swiss-style, post-Bauhaus graphics, represented for instance in the highly ordered work and 'universal' typefaces of Josef Müller-Brockmann. Much has been made of the intellectual base that the McCoys established at the Academy that took in a broad range of post-structuralist theory, from the political philosophy and cultural criticism of Jean Baudrillard to the phenomenology of Maurice Merleau-Ponty.[32] In effect, the absorption of a range of theories that preached the uncertainty of universal truths and laid emphasis on the contiguity of the moment facilitated a paradigmatic shift. The so-called functionalism of modernist design was replaced by individual approaches which reflected the 'complexity, variety, contradiction,

and sublimity of life'.[33] While syntactical playfulness was as important to Cranbrook design as to artists such as Holzer and Nauman and their predecessors in modernist literature, this was aligned with a desire for a visual complexity that, for all of its basis in theory, was experiential, assimilable and enriching. The result has been an exploration of the relationship between text and image and the processes of reading and seeing. This, in turn, has led to a new subjectivity, and has produced an ethos which respects the importance of intuition in the transactions of daily life, resulting in a fluid and malleable management of words that makes reading a far more open and creative proposition for the viewer.

Although this more subjective approach to graphic design has been criticised by critic Rick Poyner for an overemphasis on self-expression, it actually helps confirm just how close art, graphic design and, by extension, advertising have become.[34] For instance, a work such as Stephan Sagmeister's poster for AIGA at Cranbrook in 1999 – in which the copy is manipulated to look as if painfully gouged into human skin – emerges as a fusion of informational graphics and the sort of self-mutilating body art practised by Gina Payne. Poyner's criticisms were voiced in response to the publication of *WHEREISHERE*, an anthology of visual material of varied authorship gathered by the late P. Scott Makela and his wife, Laurie Haycock Makela, that includes a similar image by Sagmeister.[35] The Makelas were appointed co-chairs of the 2D design department at Cranbrook in 1996, and the non-sequential and non-hierarchical organisation of the book again reflects the emphasis on self-expression and subjectivity that the Academy promotes. The authors, for instance, claimed to 'forego being responsible for trying to effect change in their audience. Instead, they are trying to get a grip on their own existence. Trying to get a grip on the WHEREISHERE.'

The Makelas were not alone in producing books to reflect their design philosophy (books which, to me, resemble artists' books in their prioritisation of the visual experience over instruction or narrative). Others include British design groups Why Not Associates, Fuel and Tomato, all of whom work across a range of contexts, not least advertising. In addition to in-store and in-house promotional material for companies such as Nike, Why Not Associates have been instrumental, since their formation in 1987, in the promotion of contemporary art with poster and catalogue work for the *Sensation*, *Apocalypse* and *Joseph Beuys* exhibitions at the Royal Academy, London. These

works are not predominantly typographic, presenting a balance of image and text. However, Why Not Associates have, in another context, assisted in the production of large-scale, word-based public art with their work as part of an arts-led regeneration project, 'tern' in Morcombe, England. Fuel, founded in 1990, have shown themselves to be equally flexible and interdisciplinary, with work ranging from posters for companies such as Adidas and DAKS and film and television pieces (the Sci Fi Channel, BT Cellnet First, *Lost in Translation* and Heathrow Express) to the design of a number of art books and catalogues, for example, *Tracy Emin: This is Another Place* and *Jake and Dinos Chapman: The Rape of Creativity*. In addition, Fuel have produced and directed a series of their own short experimental films and have issued their own magazine, *Fuel*. The work for Heathrow Express combined words and images in a way that has been described as 'oddly ambiguous or cleverly allusive'.[36] In essence, the disintegration/reintegration of image and the indeterminate play on Warhol's 'famous for 15 minutes' in relation to the time of the train journey and the range of passengers that take it create an ambience rather than delivering a straightforward message and again call for a far more intuitive response from the viewer than in conventional advertising.

Highly significant for the development of new approaches and attitudes to typography and the use of words in the context of design and advertising is the work of Tomato. In 1996, the design group Tomato published their first book, *Process: A Tomato Project*, which portrayed 'the individual journeys and ideas behind their personal and commercial work'.[37] Although Tomato's work is also wide ranging, language, as Rick Poyner has noted, is a shared preoccupation among members of the group.[38] *Process* is peppered with references to and quotations from word artists like Lawrence Weiner and Joseph Kosuth. Moreover, one of Nauman's major influences, Wittgenstein, has been called the 'patron saint' of the team.[39] Unlike Nauman, however, members of Tomato are not so concerned with playing with language within an existential framework, but are keen to 'process' language so that it becomes experiential rather than something to be read. Indeed, the experiential character of Tomato's typography has been described by Poyner as ambient: 'comparable to the ambient music and ambient video of artist-musicians such as Brian Eno'.[40] As Poyner succinctly puts it:

Tomato's work is not so much about ideas, though it is richly

informed by them, as about emotion and expression, an attempt
to snatch and log the fleeting multiple details and momentary
atmospheric sensations of daily experience. In literature this tradition
has stretched from Joyce and Woolf's stream of consciousness to
the transcribed-as-they-come-to-me typewriter confessions of Jack
Kerouac.[41]

The popularisation of these more subjective and intuitive approaches in
typography is without doubt due largely to David Carson. Indeed, as founder
and editor of specialist youth magazines such as *Beach Culture* (1989–1992)
and *Ray Gun* (launched in 1992), Carson may be said to have been a significant
force in raising the visual awareness of subcultures that have in general been
characterised as disaffected – the 'Generation X' of Douglas Coupland's novel
of that name. Further to this, and perhaps as a result of the purchase that
the work was seen to gain in these contexts, Carson's approaches have also
filtered into more mainstream magazine design and, of course, advertising,
including Carson's own work for companies such as Nike, Pepsi, MTV and
Sony. Carson's design philosophy and approaches have been collated in three
major publications by Lewis Blackwell, *David Carson: The End of Print* (1995),
its second edition, *The End of Print: The Grafik Design of David Carson* (2000),
and *David Carson: 2ndsight – Grafik Design After the End of Print* (1997).[42]
All are amply illustrated with examples of Carson's work, including that done
for advertising. Significantly, *2ndsight* is built around the theme of intuition
and appears almost as a manifesto, intended not only to confirm intuition as
the driving force behind Carson's work, but also to legitimise it as a basis for
design methodologies. Quotations from 'iconic' cultural figures are brought
in with regularity to lend weight to Carson's espousal of intuition. These
include the scientist/philosopher Albert Einstein, the psychologist Carl Jung,
and the designer Paul Rand, and are simultaneously supported by a number
of essays devoted to the theme of intuition.

Simultaneity is a key word in trying to put a style such as Carson's into
words. One of the essential features of Carson's approach is what Marshall
McLuhan has termed an 'all-at-onceness', something that McLuhan associates
with the advent of electronic media and the end of print.[43] This 'all-at-
onceness' or simultaneity is evident in the way that texts, motifs and images
vie with one another rather than conform to any conventional hierarchical

organisation. There is often no one way to enter the work; rather, there are several possible points of entry and viewers have to take the one they are intuitively drawn to. The visual deployment of body copy often has a random feel to it with blocks of text colliding and overlapping or even starting to drop off at the edges. In addition, there is a preference for elusive structure and little regard for putting things the 'right way up,' a strategy that frees the viewer from the constraints of the conventional coordinates of the surface. In other words, the idea of a tightly bound and cohesively organised surface that presents content in an ordered and comprehensible way is completely undermined, creating instead a sense of flux and mobility. Add to this images that vary in definition and scale with no apparent rhyme or reason, as well as the ever-subjective factor of colour and the result is, indeed, a feeling of 'all-at-onceness' that, although not quite the same thing, invokes notions of synaesthesia in late nineteenth-century Symbolist art and some forms of early twentieth-century Expressionist art.

The infamous lack of legibility in Carson's intuitively developed works has meant that they connect first and foremost on an emotional level. From this point of view, Carson's intuitive approach can be seen as part of an overall tendency in cutting-edge contemporary advertising that prioritises 'attitude' and often emulates the more open and intuitive methodologies associated with art. Indeed, Lewis Blackwell has suggested that Carson brings something that 'is in him' to communication, 'more like the approach you might get from an artist'.[44] Examples of this are the television commercials produced for Glendale Federal Bank in 1994–1995, in which Carson has made the appearance of words elusive, distorting them, fragmenting them and dissolving them. However, while artists such as Holzer, Nauman and Emin have chosen to work with language in its most reductive linguistic forms, turning clichés and commonplaces against themselves, Carson has almost destroyed its coherency. This creates an ambience of a completely different order to that of the electronic signage of Holzer's *Truisms* or the neon works of Nauman and Emin and, again, an analogy with music comes to mind.[45]

In 1927, Bauhaus artist, graphic designer and photographer, László Moholy-Nagy predicted that the illiterates of the future would be not those who struggled with words but those who could not read images produced by the camera, predicting the dominance of audio-visual forms over printed text, a claim that was extended by cultural theorist Marshall McLuhan to include

digital media.[46] It is no coincidence then that Carson's first book was called *The End of Print*. However, what this title signals is not the takeover of digital technology so much as the end of a culture based on the linear thinking that the invention of the printing press has been said to promote. After all, the demise of linear thinking began in the avant-garde well before the availability of digital technology, in works, such as Joyce's novels, that were written under the aegis of traditional print technologies. Nevertheless, Moholy-Nagy's prediction, like Walter Benjamin's claim that photography and film would alter people's understanding of art, seems to have been realised to a large extent, judging by the huge amount of visual material that now circulates on a daily basis in the culture.[47] (This is not to say that literary skills have been taken out of the equation, just that the equation has expanded exponentially to incorporate the visual.) What has materialised is not an either or situation where one option has to take a fall, but a situation of increased possibilities. One of these possibilities is the synthesis of the verbal and the visual that, as I have shown, has occurred in different ways in art and advertising but which, in both cases, has also resulted in a synthesis of art and advertising. This synthesis is symptomatic of the way that the boundaries between arenas of practice and ideas of 'high' and 'low' are collapsing in the culture as a whole and provides a fitting introduction to the fluidity of practices, forms, themes and ideas that will be returned to throughout this book.

Chapter 2

Art Invades and Appropriates

Having explored encounters between the verbal and the visual in art and advertising, I now want to look at artists who have not only appropriated the language and forms of advertising, but also 'invaded' the spaces of advertising.

Art and advertising rubbed shoulders in what seemed to be an unprecedented way in the late twentieth century, when a number of artists began to display their work in public spaces normally the preserve of promotional imagery. The move into the street began in the late 1960s, with what is thought to be the first example of billboard art in the USA, Joseph Kosuth's *Class 4, Matter, 1. Matter in General* (1968).[1] Although highly conceptual, Kosuth's billboards were a pioneering attempt to take art out of the gallery and to make it publicly accessible. They were also to pave the way for later artists to use the billboard for their own subversive or oppositional purposes.[2] The desire to take art closer to the public echoes one of the key aims of the politically radical strand of the early twentieth-century avant-garde, which was to bring art closer to life and to raise social and political awareness on a wider scale. The poster and billboard art of the late twentieth century is also connected to that of the early twentieth-century avant-garde by the use of formal approaches often associated with modernism, in particular, directness

of expression and the simplification of form.[3] As will be seen, practices developed by the Russian avant-garde in the early part of the century are especially relevant to those that developed in the billboard and poster art of the late 1970s and 1980s, simply because they provided a precedent for the way that the strategies of commercial advertising can be harnessed to avant-garde practice. These developments in Russia were set against a climate of revolutionary optimism, where art was to be of functional or political value to the masses. Late twentieth-century poster and billboard art in the West, however, was to kick against the reactionary politics of the Reagan and Thatcher administrations, udring which fine art had become a fashionable and expensive commodity.

Art moved into the streets at a time when the gap between the haves and have-nots in society was visibly widening. It was a time when the social infrastructures of both America and Britain were being seriously undermined in favour of private enterprise and individual gain; a time when the avant-garde in art was in the process of redefining itself, prompting a number of artists to embrace the forms and techniques of the mass media in order to deliver oppositional messages in an accessible manner. Obviously, an industry such as advertising was prominent in the 'spectacularisation' of the entrepreneurial and consumer expansion of the 1980s, along with other forms of mass media such as glossy magazines, film and television, all of which are dominant cultural mediators that also act as popular mentors. It is no coincidence then that a number of artists who had matured in this media culture chose to express their criticisms of its values by inserting themselves into the arena of that culture, adopting and parodying its forms. Yet, ironically, many of the artists who opposed the status quo were also to profit from the economic boom of the 1980s, when the art market notably improved for members of the contemporary avant-garde.[4] As Lisa Phillips has noted, the relationship between art and the media in the 1980s was complicated because, in simultaneously criticising the system and benefiting from it, artists seemed to be having their cake and eating it. In other words, despite their counter-cultural thrust, they were also complicit in the maintenance of a commodity-based system.[5] As Richard Bolton put it, artists had to 'negotiate the space between high art and mass culture, between the elite audience and the general public, between rejection of the system and acceptance of it'.[6] Within the framework of billboard and poster art, it is perhaps only the

(mostly anonymous) poster works produced by activist groups in the 1980s that truly escaped this dilemma and evaded complicity with the marketing system of the art world.

The model provided by early Soviet art was important for the move into the streets because it denied the notion of fine art altogether and privileged forms such as advertising and propaganda that were felt to be accessible to a wider audience. Instead of abandoning commercial advertising, as might be expected under a socialist regime, the Soviet authorities of the 1920s legitimised it as 'social advertising', recognising that to stay viable the economy needed consumers as well as producers, at least in the early years of transition to a new social and economic order.[7] This idea that commercial advertising can make a legitimate contribution to a socialist society provides a useful foil to the perception of advertising that has recently dominated. Indeed, the contrast between attitudes to advertising in Russia in the inter-war period and those which developed in the West immediately after the Second World War is pronounced, particularly in the USA. On that side of the Atlantic, post-war debates about the probity of advertising developed in the climate of the cold war, when fear of Soviet infiltration into the West was rampant and when advertising for many social critics came to carry both the sins of capitalism and the sins of communism at the same time. Vance Packard, for example, while questioning the role advertising played in American consumerism, clearly conflated it with the notion of indoctrination associated with communism, citing Americans as the most manipulated people outside the Iron Curtain.[8]

In Britain, it was Victor Burgin's series *UK 76* (1976) that was instrumental in the resurrection of the notion of a socially relevant poster art. A now renowned poster – *What Does Possession Mean to You? 7% of our Population owns 84% of our Wealth* (fig. 4) – illustrates these hard-hitting statistics with an image of romantic fulfilment and sexual promise typical of the consumer advertising of the period, ironically turning the strategies of consumer advertising against themselves and exposing the contradictions of capitalism. Although *What Does Possession Mean to You?* was first fly-posted in Newcastle upon Tyne in 1976, Burgin had been working on the ironic juxtaposition of found images and text since the early 1970s.[9] At this point, it is tempting to see a connection between the development of these approaches in Burgin's work and the mounting of a major Arts Council

4. Victor Burgin, *What Does Possession Mean to You? 7% of our Population owns 84% of our Wealth* (1976). Courtesy: Victor Burgin.

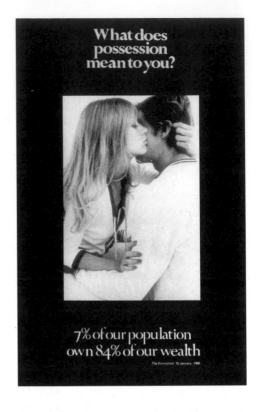

exhibition of Russian Revolutionary art at London's Hayward Gallery early in 1971.[10] Certainly, by 1976, Burgin had acquired a detailed knowledge of early modern Soviet art and subscribed to the notion of a socially relevant art based on ideas developed by the Soviet avant-garde.[11] He was, for instance, taken with the approaches to mass representation advocated by the constellation of Soviet writers and artists who gathered around *Lef* magazine in the early 1920s, especially their faith in the power of the advertisement as a 'poetic supplement'.[12] *Lef* writers and artists sought to transform social and political awareness at a deeper level through a radical restructuring of language (both visual and verbal) and were to prefigure the way that Burgin and other late twentieth-century artists sought to redefine the 'language' of art by appropriating the forms of advertising. It is also significant that the preferred methods of representation adopted by *Lef* writers and artists were those of the mass media, for example, the photograph, the magazine

and, most importantly for the relationship between art and advertising, 'the placard' or poster. 'To the easel painting – claimed to be a permanent source of agit – *Lef* opposes the placard, which is topical, designed and adapted for the street, the newspaper and the demonstration, and which hits the emotions with the sureness of artillery fire.'[13]

It is interesting here that Burgin does not actually adopt the advertising styles of the Russian avant-garde, which were bold and outspoken, but uses the more seductive approaches of western consumer advertising. However, Burgin has little time for these approaches when used in advertising, seeing them as duplicitous, creating an illusion of an almost natural world order, despite being heavily laden with ideology. According to Burgin, advertising is powerful and insidious not only because it naturalises ideology but because it is freely received in the environment and tends to pass unremarked, like ideology itself.[14] In contrast, Burgin suggests that socialist art practice is able to undermine the apparently seamless surface according to which ideology is represented in mainstream advertising. This is precisely what was achieved when he produced *Possession*.[15] For Burgin, the project, as already noted, was to turn the devices of advertising upon themselves, 'to unmask the mystifications of bourgeois culture by laying bare its codes, by exposing the devices through which it constructs its self image' and, in what might also be seen as a rehearsal of strategies employed by Les Levine and Barbara Kruger in particular, 'to expose the contradictions in our class society, to show up what double-think there is in our second nature'.[16]

However, it was the 'photomurals' produced by Docklands Community Poster Project, initiated in 1980 (fig. 5), which were to most fully reflect the ideals of the Russian avant-garde in Britain. Instead of an artist producing works to be disseminated to an anonymous public, this project actively involved the public in a way that had been explored in early Soviet Russia.[17] The Docklands Community Poster Project was set up in response to the London Docklands Development Corporation's plans to redevelop the area for commercial purposes. Government-backed, the Corporation all but had the power to develop without public consent and the Docklands residents were given little say in the plans. Reflecting the tensions between local government and Westminster, the Community Poster Project was funded by local borough councils and Greater London Arts, which was in turn funded by the Greater London Council.[18] The realisation of the project was facilitated by

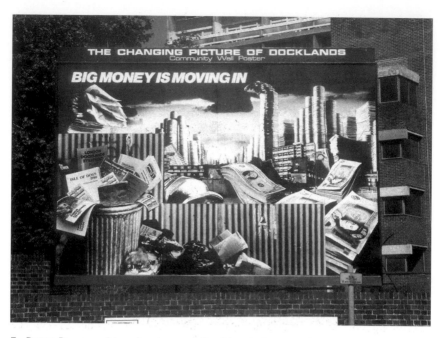

5. Peter Dunn and Loraine Leeson, Docklands Community Poster Project, *The Changing Picture of Docklands* (1980–1990). Courtesy: Peter Dunn and Loraine Leeson.

two artists who lived close to the Docklands, Loraine Leeson and Peter Dunn, who supported the residents in planning the campaign. In effect, Leeson and Dunn functioned as the sort of trained and experienced mediators that had been envisaged by Lenin as far back as 1905, who were to work with ideas from and give feedback to the community.[19] The Docklands posters were produced in two cycles: the first designed to develop awareness of what was happening to the area; the second to develop a historical perspective, showing how Docklands residents had had to struggle for better conditions in the past.

The posters were produced from photographic collages and were highly reminiscent of the anti-Nazi photomontage work of German artist John Heartfield in the late 1920s and early 1930s. This was especially evident in the critique of 'big business' in the first cycle, 1980–1984, which is thematically related to Heartfield's *The Real Meaning of the Nazi Salute* (1933), in which

Hitler's saluting hand is seen taking a backhander from big business. This image, along with most of Heartfield's photomontages, was published in *AIZ*, a magazine that adopted modernist approaches and campaigned relentlessly against Hitler and the Social Democrats.[20] In effect, the relationship of the Docklands posters with the historical avant-garde extended beyond practices associated initially with the USSR to those developed by politically radical artists in the context of Nazi Germany. However, what was essentially at stake in both of these historical contexts, as well as in the Docklands poster campaign, was the need to communicate quickly and effectively. The imagery and texts used needed to be straightforward and explicit, delivering short incisive messages, in the manner of advertising or propaganda. While the situation for 1980s billboard and poster artists was not so acute, politics was nevertheless dominated by similarly repressive right-wing forces, prompting a similar appropriation of popular forms by certain politically minded artists.

Yet, while both the billboard format and the sort of visual and textual shorthand characteristic of advertising were used for the display of the Docklands posters, the parallels with commercial advertising stop there. Leeson argued that the Docklands posters 'are designed to get across complex issues and to reveal the underlying structure of what's going on, whereas advertisements are generally designed to obscure the underlying structure and get across a product name'.[21] More accurately, the Docklands posters might be regarded as emulating the strategies of advertising's close relation, propaganda, although just to complicate things, the art critic Sandy Nairne felt it necessary to defend the Docklands posters as art. In discussing the state of contemporary art in the television series and accompanying book *State of the Art* in 1987, Nairne refused simplistic categorisations based on the conventional hierarchical ordering of the visual arts, observing that 'The art-propaganda divide is itself propaganda on behalf of a certain view of art.'[22] In short, Nairne identified a changing agenda for the production of art and recognised the diversity of the roles that it can play in an expanded field of practice. Commenting on the limitations of the conventional hierarchical organisation of the visual arts, Nairne stressed the artistic value of the Docklands project as an outstanding example of the inventive use of posters, borne out by other examples of this sort of work that Leeson and Dunn had produced for exhibitions in America and Canada and international magazines. However, while Nairne's desire to classify the Docklands poster project as art

can be seen as expanding or even democratising the remit of art by including popular forms, it still sets up a demarcation between advertising, propaganda and art. In his desire – or need – to hang on to the category of art, Nairne reflects the persistence of a related need: to attach a name to the producer of the work, which, in the case of the Docklands Community Project ought to have been the Docklands residents as much as Leeson and Dunn.

Even with champions such as Nairne, however, the acceptance of popular forms such as the billboard as art in Britain was slow and somewhat difficult. The reluctance to legitimise such forms is demonstrated by Declan McGonagle's need to justify this type of work as recently as ten years after the publication of Nairne's book. In an article in 1997 that advocated the use of publicly accessible spaces for the display of contemporary art, McGonagle, in essence, reiterated Nairne's arguments concerning hierarchies in the visual arts. McGonagle's basic quarrel was, firstly, with the idea that art has some sort of eternal relevance, 'that there is a separate, absolute current of meaning, independent of the present tense or social environment with which some artists connect and some others miss' and, secondly, with the idea that art should occupy a neutral zone such as that of the modernist art museum. Fittingly, McGonagle's criticisms of a system that disconnects art and the artist from society have formed the basis of his curatorial activities, including the production, as Director of Exhibitions at the ICA in London, of Dublin-born artist Les Levine's controversial billboard project, *Blame God* (1985; fig. 6), contemporary with the second phase of the Docklands Community Poster Project. While *Blame God* was initiated in an attempt to make art more socially relevant, the project was also important for bringing art and advertising closer together – in form, if not in spirit. Levine, like the more widely known American poster artist Barbara Kruger, has made billboards a sustained part of his work, producing, as Kruger has, at least twenty and, also like Kruger, has made it his business to interrupt the uncritical reception of billboard advertisements by the insertion of 'art' billboards.[23]

Much of Levine's early work had been concerned with exposing the relationship between art and commerce. This is demonstrated by works such as *Disposables* (1966) or *Levine's Restaurant* (1969), both of which issued a challenge to the notion that the artwork should be unique and viewed as if it carried an aura of exclusivity.[24] Levine also sought to expose the business and marketing systems upon which the art world is founded. *Levine's Restaurant,*

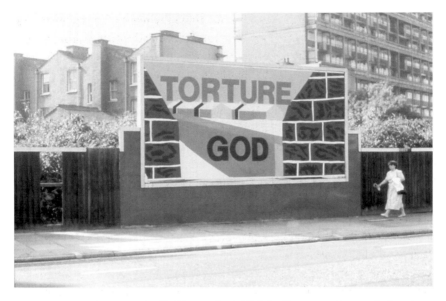

6. Les Levine, 'Torture God', *Blame God* (1985). Courtesy: Artangel, London.

for instance, was a response to the celebrity mentality and pretensions of New York's art bars.[25] *Disposables*, shown in the Fisbach Gallery, New York, comprised coloured, mass-produced, vacuum-formed, two-dimensional shapes such as squares, diamonds, circles or, in some cases, three-dimensional objects which looked as if they had been formed around cylinders or boxes. Levine's point was that, in many cases, it is only market mechanisms that restrict the supply of artworks and that the inaccessibility of the artwork is not so much to do with scarcity as with economic strategies. Kenneth Noland's stripe paintings of the 1960s, for example, could easily have been mass reproduced with hardly any loss of quality.[26] As Levine himself commented:

> Thousands [of the disposables] have sold and some have thrown them out. They've probably been sold to only ten or twelve people who could be considered collectors; this means that many people who have never owned a work of art have gotten involved in the activity of collecting. You see it's like Keynesian economics: it's not what you produce that's so important, but turnover and circulation. Economically art movements work the same way.[27]

It follows that the size and nature of the public to whom the work was to be addressed would also be an issue for Levine and that the commitment towards a wider public was what motivated his billboard work as well as what brought it closer to advertising. Speaking of the *Blame God* posters, Levine makes their intended relationship with advertising clear, referring to them for instance as a campaign.[28] Levine also confirmed that the importance of choosing the billboard as a medium was the fact that the works would be out on the street and seen by a significant number of people. He claimed that his messages were spread in a similar way to the advertising message, by 'infectious connection', suggesting that not everyone needed to see the work but that the message could be spread to the community at large by those who saw the billboard: 'It doesn't have the same degree of immunisation as a painting or sculpture.'[29]

It is, of course, much more difficult for unique works of art to have this sort of directly contagious effect, even when disseminated through infectious media such as television or magazines, since their exposure to the public is limited to interested audiences rather than inserted freely into public spaces. In addition to the advantages offered in terms of commanding public attention, Levine settled upon the medium of the billboard because he also believed it allowed a radical contribution to the methodologies of both art and advertising. The use of billboards for the *Blame God* campaign was an attempt to make both practices 'high risk' and contentious. In effect, it proved to be a rehearsal for the sort of contention caused by Oliviero Toscani's highly controversial *Shock of Reality* campaign for Benetton in 1991–1992. As Toscani was to do, Levine produced images that sat somewhere between art and advertising and that deliberately disrupted and outraged the public:

> ... by nature of using advertising, it is simply not enough to create images that are interesting to the art world, or that are titillating or provocative on a political level. One must make images that absolutely put your life on the line. That's what people need from artists, that they're willing to put themselves out on a limb. [The *Blame God* posters are] very hot images and, as it is with any hot thing, they can be bounced around by many people at different levels.[30]

The shock value of the *Blame God* campaign was demonstrated by the media attention that it received throughout September 1985, many examples of which were reproduced in the ICA publication accompanying their exhibition of Levine's work in the same year. The depth of feeling behind the negative responses that the campaign provoked can be gauged not only from complaints received, but also in the fact that the hoarding company, London and Provincial tried to renege on their posting contract,[31] and from the hostile behaviour of one member of the public, who threw a pot of black paint over one of the posters near the Elephant and Castle in London. As Michael McNay, writing for *The Guardian*, noted, this gesture seemed to reverse Ruskin's libellous statement about Whistler throwing a pot of paint into the public's face and perhaps conferred an aura to the work by default. It certainly transpired that Levine, despite his earlier critiques of art and commerce, was able to price his posters at £50,000, on the basis that they were limited-edition screen prints.[32] The introduction of this sort of pricing seems to be a far cry from the philosophy that underpinned the *Disposables* and, although Levine's billboard posters acquired radical potential by temporarily mimicking advertisements, this sort of price tag demonstrates that their ultimate destiny was that of a collectible work of art. This raises questions about how far Levine's claims that his billboards functioned as advertisements were realised. In provoking media attention and a violent response, the posters were successful in making people pay attention to the issues that they raised and prompted debate about the posters, so from this point of view they can be seen to have achieved at least some of the desired effects. Yet, it could also be argued that what was generated was not an engagement with the works themselves but publicity about the 'campaign', which added value to the works as art commodities.[33]

As far as the public responses to Levine's posters are concerned, it seems that the problem was largely with the ambiguous nature of the wording on the posters which, intended as a comment on the absurdity of committing genocide in the name of God, could all too easily be seen as a religious slight. Applied to the subject matter of the posters – the conflict in Northern Ireland – imperatives such as 'blame God', 'attack God', 'hate God' or 'torture God', forced the viewer to rethink the message itself and highlighted their irreverent and blasphemous content.[34] As is the case with Barbara Kruger's billboard work, this mode of address also called for the viewer to rethink the

way that the imperative is used rather than absorbing it uncritically as is the case in most conventional advertising. When used to direct the consumption of beauty products, for instance, the imperative appears innocuous, a bidding to do something to the consumer's advantage while, in effect, establishing an ethos of conformism. McGonagle notes that the fiercest resistance to Levine's work came from his staunchest Christian critics who were, of course, particularly angered by the inverted message that Christian societies are actually killing, starving or bombing.[35] Both McGonagle and Levine pointed out that advertisements that promote cancer-giving products or demean women tend to escape public censure. In other words, the *Blame God* campaign outed not only the hypocrisy of the traditional Christian church but also the hypocrisy of traditional advertising practices that made superficial promises towards an improved quality of life but, in the long run, were detrimental to the quality of people's lives. In this, Levine made serious demands of his viewers, asking them to read deeply rather than superficially and, in this respect, he shared approaches practised by several other artists working in public spaces.

Along with and perhaps even more so than Levine, it is Barbara Kruger who epitomises the politically motivated, media-conscious artist described at the start of this chapter. As Kruger herself readily admits, a major factor in her engagement with the forms of advertising and the mass media is the training she received and the work that she subsequently did as a graphic designer. When, after some ten years of billboard production, she was asked by Karrie Jacobs in an interview for *Eye* in 1991 whether she still felt as if she was doing design or advertising, she expressed a preference to be seen as 'someone who works with pictures and words'. Nevertheless, she noted that she felt that, rather than deriving from advertising, her methods stemmed from the work she had done in editorial design.[36] Kruger had been slightly more forthcoming on the subject in an earlier interview, this time with Jeanne Seigel for *Arts Magazine* in 1987.[37] Here, Kruger also emphasised the importance of her experience as a graphic designer, which she claims took precedence in the late 1970s over the influence of her peer group, who were also heavily involved in 'a vernacular form of signage'. While characterising her skills as knowing how to 'deal with an economy of image and text which beckoned and fixed the spectator', she admitted that her method combined the 'ingratiation of [the] wish desire' of advertising with her own 'criticality of knowing better'. Here, Kruger acknowledged that she shared common strategies with advertising,

but explained that she used these devices 'to get people to look at the picture, and then to displace the conventional meaning that the image usually carries with perhaps a number of different meanings'.[38]

Yet, as several critics have noted, Kruger does not in fact reference contemporary advertising but employs period images that carry a certain nostalgia for the 1940s and 1950s.[39] This strategy allows Kruger to tap into shared memories that give added value to such images, removing them from the immediacy of contemporary advertising and creating a particular hold on the viewer. Even though, as Liam Gillick notes, examples of the same 'clunky American advertising technique' survived well into the 1990s, most leading mainstream advertisements of the 1980s fell into an approach that has been dubbed 'Capitalist Realism', which will be discussed in more detail in Chapter 3. In essence, this is a type of advertising characterised by glossy photographic representations of the good life, attending to subliminal desire rather than acting as rather simplistic exhortations or announcements.[40] In effect, the poster and billboard work of both Kruger and Levine fits into an older exhortatory or annunciatory mode of advertising. According to this set of conventions, the image is used as a straightforward illustration or amplification of the verbal message, although, of course, this is hardly ever simply the case in the work of either Kruger or Levine, where the relationship of image to text is almost invariably subject to an ironic twist. Moreover, in Kruger's case, the verbal messages are frequently juxtaposed with images that have become grotesque in their transposition from one context to another, for example, in *Untitled (Buy me, I'll change your life)* (1984; fig. 7) or *Untitled (You are a captive audience)* (1992). In both cases, the images are taken from the humble source of magazine photography and, although congruous with the text, the result is both jarring and alienating, due to a process of drastic cropping and enlarging.

A form of sarcasm also underpins these and other less grotesque works such as the *Help* series, a public art bus shelter project, mounted in Queens, New York, in 1991 (fig. 8). Each of the posters presents the word 'HELP!' as a strap-line, upper case, in white on a red background that in turn overlays a photograph of a three-quarter-length male figure. The male figures vary in social type, but all are accompanied by a brief piece of autobiographical copy which tells of reaching a point of achievement in their lives then ends in an ironic ruse in the form of another strap-line reading 'I've just found out

7. Barbara Kruger, *Untitled
(Buy me, I'll change your life)*
(1984). Photograph, 72 x 48 in.
Courtesy: Mary Boone Gallery,
New York.

I'm pregnant. What should I do?' Such a dilemma, of course, only applies at
a remove to men, making the message about gender inequality abundantly
clear. Needless to say, the use of grotesque imagery or ironic copy of this sort
is normally alien to consumer advertising.

Kruger has also repeatedly employed straight-speaking modernist typefaces
such as Futura or Helvetica Bold, which has been termed, 'the signature
typeface of post-industrial capitalism', providing another indication of her
origins as a graphic designer as well as another link with modernism.[41] This
identification with the signature style of modern typography is interesting
because, in employing these typefaces in conjunction with black and white
photographs and red strap-lines, Kruger has developed a signature style of
her own. Indeed, in spite of the appropriations from more anonymous arenas
of representation such as advertising and graphic design, and in spite of
their presentation on billboards, Kruger's works have been readily received
as art and the products of individual authorship. Through this development

8. Barbara Kruger, *Untitled* (1991). One of three posters for 100 bus shelters citywide, New York. Photo: Timothy P. Karr. Courtesy: Public Art Fund, New York.

of a signature style, Isabelle Graw has suggested that Kruger 'prefigures the currently acceptable idea that the artist has to develop a label'. At the same time, however, Graw also recognises that Kruger was producing a socially engaged art, acting as an author-producer in a way envisaged by Walter Benjamin earlier in the century.[42] Not only, as Graw argues, does Kruger make use of the montage forms praised by Benjamin (which, of course, bring her close to the Constructivist influence that she denies), but the social and political themes addressed in her work also align with Benjamin's suggestion that art should address the class relations of the society in which it is produced.

It is here that Kruger's relationship to the early twentieth-century avant-garde becomes more apparent. Kruger has expressed frustration at having to deal with an 'art subculture' that had no understanding of the significance of her experience in graphic design and that persisted in situating her in relation to the Constructivist strand of the historical avant-garde, of which she knew little in her formative years as an artist.[43] However, her reading of Benjamin was a formative influence, as she confirmed in an interview with Thyrza Nichols Goodeve for *Art in America* in September 1997, admitting to being 'blown away' by both Walter Benjamin and Roland Barthes.[44] And, although Kruger denies a direct connection between her work and that of the Constructivists, a link nevertheless exists in the call for a socially relevant art and in the advocacy of popular forms of representation and the more active engagement of the 'reader' that are made in Benjamin's 'The Author as Producer'.[45] However, while approaches that originate in the practices of the early twentieth-century avant-garde are used to harness and expose the 'class' struggles of the late twentieth century, Kruger simultaneously uses them to provoke reflection upon the ideological role of language rather than to deliver ideology per se. In other words, it is this introduction of critical reflexivity that separates Kruger's works from the works of the early twentieth-century avant-garde and ultimately renders them postmodern rather than modernist.

The radical wing of the late twentieth-century avant-garde in art did not just appropriate forms and approaches from the historical avant-garde, but took their works into the 'street'. Again this is highly reminiscent of practices established in Russia shortly after the October Revolution of 1917, when the notion of fine art was discredited and replaced by the more directly socially relevant categories of agitational propaganda art (agit-prop), laboratory art and production art. Laboratory art was basically visual research of a formalist

nature and was meant to underpin production art, which, in essence, had replaced the notion of the applied arts.[46] Of the three types of 'art', it is agit-prop art that prefigures the practices taken up by Kruger, Levine and other artists who invaded the streets, including Jenny Holzer, who began her work in public spaces with electronic displays of verbal messages (for example, *Protect me from what I want*, Piccadilly Square, London, 1991). Unsurprisingly, agit-prop art largely consisted of poster work, although, more unexpectedly, the use of 'high-tech' was anticipated in projects for the cinematic projection of messages.[47] The aims of Russian agit-prop art were to spread the revolutionary message as widely, quickly and directly as possible to a population that was frequently uneducated and, in remoter parts of Russia, unaware of the Revolution and the political issues that prompted it. These messages were not only displayed in the streets but on the sides of long-distance boats and trains. In this, Russian agit-prop art set a clear precedent for artists and producers such as Burgin, Leeson and Dunn, Levine, Kruger and Holzer, who took their art out of the more exclusive confines of the gallery space into public spaces. By and large, these spaces are readily accessible and, importantly, were not only spaces of mass communication and popular culture but are also spaces that, in their anonymity, have a history of popular resistance.

Writing in relation to Holzer's work, David Joselit speaks of its presence in 'those sites of anonymous transportation, consumption and entertainment from local supermarkets to international airports'.[48] For Joselit, Holzer's texts 'seize the institutional power of language as it exists in the built environment', mimicking it but always recoding it.[49] Employing a term coined by the anthropologist Marc Augé, Joselit also refers to these anonymous sites of consumption as 'non-places', which are defined by the mobility of 'supermodernity' and the transitory cultural interventions it brings (such as the words and images of advertising) as much as by bricks and mortar.[50] It has been argued elsewhere that spaces of this sort have become the privileged spaces of the postmodernisation of society. Mike Featherstone, for instance, has suggested that the existence of such spaces is symptomatic of the collapse of the old social hierarchies embodied in traditional architecture and monuments.[51] In these newly privileged spaces of postmodernity – such as the shopping mall or the airport – social values are inscribed in the cultural practices that are developed in and around the spaces of the city. Here, signs,

advertisements or shop windows, for example, are to be read symbolically rather than functionally and to assist in the styling of life.[52] From this point of view, it may be argued that art's entry into the world of consumer signs was facilitated by the fact that the viewer was already disposed to treat the street as a place for the acquisition of symbolic knowledge through a wide variety of signs, including posters and the display of consumer goods. Such knowledge is acquired almost by a process of grazing and the signs that supply it are not presented or read in a systematic way.[53]

Augé and Featherstone's notions of 'supermodern' or postmodern spaces relate to the notion of social space, which was put forward in 1974 by French theorist Henri Lefebvre. In line with fellow French theorist Michel de Certeau, Lefebvre recognised that there are ways of appropriating public spaces to turn them into sites of resistance against the controls of the dominant culture.[54] For Lefebvre, appropriated space is situational, a matter of creating and responding to situations, a place for actions and interactions, expressiveness and revolt. Significantly, one of the ways in which space becomes situational is again through the world of signs and images.[55] Lefebvre comes close here to the notion of *detournement* put forward by the Situationist International, a radical association, formed in 1957, that was made up of a broad spectrum of people who shared similar counter-cultural values, including philosophers, writers, artists and architects.[56] *Detournement* – literally 'diversion' or 'rerouting' – meant finding ways in which the environment could be subverted in order to make people critically aware of their 'situation'. In appropriating billboards or poster hoardings, artists are able to intervene in and redirect the world of signs, opening it up to alternative meanings and inflections. Art can thus be seen to form a bridge between the relatively unstructured everyday resistances, sitting down while the national anthem is being played, for instance, or even trespassing on the grass, that are small but vital demonstrations of disaffection with the controls exerted by the dominant culture.[57] What is important about billboard and other forms of street art is that they change the way that social space is produced and consumed, opening it up to that which is non-mainstream or 'other' and destroying the sense of coherency produced by conventional and ordered uses of space.[58] The difference between these works and consumer advertisements is that the disruptions brought by the latter tend on the whole to work as welcome distractions or even minor irritations rather than as direct challenges to the status quo. While Lefebvre's notion of

the situational and the Situationist notion of *detournement* chimes neatly with the interventions made by artists such as Kruger and Levine, it also fits with the interventions of activist art, a form of cultural terrorism largely identified with American groups such as Gran Fury (AIDS), the Guerrilla Girls (Gender equality in the art world) or Adbusters (campaigning against and subverting commercial advertising).

Driven by pressing single issues and less inclined to examine general attitudes and principles than most of the work discussed earlier, the work of activist groups was often anonymous, coming close to public service and charity advertisements. In activist art, a vital social message needs to be conveyed quickly and effectively, usually, although not always, without the appeal to the libido or desire that characterises so much of consumer advertising. For their part, advertisements operating without this sort of libidinal content often represent social themes and have also fulfilled the promise of social advertising advocated by the Russian avant-garde. Leaders in the field of current 'social advertising' are Saatchi & Saatchi, who have a substantial record of producing high quality social-cause campaigns. Numerous examples of Saatchi 'social advertising' from branches of the Saatchi & Saatchi agency worldwide can be found in *Social Work: Saatchi & Saatchi's Cause-Related Ideas*, a publication which accompanied a travelling exhibition of their public service posters.[59] These include a well-known pioneering example, *Pregnant Man*, for the Health Education Council in 1970, and the uncompromisingly illustrated *Women and Children First* poster for Greenpeace (1996), which showed a baby with hydrocephalus, the result of 'harmless' radiation tests in Kazakhstan. The placing of these advertisements into an exhibition, of course, can be seen as the opposite move to that of taking art into the streets, undermining the purpose and effectiveness of the original campaigns by turning them into objects of artistic contemplation.

Moreover, these campaigns clearly originated in the realm of advertising and did not in themselves play an active part in the blurring of the boundaries between art and advertising in the way that billboard and activist art did. In terms of public service campaigns, this erosion of boundaries was achieved by an AIDS-awareness campaign that was not generated by advertisers but by a number of well-established contemporary artists. *On the Road: Art Against Aids* (1989) was to be one of the most highly visible AIDS poster campaigns in America, and was commissioned by the American Foundation

for AIDS Research (AmFAR).[60] The works produced varied in whether they looked like 'art' or 'advertising', ranging from the direct, recognisable graphic styles of John Lindell and Barbara Kruger to the less pointed, more reflective photographic representations by Brian Weil of an HIV-positive baby and by Robert Mapplethorpe of two men embracing.[61] In all, twenty-two artists were asked to develop works that were to address the issues of AIDS in public sites such as billboards, bus shelters and bus panels. As these are 'non-spaces' with no pretensions to high culture, the status of the works is ambiguous, neither art nor advertising per se but something in between that takes the best of both. The morally questionable aspects of consumer advertising do not figure and the much-criticised elitism of art is no longer an issue.

Nevertheless, the co-option of named artists in this project raises issues of authorship and authentication. The move into outdoor sites usually dedicated to consumer advertising not only signals a shift in the perception of the artwork as unique and original, but also proposes a shedding of the aura that emanates from the framing of art in galleries, museums or private collections. Yet, while billboard art is accessible in the way that advertisements are, it is not always anonymous in the way that advertisements are. The work of major billboard artists was quickly identified as the product of individual authors and gained much of its status and authenticity from this fact. Interestingly, however, while works of art which ironically and parodically mimicked advertising without recourse to a product were appearing in the contexts normally associated with advertisements, the avant-garde advertisements which appeared at the same time began to shed any direct representation of the product and develop a signature style. Just as most of the works of art discussed above were authenticated by the name of the author, these advertisements developed a particular style that was not only authenticated by the name of a brand (which as Naomi Klein has recently shown is by no means the same as a product) but also by a distinct type of imagery.[62] In developing such an identifiable style, these major campaigns gained an aura almost equivalent to that of the name of an artist and have undermined functionalist perceptions of advertising. As I will show, advertisers did as much in their own way as poster or billboard art to bring art to the streets in the late 1970s and 1980s.

I want to finish this chapter by flagging up an acclaimed word-based advertising campaign that also made use of unconventional spaces and

that is particularly significant because here we see cutting-edge practices in the *advertising* of *art*. The campaign was devised for britart.com by the comparatively young award-winning agency Mother and ran for eight months from August 2000. The strategy behind the campaign was to produce advertising material that reflected the popularising remit of britart.com which, with its motto 'art for the many not for the few', set out to make the viewing and buying of art 'an everyday occurrence rather than an extraordinary occurrence'.[63] The form the campaign took was that of fly-posters on street furniture, pavements, walls and even trees (fig. 9). However, rather than imitating advertising copy, the creatives simulated the sort of labels that accompany artworks in an exhibition and treated the site as an artwork. For example, the poster on junction boxes read 'Junction Box, 1971, steel, paint, wiring, electricity, 100 x 120 x 50 cm'; the wording on the pavement flyer read 'Pavement, 1962, concrete slabs, cement, shoe prints, dog excrement, chewing gum, 8000 x 15050 x 10 cm. Here, we are back in the territory not only of ambient advertising but also that of conceptual wordsmiths such as Lawrence Weiner, who raised issues about the nature of art itself.

What was required for the advertising of a retail outlet that wanted to show the affordability of contemporary art was a campaign that could 'alter the perceptions of a previously elitist and mystifying market'.[64] In producing a series of posters that labelled street objects in the manner of the gallery, Mother simultaneously parodied the practices of high art and made a joke out of the fact that almost anything can be designated art. Moreover, the relegation of the promotional message to the comparatively diminutive strap-line 'art you can buy' and the playful attachment of the red 'sold' dot to the logo assists in the reading of the posters as works of conceptual art rather than advertisements, at least in the first instance. In adopting 'interventionist' strategies in order to advertise art, the britart.com campaign blurred the boundaries between the two regimes in a way that is symptomatic of the apparently ever-increasing fluidity of contemporary culture. Indeed, the fact that the campaign could take such a publicly irreverent stance towards both traditional and contemporary art can be read as a sign of détente and of the demystification of art.

What was generated around the formation of britart.com was a rhetoric not only of the affordability but also of the now more relational or personalised approaches that characterise contemporary art, reflected in the direct-mail

9. Mother, *britart.com*
2000-2001 ('Pavement, 1962,
concrete slabs, cement,
shoe prints, dog excrement,
chewing gum, 8000 x 15050 x
10 cm'). Courtesy: Mother and
britart.com.

strand of the campaign. The mailings invited the interactivity of the recipients
and, in some cases, gave them a producerly role to play: for example, the
boxed 'Art Pencil' that held the promise that everything it drew would
become art.[65] That an avant-garde gambit such as this is now used as a means
of advertising art rather than as means of disrupting convention through
art shows that conceptualism has become a form of popular, if not exactly
common, currency. The question is to what extent this signals the taming
of the avant-garde or to what extent it might be seen as a productive and
desirable popularisation of its practices. As I have noted, it was the intention
of key members of the early twentieth-century avant-garde not only to make
art inclusive but also to employ art to reshape people's lives and values. It
seems, as Walter Benjamin predicted in 1936, that this could only occur
through the mass reproduction of images.[66] Yet this did not in itself prove to
be enough and it emerged that what was also needed was for avant-garde
approaches to become a viable form of expression in the mass media and
for avant-garde art itself to become more understandable, accessible and
tolerable to a wider public. This process of assimilation was already well under

way in some of the major cutting-edge consumer advertising campaigns of the late twentieth century.

10. (above) Collett, Dickenson Pearce & Partners, *Mousehole*, advertisement for Benson's Pure Gold (1978). Reproduced from CDP Collection at HAT Archive (www.hatads.org.uk).

11. (right) M & C Saatchi, *Single Cut*, advertisement for Silk Cut (1984). Courtesy: M&C Saatchi. Photo: Graham Ford.

LOW TAR As defined by H.M. Government
DANGER: Government Health WARNING:
CIGARETTES CAN SERIOUSLY DAMAGE YOUR HEALTH

Chapter 3

From Capitalist Realism to Surrealism

(and back again)

Art and advertising came even closer together from the late 1970s to the present through the development of signature styles in advertising campaigns. While building brand identity through the deployment of a distinctive type of imagery, several major campaigns played down the product itself and developed strategies that were alien to advertising but familiar in art. At the same time, but in an opposite move, the commodity became central to the work of a number of neo-avant-garde artists and was displayed in a way that brought art closer to advertising. In discussing these developments, I shall be using the term 'Capitalist Realism' to stand for two things: the dominant form of advertising that preceded the development of signature-style campaigns; and for art which is commodity-based, from the Pop Art of the 1950s and 1960s to the commodity art of the 1980s and 1990s. However, because the contexts in which Capitalist Realism developed represent two sides of consumer culture and its representation, the term will ultimately be used to forge a bridge between them. The term is also convenient because it helps distinguish commodity-centred representation in both art and advertising from the informing spirit of the most radical changes that took place in advertising in the late 1970s and 1980s – Surrealism.

The two major signature-style campaigns to incorporate Surrealist strategies were Benson and Hedges' Pure Gold, launched in 1977, and Benson and Hedges' Silk Cut, begun in 1983 (figs. 10 and 11). However, before I look in detail at these two campaigns, I want to make a brief note of the broad context that surrounded the sort of radical changes that they brought to advertising and begin to explore the notion of Capitalist Realism.

The removal of the centre of the avant-garde in art from Paris to New York after the Second World War temporarily put the emphasis back on the hierarchical divisions between the arts, widening the divide between art and life that the historical avant-garde had sought to close during the inter-war period. From the late 1940s to the 1960s, artists were encouraged by the US government, dealers and media alike to set themselves apart. The Abstract Expressionists, in particular, were to develop a sense of a separate and higher mission and present themselves or be presented as isolated geniuses.[1] This stance was supported intellectually by the highly influential formalist rhetoric of the American art critic, Clement Greenberg, who stressed the autonomy of the artwork and was instrumental in the development of an ivory-tower ethos.[2] Although commercial art and design still fed off the avant-garde in art after the Second World War, the interdisciplinarity of the historical avant-garde lost its momentum and was temporarily replaced by a stronger hierarchical delineation and a more one-way traffic. Although cutting-edge developments in art provided the impetus for stylistic developments in the applied arts, practitioners at this time tended to remain within their own fields.[3]

The ethos that developed in advertising in this period also favoured a distance between art and applied or commercial arts.[4] The rapid emergence of a consumer boom and commercial competition in post-war America meant that advertisers had to concern themselves with finding ever more effective methods and strategies. An important factor in the development of representational strategies was the notion of subliminal persuasion that came out of the widespread sense of paranoia created by the cold war and the accompanying threat of nuclear bombardment. At its crudest, the idea behind subliminal persuasion was that people could be subconsciously manipulated by hidden messages by, for example, inserting clips into films that were too short to be registered consciously but which nevertheless left an imprint on the mind. A similar form of subliminal persuasion was felt to be at work in the realms of consumer goods and advertising, with Brian Key, for instance,

famously claiming that letters spelling out sex were imprinted onto Ritz crackers.[5] While integral to the paranoia generated by the cold war, the idea of subliminal persuasion was also deeply rooted in post-Freudian psychology, which led to the development of motivationalist approaches that sought to manipulate deeply rooted emotions and drives. There are two major texts on motivational approaches in advertising from the period: the first, by Vance Packard (1957), was highly critical of subliminal methods; and the second is by Ernest Dichter (1960), who was highly in favour of them.[6] Both of these texts describe examples of motivationalist approaches put into action, evidencing an ideology based on the fulfilment of desire or the allaying of anxieties through consumerism. In their attempts to influence consumer decisions, advertisers embedded their subliminal messages in narratives of desire, possession and fulfilment in an approach that has since been termed Capitalist Realism.

As already signalled, Capitalist Realism cropped up as a label in two different historical contexts in the second half of the twentieth century, although, significantly, both versions appear to share a need to put a conceptual framework around the rapid development of consumerism during this period. The initial coining of the term Capitalist Realism was not specifically in relation to advertising but was formed in the context of the emergence and formulation of German Pop Art in the early 1960s, where it was one of a cluster of labels used to describe post-war consumer culture.[8] The second instance in which the term cropped up was in the mid 1980s, when Michael Schudson used it as a label to describe mainstream practices in advertising. Schudson's version of Capitalist Realism gives a clear picture of the motivationalist-inspired approaches that were dominant at the time and provides an essential foil against which the changes that occurred with the Pure Gold and Silk Cut campaigns can be set. Both versions of Capitalist Realism refer to approaches to representation in the same sort of consumer culture (American-style consumerism was being vigorously promoted in Western Germany in this period). German artists practising according to their version held the culture at a critical distance, however, while American (and Western European) advertisers were practising a version that was, according to Schudson, largely uncritical of the consumer framework in which they operated. Towards the end of this chapter, I shall suggest a third version or instance of Capitalist Realism in the so-called commodity art of the 1980s and 1990s.

Interestingly, Schudson categorises Capitalist Realist advertising as art, although a 'flattening' art that can be equated to Russian Socialist Realist painting. As with Socialist Realist art, advertisements, however 'real', do not ask to be taken literally but set up symbolic structures in which people and situations are typified and abstracted. In comparing Capitalist Realist advertising to Socialist Realist art, Schudson showed how close parallels could be drawn between both types of practice. In addition to simplifying and typifying in a way that communicates effectively with the masses, Socialist Realism proposed that art should:

> picture life, but not as it is so much as life as it should become,
> life worth emulating... that art should picture reality not in its
> individuality but only as it reveals larger social significance... that art
> should picture reality as progress toward the future and so represent
> social struggles positively. It should carry an air of optimism... art
> should focus on contemporary life, creating pleasing images of new
> social phenomena, revealing and endorsing new features of society
> and thus aiding the masses in assimilating them.[9]

As Schudson observes, this agenda and his description of broad representational strategies seems to fit conventional advertising practices perfectly, although with the essential difference that Russian Socialist Realist art idealises the producer whereas western advertising idealises the consumer.[10] The idealised life presented by Capitalist Realist advertising was closely approximated and parodied by American artist Jeff Koons in his *Luxury and Degradation* series (1986), part of which was made up of meticulous painted copies of actual advertisements. An example is *Hennessy: The Civilized Way to Lay Down the Law* (fig. 12), in which a black couple are typified and abstracted into a pleasing image of the relatively new social phenomenon of upward mobility, in this case that of the black minorities in America. (See Chapter 7 of this book for further discussion of this work.)

When coined in relation to Pop Art in Germany, Capitalist Realism was used to define a key moment of change in West German contemporary art when Gerhard Richter, Sigmar Polke, Konrad Lueg and their peer group in Düsseldorf began to engage with popular culture. Although it had formed part of the title of the exhibition he had organised with Konrad Lueg, *Living*

Hennessy
the civilized way
to lay down the law

The world's most civilized spirit

12. Jeff Koons, *Hennessy: The Civilized Way to Lay Down the Law* (1986).
Oil, inks on canvas, 45 x 60 in. Courtesy: Sonnabend Gallery.

with Pop: Demonstration for Capitalist Realism in 1963, Richter has always
downplayed the significance of the term that was to refer to a short-lived
moment in his career as a whole. To be fair, the exhibition was actually
an installation/event in the Berges Furniture Store that lasted one night
only and is not really indicative of the complex and mixed trajectories that
Richter's career was to follow. However, the label has proved resonant among
historians and critics, seemingly because it helps in the mapping out of the
context in which German Pop Art developed and underscores the problematic
relationship with consumer culture experienced by artists such as Richter
and Polke, who had originated from and trained in East Germany. As part
of this mapping exercise, Richard Storr has made a similar link between
Capitalist Realism, as represented by Pop Art, and Socialist Realism, as made
by Schudson, between Socialist Realist art and Capitalist Realist advertising.
However, as already noted, Richter and Polke's Capitalist Realism was a far
more reflexive and critical practice than its version in advertising. As Storr has

observed, Capitalist Realism can be seen both as a play on Socialist Realism and as a lampooning of much of Pop Art's seemingly uncritical embrace of consumerism: 'it turns the tables on the eastern-bloc aesthetic dogmas in which Richter had been schooled, but it has an even more satirical effect when applied to the commercial culture of the West as a substitute for the label *Pop*.'[11]

In reality, German artists' engagement with popular culture was closely related to the critical position occupied by Dada. The recuperation of Dada in Germany was evidenced by the exhibition *Dada: The Documents of a Movement*, mounted in Düsseldorf in 1958. Although the exhibition has been criticised for having contributed to the institutionalisation of Dada in the post-war period, it has also been credited with the opening up of new possibilities for German neo-avant-garde artists who were, at the time, becoming hidebound by the influence of American abstraction.[12] The first manifestation of this opening up came with the founding of Fluxus in Wiesbaden, West Germany in 1962, quickly followed up by two exhibitions organised by Richter, Polke and others: *Demonstrative Exhibition* (1963), a German 'Pop Art' exhibition which allowed German artists to take up critical positions in relation to consumerism and American pop; and the above-mentioned exhibition, *Living with Pop: Demonstration for Capitalist Realism*.

George Maciunas, founding member of Fluxus, clearly voiced a similar mission to that which had underpinned the central aims of the historical avant-garde – to take art away from the elitism of the gallery system and connect it with life: 'The anti-art forms are directed primarily against art as a profession, against the separation of performer from audience, or creator and spectator, or life and art.'[13] What was missing from this equation between life and art was any real connection with radical politics, or the means to distribute this art to a significantly large audience. Indeed much has been made of the 'political' failure of the neo-avant-garde to bring art and life together in a way that would radically change the world – a somewhat unfair charge, particularly in the latter part of the twentieth century, with artists working in the face of the forces and influences of consumerism and complacency brought by more middle-of-the-road politics.[14]

Nevertheless, the neo-avant-garde still managed to introduce serious critiques of the cultural politics of establishment into the public realm and attempted to resist the institutionalisation of art.[15] While the absence of

radical political connections is obviously greater in advertising than in the work of the neo-avant-garde in art, it is equally clear that the producers of the Pure Gold and Silk Cut advertisements had practically no disadvantage at all in terms of reaching a mass audience. This is as crucial to the radicalism of these campaigns as was the decision to borrow approaches from Surrealism, a notoriously transgressive movement from the early twentieth century. Not only did these advertisements help diffuse postmodern attitudes and outlooks to a much wider public than ever before, but, according to the mission if not exactly the spirit of the historical avant-garde, they successfully brought art and life together in a highly accessible manner. Not only were these campaigns key to the remoulding of consumer attitudes, they were also vital agents in the opening up of people's mindsets and sensibilities, to the effect that this might be seen as a radical, if not political, shift, even though unintended and non-specific.

In contrast to Capitalist Realist advertising, the groundbreaking Pure Gold and Silk Cut advertisements which appeared in the UK relied heavily on the sort of ambiguity of meaning found in Surrealism. Moreover, it is through the appropriation of images and themes that were unrelated to the product in any functional way, as well as the appropriation of strategies of representation that made no sense in terms of the current orthodoxies of advertising, that the campaigns can be seen as postmodern. The emergence of postmodern approaches in the visual arts has been situated by Scott Lash in the early part of the twentieth century, when modernism was still undergoing a process of development and an attempt at consolidation of approaches and attitudes. Significantly, Lash identifies Dada and Surrealism among other movements and developments as postmodern *avant la lettre*, because they made a radical attack on ideas of the autonomy of art and its aura-bearing status – in other words, because they attempted to close the gap between high and low, art and life.[16] For Lash, the reason that these movements or developments did not constitute a dominant postmodern culture at the time was that socio-economic conditions did not allow for a large enough audience for them.

Postmodern attitudes and practices have also been identified in relation to the avant-garde practices of the early part of the century by Michael Newman. Significantly, Newman saw a backlash to the privileging of abstraction as the dominant trope of modernism in Constructivism as well as in Dada and Surrealism, noting the absorption by these movements of

forms and approaches which exist outside of the traditions of 'high' art: for example, primitive art, children's art, the art of the insane, consumer imagery and graffiti.[17] As importantly, however, for the trajectory that I wish to follow, Newman saw Conceptual Art as having the most potential to undermine modernist autonomy, because of its rejection of the commodity status of art objects and its criticisms of the institutionalisation of art. Moreover, when it emerged in the late 1960s, Conceptual Art, according to Newman, was also unable to have a widespread effect upon the postmodernisation of culture because of the incomprehension it aroused. In spite of this, Conceptual Art can still be seen to have made its mark: in the way that artists and critics began to build theoretical rationales to underpin the production of contemporary art; and in the approaches adopted by the newly emerging avant-garde in advertising. The ability to think reflexively and ironically is fundamental to avant-garde advertising campaigns such as Benson's Pure Gold and Silk Cut. Moreover, good practice in advertising, whether avant-garde or not, now requires that it is concept-driven, just as there seems to be a tacit understanding that contemporary avant-garde art should be ideas-led or supported by a conceptual framework.

There are other factors that prepared the way for the abandonment of advertising's version of Capitalist Realism and the embrace of Surrealism. On a broader cultural level, criticisms of the motivational approach, like that offered by Vance Packard as early as 1957, were beginning to make an impact on the way that advertising was viewed by the public in general. While riddled with cold-war-style paranoia about the takeover of people's minds, this account of 1950s subliminal strategies was, at the same time, a clear forerunner of the counter-establishment attitudes that emerged in the 1960s. Such attitudes assisted in the opening up of postmodern outlooks within the culture that were marked politically by a recognition of and respect for cultural diversity and difference.[18] Set against developments of this sort, Capitalist Realism, with its emphasis on dominant cultural values, was not really able to remain in sole command of the field, especially when the economic boom of the 1980s brought home the need for advertisers to differentiate between and address an increasing number of new consumer groups. In what was by then a noticeably more pluralistic culture, conventional methods of consumer categorisation, such as class or income, were seen to be over-simplistic, if not counter-productive. The result was the development of new methods

that approached potential consumers with more subtlety and creativity, abandoning the narratives of Capitalist Realism, although not necessarily abandoning motivationalist theory.[19] This allowed for an unprecedented creative freedom in advertising and the production of exceptional works such as Ridley Scott's *1984* for Apple computers or the enigmatic late-1980s Guinness campaigns featuring Rutger Hauer. Scott's *1984*, an obvious reference to the Big Brother society described in George Orwell's novel, has been seen as a major 'advertising breakthrough' that 'relied on emotion, abstractness and over-the-top theatricality'.[20]

In addition to these broader cultural developments, the changes that took place in the British advertising industry's Code of Practice were to prove a particularly important catalyst. A highly specified set of legal restrictions on traditional practices in cigarette and tobacco advertising was introduced by the Code of Advertising Practice Committee, working under the aegis of the ASA, in 1976. This was the very same year that Victor Burgin issued his biting parody of Capitalist Realism, *What Does Possession Mean to You?: 7% of the Population owns 84% of our Wealth*. The guidelines developed with regard to cigarette advertising were to profoundly restrict the methods that had conventionally been used for the advertising of cigarettes in order not to misrepresent the health risks.[21] The Code gave a detailed account of what could and could not be depicted in an advertisement, prohibiting the representation of people in quite specific terms. The actors in cigarette advertisements were only to be shown in situations in which smoking would be appropriate; no association was to be struck between cigarettes and health, such as the use of outdoor settings, nor any association with either relaxation or concentration that might imply that cigarettes are an aid to these states. Also prohibited was the implication that smoking would enhance personal qualities such as manliness, courage or daring, as well as the featuring of real or fictitious persons of obvious distinction.[22] In short, most of the stock methods employed in Capitalist Realist advertising were written out by the 1976 Code. Primarily, the idea that advertisements are meant to directly seduce or persuade the consumer to make a purchase was undermined. Even more radically, the notion that the product had to play a specific role in a consumer drama was successfully challenged, to the extent that explicit representation of the product began to disappear in the early 1980s, causing advertisements to look more like art than promotional exercises.[23]

The Pure Gold campaign came into being a year after the Cigarette Code was introduced by the ASA. The agency responsible – Collett, Dickenson Pearce & Partners – had represented the brand previously but earlier advertisements were relatively uninspired, framed within the sort of conventional Capitalist Realist approach described earlier. The first Pure Gold advertisement in which new approaches made their appearance was *Mousehole* (fig. 10), in which a packet of Benson and Hedges was shown in the corner of a room, positioned as a mousetrap, near to a mousehole in the skirting board. This pioneering, oddball image was quickly followed by a stream of like-minded examples, including *Art Gallery*, *Flying Ducks* and *Birdcage*. At this point, cigarette packets still featured prominently but were placed in bizarre contexts and substituted for the sort of objects that one would, logically, have expected to be present. Later, the packet was to be metamorphosed, for example, into a tap and running water or a chameleon whose colour is changing to gold with the words Benson and Hedges emerging on its back. Eventually, the packet became almost completely disguised in certain cases, as in the advertisement featuring the Pyramids, working by colour association alone. Indeed, it was colour combined with trademark surrealist humour that was to set the signature style of both the Pure Gold and the Silk Cut campaigns.

The strategies employed in these two campaigns were discussed in a BBC 2 *Late Show* item on cigarette advertising, screened to coincide with a debate over a bill to ban cigarette advertising which was held at the European Parliament in March 1990.[24] Representatives from Collett, Dickenson Pearce & Partners clearly located their influences as stemming from Dada and Surrealism, quoting Duchamp, Magritte, Dali and Picabia (as well as the closely related work of de Chirico). They claimed that, by turning to these sources, they had experienced a marked degree of creative liberation as well as the opportunity of functioning as artists. Robert Shaw, author of *Dada and Surrealism* (1980), noted that these advertisers, like their avant-garde predecessors, were interested in creating an effect of defamiliarisation. He was, however, anxious not to take the correspondences too far, as the radically subversive politics of Dada and Surrealism are obviously not deliberately incorporated into these advertisements, which, for Shaw, only really operate at the level of parody.[25] The extent to which Surrealist strategies in particular have been co-opted by the advertising creatives working on these campaigns has been carefully analysed by Paul Jobling and David Crowther in the

penultimate chapter of their book on reproduction and representation in graphic design.[26] René Magritte is again cited as a major influence for his use of syntactical eccentricities and visual puns, visible for instance in *Birdcage* (1978), where the caged-egg motif from Magritte's *Le Chant D'Orange* (1937) is metamorphosed into a cigarette packet casting the shadow of a bird in the advertisement.[27]

Jobling and Crowther proceed to show the complexity of the correspondences with Surrealist representational tactics, demonstrating how key strategies such as the *erotique violée* ('veiled erotic'), *explosante-fixe* ('fixed explosion') and *magique circonstancielle* ('circumstantial magic') are all identifiable in various advertisements from the campaigns.[28] Erotic veiling is exemplified by the technique of doubling, in which the same object can be read in two ways. This strategy is found frequently in the work of Salvador Dali and is demonstrated in the Pure Gold campaigns, as Jobling and Crowther show, by the 1984 advertisement in which the packet doubles as a newly shed snakeskin. The jumbled and tumbling letters in *Tap* (1986), are cited as an example of the fixed explosion, in which arrested motion reveals a transformation of form and substance. *Snail* (1990), which is suggestive of a more mysterious or alchemic transubstantiation, is given as an example of circumstantial magic.[29] However, despite the closeness of the correspondences described above, Jobling and Crowther suggest, as Shaw did, that the reliance on Surrealism is little more than 'gratuitous, postmodern style-raiding', quoting Fredric Jameson's phrase, 'Surrealism without the unconscious'.[30] By extension, it seems that the Pure Gold advertisements are seen as examples of Jameson's category of postmodern pastiche rather than the more critical method of parody.[31] Similarly, it could be argued that, under Henri Lefebvre's scheme of things, already discussed in Chapter 2, these advertisements operate as signals in the world of signs rather than as symbols. The former giving quick, easy-to-follow messages, while the latter represent the wider ideological themes of society.[32]

Yet, against the idea that the Pure Gold advertisements represent no more than postmodern eclecticism or historicism, I would argue that the archetypal subliminal content that Jobling and Crowther identify suggests otherwise, at least in certain cases. Moreover, the claim that a faux-Surrealism is in play assumes that Surrealism, rather than suffering internal disputes and contradictions, was somehow a unified movement, and that Surrealist

artefacts always had a deep and genuine connection to the unconscious. The rather obvious way in which Salvador Dali and Max Ernst, for instance, grafted Freudian ideas onto their familial or interpersonal relationships – for example, Dali's *The Lugubrious Game* (1929) or Ernst's *Oedipus Rex* (1922) – demonstrates that the unconscious was sometimes consciously, if not prescriptively, channelled through some fairly obvious psychoanalytic models rather than represented directly and spontaneously, as might more credibly be argued for automatists such as Masson and Miro.[33] As Martin Davidson has argued, the incorporation of Surrealism into cigarette advertising:

> gave this new taboo an interesting cultural history, putting it up
> there with all those other interesting pleasures that we have been
> led to believe forced surrealists into a language outside rules and
> conformities in the first place, flouting repression.[34]

At this level, it is Surrealism itself rather than any particular use of symbolism that can be seen as the primary signifier, connoting 'forbidden subjects and dangerous elisions'.[35]

At yet another level, the imagery employed in the Pure Gold campaigns can be seen, at least on some occasions, to address deeply embedded notions of magic or deeply embedded sexual anxieties. While this may not be a regular ingredient of Pure Gold advertisements and while many do operate at the level of pastiche, a consistent connection with unconscious anxieties concerning sex and death has been identified in Silk Cut advertising. The novelist David Lodge has been instrumental in the identification of subliminal sexual meanings in Silk Cut advertisements and also, because of the popularity of his work, important for the dissemination of such interpretations. In *Nice Work* (1988), Lodge's female protagonist, Robyn Penrose, a feminist academic, explains the subliminal meaning of the key motifs of the silk and the cut to the male protagonist, Vic Wilcox, an industrialist (fig. 11). The relevant passage is quoted here at length as it not only explains semiotic methods clearly and succinctly while demonstrating the kind of sexual anxieties that the advertisements have been accused of exploiting, but also because Vic's response also typifies the denial experienced by many when these meanings are revealed to them:

It was in the first instance a kind of riddle. That is to say, in order to decode it, you had to know that there was a brand of Cigarettes called Silk Cut. The poster was the iconic representation of a missing name, like a rebus. But the icon was also a metaphor. The shimmering silk, with its voluptuous curves and sensuous texture, obviously symbolised the female body, and the elliptical slit, foregrounded by a lighter colour showing through, was still more obviously a vagina. The advert thus appealed to both sensual and sadistic impulses, the desire to mutilate as well as penetrate the female body.

Vic Wilcox spluttered with outraged derision as she expounded this interpretation. He smoked a different brand himself, but it was as if he felt his whole philosophy of life was threatened by Robyn's analysis of the advert. 'You must have a twisted mind to see all that in a perfectly harmless bit of cloth,' he said.

'What's the point of it, then?' Robyn challenged him. 'Why use cloth to advertise cigarettes?'

Well, that's the name of 'em isn't it? Silk Cut. It's a picture of the name. Nothing more or less.'

'Suppose they'd used a picture of a roll of Silk cut in half – would that do just as well?'

'I suppose so. Yes. Why not.'

'Because it would look like a penis cut in half, that's why.'

He forced a laugh to cover his embarrassment. 'Why can't you people take things at their face value?'

'What people are you referring to?'

'Highbrows. Intellectuals. You're always trying to find hidden meanings in things. Why? A cigarette is a cigarette. A piece of silk is a piece of silk. Why not leave it at that?'

'When they're represented they acquire additional meanings,' said Robyn. 'Signs are never innocent. Semiotics teaches us that.'

'Semi-what?'

'Semiotics. The study of signs.'

'It teaches us to have dirty minds, if you ask me.'

'Why d'you think the wretched cigarettes were called Silk Cut in the first place?'

'I dunno. It's just a name, as good as any other.'

'Cut has something to do with tobacco, doesn't it? The way the tobacco leaf is cut. Like "Player's Navy Cut" – my uncle Walter used to smoke them.'

'Well what if it does?' Vic said warily.

'But silk has nothing to do with tobacco. It's a metaphor, a metaphor that means something like, 'smooth as silk.' Somebody in an advertising agency dreamt up the name 'Silk Cut' to suggest a cigarette wouldn't give you a sore throat or a hacking cough or lung cancer. But after a while the public got used to the name, the word 'Silk' ceased to signify, so they decided to have an advertising campaign to give the brand a high profile again. Some bright spark in the agency came up with the idea of rippling silk with a cut in it. The original metaphor is now represented literally. But new metaphorical connotations accrue – sexual ones. Whether they were consciously intended or not doesn't really matter. It's a good example of the perpetual sliding of the signified under the signifier, actually.'[36]

While presenting this interpretation of the advertisements in the form of a gentle satire, Lodge draws attention to the extremely specific nature of Silk Cut imagery, which, like that of Dali in particular, trades on sexual anxiety concerning both rape and castration. Unlike Dali's nightmarish scenarios, however, the Silk Cut advertisements seem knowing send-ups of Freudian-inspired phallic imagery. In their blatant and exaggerated symbolisation of sexual power relations, they crack the kind of jokes that are common to carnival and the carnivalesque, in which the humorous rendering of such explicit and violent sexual acts would act as a sublimation of, or a safety-valve for, sexual anxieties.[37] As Freud has argued, jokes are coping mechanisms that, like dreams, enable the confrontation of issues that are often too traumatic to face in the normal course of things and which can provide cathartic release.[38]

Nevertheless, the use of this type of imagery has raised heavy criticism from some quarters, where it has been taken to task for the way that it plays on people's unresolved anxieties, if not actually engendering them.[39] Alistair McIntosh, for instance, sees Silk Cut's repeated references to rape and castration, often suggestive also of death, as nothing less than sinister, a means by which the consumer subconsciously legitimises the addiction to a product that is known for its deadly side effects.[40] Despite their comic intent, McIntosh takes motifs such as the *Psycho*-like shower head with silk shower curtain and the Venus flytrap tearing the crotch from a pair of purple silk pants deadly seriously.

Such arguments aside, what broadly unites the practices of the original Surrealists with those of their followers in advertising is the illogical bringing together of unrelated objects and places which may in postmodern terms be seen a matter of bricolage. Although first identified by Claude Levi-Strauss as a life strategy for low-tech societies which depend on the ad hoc use of the 'means at hand' for their day-to-day tasks, it was Jacques Derrida who spotted the potential that bricolage has as a postmodern strategy which lends itself to openness and playfulness in language.[41] Moreover, there is a strong sense of play and indeterminacy in the production of an open text that allows for performativity on behalf of the viewer and provides the opportunity for active participation in the construction of meaning.[42] Not only are the advertisements constructed by means of bricolage, but the viewer is also asked to act as a bricoleur in deciphering their imagery. While, for Derrida, bricolage was a method for the deconstruction of conventional structures of language and knowledge, Dick Hebdidge suggested the idea of bricolage as a strategy through which subcultural identity is achieved, seeing it as an aspect of the kind of semiotic guerrilla warfare (a term he took from Umberto Eco) that is practised by oppositional subcultures and rooted in Dada and Surrealism.[43]

In the case of the Pure Gold and Silk Cut campaigns, the use of bricolage might have been forced by the strictness of the Cigarette Code, but it was also a subversive strategy rooted in the unorthodox practices of Surrealism that succeeded in stretching people's imaginations in an unconventional way. Although not exactly the sort of guerrilla warfare envisaged by Hebdidge, the result was a highly effective form of defamiliarisation that, in its refusal to treat the viewer as a coherently structured subject with a unified world-view, and

in the demands that were made on the viewer to think outside of the frame, may even be seen as a form of politicisation. The idea that defamiliarisation, in itself, has political repercussions again reflects the thinking of the historical avant-garde, although this time its Constructivist strand, which, as was discussed in Chapter 2, sought to change people's political consciousness by effecting deeper structural changes in their world-view.

In his work on postmodernism and popular culture, Mike Featherstone has attributed the spread of postmodernism among a wider public to the fact that there is a growth in the number of cultural intermediaries in society. Drawing from Pierre Bourdieu, he speaks of the new middle class that 'creates not only specialists in symbolic production and dissemination but also a potential audience that may be more sensitive and attuned to the range of cultural and symbolic goods and experiences that have been labelled postmodern'.[44] Unsurprisingly, these new cultural intermediaries often work in the media, including, of course, advertising. I might then argue that the producers of the Pure Gold and Silk Cut campaigns perform this task of postmodern symbolic production and dissemination almost to the letter. In the case of these particular advertisements, however, I would suggest that they were not the preserve solely of the new petite-bourgeoisie; they were, in fact, relatively classless, requiring little more than the ability to accept their incongruities and play with them. That the public at large were more than happy to assimilate such approaches is evidenced by the popularity of the Pure Gold and Silk Cut campaigns, which won rapid acclaim and which have survived without fundamental change for over twenty years, a remarkably long period for a campaign to last in advertising.[45]

The disappearance of the product in postmodern advertising was matched by the embrace of consumer commodities as the subject matter in contemporary art. The products of mass production and consumer culture had, of course, already made an entry into the art of earlier avant-garde movements such as Cubism, Dadaism and Surrealism, and this sort of subject matter was to gain special significance for Pop Artists due to the huge boom in consumerism in the West following the Second World War. What is of concern here, however, is the foregrounding of the commodity and of the theme of consumerism the 1980s and 1990s in avant-garde art; this can be seen as a reprise of the issues raised by Richter and fellow German artists in relation to Capitalist Realism. In particular, the continued and more

widespread relevance of Richter and Lueg's 1963 exploration of consumer products and lifestyles is evident in the commodity-based works produced by Jeff Koons, Haim Steinbach and Sylvie Fleury in the 1980s and 1990s, all of whom have imported ready-made commodities into the gallery and presented them as ready-made works of art.

Koons's series *The New* (1980–1986) consisted of brand-new vacuum cleaners in neon-lit Plexiglas showcases (fig. 13). On the one hand, these works seem to fetishise consumer objects that are ordinarily taken for granted and to call attention to the way that 'consumerism appears to become ever more cultural, less the realm of selling things but of selling or merely displaying images, sounds and words.'[46] On the other hand, their isolation in the gallery,

13. Jeff Koons, *New Hoover Convertibles, Green* (1985/6). Green, Red, New Hoover Delux Shampoo Polishers, New Shelton Wet/Dry 5-gallon Displaced Triple Decker, 3 convertibles, 2 shampoo/ polishers, 1 wet/dry 5-gallon, Plexiglas, fluorescent lights, 123 x 54 x 28 in (312 x 137 x 71 cm). Courtesy: Sonnabend Gallery, New York.

as Koons has claimed, recodifies the objects and also allows us to ask why and how consumer objects are glorified.[47] Steinbach similarly takes consumer objects and displays them on shelves, mimicking their presentation in shops: for example, *supremely black* (1985; fig. 14) presents two identical black vases alongside a row of three packets of Bold washing powder on a display shelf. As with several other shelf-works, the title echoes the clichéd language of sales brochures that tends to present their products in the superlative. Again

14. Haim Steinbach, *supremely black* (1985). Courtesy: Haim Steinbach/ Sonnabend Gallery, New York.

there is a strong sense of fetishisation and an opportunity to take pleasure in 'objects that are easily accessible and interchangeable', while also 'being complicit with the production of desire'.[48] Pleasure, desire and fetishism also underpin the work of Fleury, although her works are often more specifically grounded in the sensual or sexualised side of consumerism, as in *Bedroom Ensemble* (1997), for example, where the erotic associations of the bedroom are heightened by the use of fake fur to cover hard furnishings and the dominance of reds and pinks.

Approaches such as these may be said to comply with Richter and his contemporaries' inquiry into the consumer values of Capitalist Realism. They also, however, fit with Schudson's understanding of Capitalist Realism as a representational strategy in advertising. Although some are more functional and downmarket than others, the objects that are selected are familiar products that make up the theatre or spectacle of a wide spectrum of contemporary middle-class consumerism. Moreover, in the case of Koons and Steinbach at least, they are presented in a way that calls attention to their typicality, repeated in a regularised format that is resonant of their origins in mass production. In this respect, they become what the modernist architect, painter and designer Le Corbusier identified as *objects-types*, standardised objects that are also ideal in their flawless replication.[49] This brings the discussion into Neoplatonic territory or the world of ideal forms, ground which, I would argue, is also shared by the typifying and idealising impulses that underpin Capitalist Realist advertising.[50] The actors, products and scenarios created

by Capitalist Realist advertising are frequently presented as ideal types and, even if sometimes given specific characteristics or grounded in anecdotal subject matter, usually speak to an ideal life and an ideal set of values. In other words, the consumer-object-based works of Koons and Steinbach meet Capitalist Realist advertising in their recognition of the ideality of the objects they appropriate and, by extension, the belief in the ideality of the consumer lifestyle that these objects represent. The same claim can be made concerning Fleury's choice of objects, although their typicality is often masked by an 'exclusive' designer name or by a more sensual presentation.

In (re)presenting consumer objects in the more detached space of the gallery and in displaying them in cabinets, on shelves or in sensual ensembles, Koons, Steinbach and Fleury all call attention to their desirability rather than their usability. Koons, moreover, has built sexual puns into his displays of vacuum cleaners which are 'invariably presented so that the hose protrudes from the front midsection of their bodies' and where 'these respiring machines, sometimes lunglike vacuum bags often also bear orifices that suck in addition to holes that expel air.'[51] (In their humorous anthropomorphism and blatant use of phallic symbolism, Koons's vacuum cleaners can also be seen to relate quite closely to strategies used in Silk Cut advertisements.) Meanwhile, Steinbach places his objects on shelves and gives them lower-case titles that issue a less formal invitation for the viewer to fantasise: *dramatic yet neutral* (1984), *charm of tradition* (1985). As Giorgio Verzotti has noted, Steinbach presents 'phantasy substitutes, odds and ends of reality, a reality that is transfigured by desire.'[52] Fleury also blurs the boundaries between the object and its promotional texts by snatching promises and slogans from the cosmetic industry and turning them into (indoor) neon signs. In Fleury's case, it is often feminine desire and seduction that is addressed and expressed through fashion and beauty accessories. *Pleasures* (1996), for example, was an installation that consisted of unopened boxes of expensive high-heeled shoes set against pink walls on which the word 'pleasures' had been written.

As in a great deal of consumer advertising, the subtext of these works is often one of desire, or the fulfilment of desire. This creates a duality where the objects are offered both for critical scrutiny and for the pleasures that they represent. This dual representation of the object may be seen as symptomatic of the 'anxiety of late capitalist culture', which Steinbach defines as:

the futility we experience in value systems when faced with our reality; in the futility we find in moralizing as a way of determining what's good or bad, and which is something perhaps experienced by both producers and collectors of art at their complicity in the systems of commerce.[53]

For Steinbach, it is not so much the object itself that is the problem but our relation to it. In substituting mass-produced objects for art objects, Steinbach and Koons call attention to the artwork as commodity, suggesting that the relationship that people have with consumer products is analogous to their relationship with art. Here, we are not so far away from the thoughts of British cultural theorist Raymond Williams, who saw advertising as a magic system which had developed in the face of 'a cultural pattern in which objects are not enough but must be validated, if only in fantasy, by association with social and personal meanings which in a different cultural pattern might be more directly available'.[54]

These arguments concerning the magic of objects and the magical status of advertising suggest that the commodity art of the 1980s and 1990s plays a similar role to that of the avant-garde advertising discussed above. Jean Baudrillard has suggested that the primary function of advertising is to address the need to play or to dream. He has stated that advertising is less a determinant of consumption than an object of consumption, echoing the point that the aesthetic itself is as much an object of consumption as the products that it puts on display.[55] In effect, whether the product is implied in its absence or foregrounded, it is still experienced at a remove, within an aesthetic rather than a functionalist framework, taking the aesthetic in the sense of a playground for the emotions, imagination and intellect.[56] This is not to forget that commodity art and advertising usually inhabit different aesthetic arenas, nor is it to say that this does not make a difference. It does, however, show how far advertising has moved in the direction of art and, to a lesser extent, vice versa. Campaigns such as Benson's Pure Gold and Silk Cut have reinforced this analogy with art by developing a signature style that acts rather like an artist's signature to authorise the work and give it distinction (while also obviously creating brand identity).

The changes in conditions of production that brought about signature styles in advertising also favoured a general upsurge in creativity in the advertising

industry in the mid 1980s and 1990s, so that leading advertising creatives were able to break free of the constraints imposed by Capitalist Realism and build narratives and scenarios of a different order, particularly with respect to luxury goods. In order to achieve this shift, some advertising creatives, for example, British producers Ridley Scott and Tony Kaye were motivated and informed by their ambitions and capabilities as film-makers. Some, such as the creatives at the American agency Wieden+Kennedy, were able to tap into popular culture and identity politics. Others, such as the producers of Pure Gold and Silk Cut campaigns and the New York branch of Chait/Day, producers of the Absolut Vodka campaigns, were to source their work more directly in art, while certain artists have actively sought out brand identities. However, before moving on to discuss these related developments, 1 will, n the next chapter, continue to discuss the role of realism in advertising, albeit a very particular form of realism that has been dubbed 'traumatic realism'.

Chapter 4

Reality Bites

From the Abject to the Sublime

While disturbing subject matter forms an established part of the repertory of contemporary art, commercial advertising tends to be equated with notions of pleasure and fulfilment, often masking the realities of life. Indeed, it is rare and remarkable for consumer advertisements to transcend this framework but there have been notable examples, like Toscani's *Shock of Reality* campaign, which have represented the harsher side of life.[1] With such advertisements in mind, I would like to add to the growing complexity of the relationship between art and advertising that has been developed so far with an examination of how the 'real' and of how traumatic realities in particular have been dealt with in both arenas of practice. Moving beyond types of realism as strategies for representation, I will now examine the ways in which both contemporary art and contemporary advertising have in fact connected with reality, not only in terms of what shape the real has taken in both arenas, but also in terms of what sort of subject matter and what themes have been necessary to this exploration of reality. Obviously, terms such as 'the real' and 'reality', which are philosophically contested and ultimately relative, are provisional. Yet, while recognising that one person's reality is not the same as the next person's, reality is nevertheless lived in a shared cultural context, a context in

which lived experience is managed in many ways, not least in its construction and representation in art and advertising.

It was in advertising, rather than art, that this turn to the real first became a public issue, when hard-hitting images of tragedy and disaster were incorporated into the advertisements produced for the Benetton *Shock of Reality* campaign. The campaign incorporated a range of disturbing subject matter, including a dying AIDS patient, a burning car, an electric chair, a Mafia killing and ecological disasters, all (with the possible exception of the image of a newborn baby) way beyond the conventional remit of consumer advertising.[2] Benetton were hugely criticised for using this sort of subject matter for the advertising of fashion knitwear, causing an enormous amount of debate in the media, subsequently only approached in terms of controversy by the debates that have surrounded the 1998 exhibition *Sensation: Young British Artists from the Saatchi Collection* (1997).[3] While the debates concerning the real in art were of a slightly different order, there are common issues of probity in both instances. If Marcus Harvey's *Myra* (1995) and Benetton's so-called AIDS advertisement are taken as examples, it is clear that both are transgressive in similar ways, both representing real deaths in a way that was deemed sensationalist, inappropriate and insensitive. Both of these examples foreground very specific real events that were initially brought to public attention by the media and paradoxically both make use of media representations to return the viewer to the real.

Hal Foster has made an astute examination of the preoccupation with the real and trauma in contemporary art in *The Return of the Real* (1996). Before going on to examine key aspects of the way that art and advertising are linked in their representation of the real, it is well worth looking at the points he makes concerning why and how the real became an issue in neo-avant-garde art in the 1980s and 1990s.[4] Essentially, Foster identifies a bleak understanding of the real in contemporary art, seeing it in terms of a lineage of trauma and abjection that stems from Warhol's 'Death in America' images. In mapping out the ways in which the real is accessed by neo-avant-garde artists, Foster raises the issue of realism as a genre of representation and decides upon a new category, which he calls 'traumatic realism', as opposed, for instance, to the more superficial simulatory realism of the majority of Pop Art. Using a model taken from the French psychoanalytic theorist Jacques Lacan, Foster invokes the device of a screen to explain the way that the real

is captured in a reciprocal exchange between object and subject within what is an all-encompassing field of vision. The crucial point for Foster is that seeing is a more complex process than simply a one-way exchange in which the viewer is in full control of the experience. Rather, it is more a matter of a reciprocal meeting point between viewer and object, and, following Lacan, this meeting point is described figuratively by Foster as a screen.

To screen something could mean either to veil or to filter it in some way or, as in cinema, to project it onto a surface/screen. It might be said that the painter, for instance, does both of these things, screening the real for the viewer and then projecting his or her filtered or veiled version onto a surface/screen. The relationship between object, viewer and surface/screen in this scenario is abstracted – boiled down to a diagram in Lacan that is reproduced by Foster. The model it provides enables Foster to demonstrate the difference between the more conventional forms of realism used in most Pop Art and the traumatic realism that he identifies in the work of Andy Warhol. While the surface/screen in more conventional forms of realism is rendered as a cohesive projection of the real, it is undermined or punctured in traumatic realism, returning the viewer to the real rather than veiling or filtering it. In Warhol's case, for instance, Foster argues that this occurs not only through the shocks delivered by the subject matter which reveal 'moments when the spectacle cracks' but also through the repetition of the image and the famous mistakes in the screenprinting processes, all of which act as telltale cracks in the means of representation.

Foster's category of traumatic realism can readily be seen to apply to examples in contemporary art and advertising, like the Benetton AIDS advertisement (fig. 15) and Marcus Harvey's *Myra* (fig. 16). Both of these works seem eminently classifiable in this way as both may be said to form cracks in the spectacle of media representation and both produce disruptions through the means of representation. The Benetton AIDS advertisement appropriated an award-winning photo-documentary image taken in 1990 by Thérèse Frare that had previously been published, without controversy, in *Life* magazine. The original black and white photograph showed AIDS activist David Kirby on his deathbed surrounded by his family but, when redeployed in the advertisement, the image was digitally coloured and Kirby's face touched up to resemble the dead Christ. Benetton's creative director, Oliviero Toscani, had negotiated the use of the image with Frare and obtained the permission

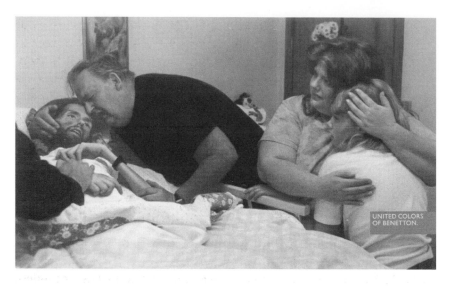

15. (above) Oliviero Toscani for Benetton, *AIDS – David Kirby* (1992). Courtesy: Benetton. Photo: Thérèse Frare.
16. (left) Marcus Harvey, *Myra* (1995). Acrylic on canvas, 13 x 10.5 ft. © the artist. Courtesy: Jay Jopling/White Cube, London.

and blessing of Kirby's family, following Kirby's wish to bring the issues of AIDS firmly into the public realm.[6] Although not strictly speaking a crack in the means of representation, more a disruption of representational protocols, this shift in context – from news magazine to advertising – caused what was originally a piece of uncontentious documentary realism to become a piece of traumatic realism. It was not only the co-option of its tragic subject matter into the realm of consumer imagery (one of the most fertile arenas of spectacle) that was to puncture and disrupt normally complacent consumerist viewing habits, but also the uncompromising rendering of it through the codes of documentary representation. This introduced what Bill Nichols has referred to as a 'discourse of sobriety' into the normally pleasure-based arena of consumer advertising.

Harvey's painting of Myra Hindley, the infamous 'Moors Murderess' was based on a mugshot image which likewise had made its appearance in the media in its previous incarnation. It has been reproduced on countless occasions since her arrest in any number of newspapers and magazines and television broadcasts (other highly productive arenas of spectacle), usually at the times of her parole hearings and most recently with the news of her death. In the case of Harvey's painting of Hindley, however, the means of representation was disrupted in a radical way through the contentious use of children's handprints to reproduce the tonalities of the original photograph and by its transformation into a large-scale painting, 'making what she did – and our feelings about it – real again'.[7] Again, an image that was originally only meant to show a likeness, and which had been seen so many times that its powers were in decline, became a piece of traumatic realism. On one level, a rupture occurs with the realisation that the image is made up of children's handprints, which only becomes apparent as the viewer gets closer to the image. At this point it becomes difficult to see the handprints and the image simultaneously and the result is a tension between a signifier of childhood innocence and a signifier of evil. At another level, the trauma elicited by *Myra* was increased by the well-reported attempts to traumatise the painting by two other artists, Peter Fischer (who threw Indian ink at it) and Jacques Rolé (who threw eggs at it). A further level of trauma was added to the work by the reactions of the victims' relatives, who were not consulted and mounted visible protests in the media and, in the case of Winnie Johnson, the mother of one of the victims, outside the Royal Academy itself.[8] In contrast to the

pains Toscani took to consult with David Kirby's family, Harvey's neglect of the relatives betrays a level of insensitivity that has contributed to the brand-image of young British artists as parasitic and attention-seeking.

There is, of course, a difference of context between Harvey's representation of Myra Hindley in a highly respected gallery and Toscani's intention to place David Kirby's image in the more public spaces of advertising – although this distinction was substantially undermined by the publicity that *Myra* received in the news. The criticisms of *Myra* mirrored the media criticisms made against Benetton's AIDS advertisement (in both cases concentrating on the attention-seeking exploitation of real-life tragedies for sensationalist purposes). However, had *Myra* not been displayed in the name of 'Sensation' and had the relatives been consulted, the work might well have escaped the censure it received. After all, 'shocking' subject matter is not new in art, but a historically legitimate practice, as the Chapman brothers' appropriations from Goya's *Disasters of War* demonstrate. This begs the question of whether some things are possible in art but not possible in advertising. My view is that, despite the request for the withdrawal of the AIDS advertisement from the ASA, Toscani has substantially extended the repertoire of consumer advertising and its terms of engagement with his *Shock of Reality* campaign and others that have followed, such as the *United Colors* campaign (based on Death Row portraits). This has not been done with impunity, however, and has not really been repeated to the same extent in any other consumer advertising campaigns. However, as will be seen in my discussion of Tony Kaye's work in Chapter 5, the big themes of life have been successfully addressed in other examples of consumer advertising. In other words, thematic content usually the preserve of art has been legitimised by Toscani and has brought the two arenas of representation closer together.

Contexts of representation aside, the subject matter of *Myra* and the Benetton AIDS advertisement aligns in both cases with the notion of abject art, which was brought to public attention when the Whitney Museum of American Art mounted an exhibition on the theme of abjection in 1993.[9] For most of the artists contributing to this exhibition, the abject was expressed through the body, its fluids and excretions. In this and another exhibition which foregrounded the abject – *Rites of Passage: Art for the End of the Century*, held at the Tate Gallery in 1995[10] – the abject was conceived according to the definition formulated by another French psychoanalytic

theorist, contemporary with Lacan, Julia Kristeva. In line with the usual dictionary definition of the abject, which describes the state of abjection as to be 'cast down, degraded, cast off, treated as refuse', Kristeva defined the abject as that which is cast aside, neither subject nor object, an indeterminate state, a category which attempts to categorise the uncategorisable:

> In the dictionary, abjection signifies a state of degradation, of self-disgust and disgust towards others. It is both psychological and theological: when one sins, one is in a state of abjection. In my use of the term, I insist on the private aspect: 'ab-ject' which means for me that one is neither subject nor object. When one is in a state of abjection, the borders between the object and subject cannot be maintained. In other words, the autonomy or substance of the subject is called into question, endangered. I am solicited by the other in such a way that I collapse. This solicitation can be the result of fascination but also of suffering: the other disgusts me, I abhor it, it is – we are – waste, excrement, a corpse: it threatens me.[11]

As Foster has shown, Cindy Sherman's work of the 1990s, particularly the *Disgust* series, both exemplifies this definition of the abject and demonstrates its relationship to another recently fashioned category: that of the *informe* or the formless, in which the body is not only made strange but is primarily represented by signifiers of disgust – 'menstrual blood and sexual discharge, vomit and shit, decay and death'. More than this, however, such works go beyond the abject to the territory of the obscene in its literal sense, '*as if there were no scene to stage it, no frame of representation to contain it, no screen*' (Foster's italics).[12] Here, we are obviously back to traumatic realism which, in Sherman's case, is produced by an over-exaggeration of simulation rather than a puncturing of it, an illusionism that stretches so far into the real that it fails to cover it up, serving rather to uncover its uncanny aspect.

In the case of object-based art, there is no need for illusionism but, as Foster has also noted, the focus is on making body-related objects strange, or is placed on the broken boundaries of the open, exposed, vulnerable or violated body, as in the work of Robert Gober and Kiki Smith (both participants in the Whitney exhibition of abject art). In the representation of the vulnerable body, trauma is produced not so much by a disruption in the

means of representation but by a more direct probing of the wound through an iconography of the permeable or fragmented body and of formlessness.[13]

Benetton's *Shock of Reality* campaign represents the abject by depicting the body as vulnerable, diseased or violated. For example, the spilt blood of a dead Mafia victim occupies a good half of the otherwise almost empty foreground of one 1992 advertisement. The spilt blood of the violently wounded also figures prominently in a later advertisement of 1994, which presented the blood-soaked clothes of, allegedly, a young Bosnian soldier. In a further example from the 1992 campaign, a Libyan soldier is photographed from the back, a Kalashnikov rifle strung across his back, carrying a human femur.[14] An important factor in the incorporation of such subject matter was Toscani's ability to operate with an unusual degree of independence as creator of the campaign, which, in its representation of death and disaster, was not only a far cry from the meta-narratives of pleasure and gratification that accompanied mainstream advertising at the time, but was also light years away from the bland and ultimately interchangeable representations of the body in Benetton's previous interracial advertisements.

Two other factors were instrumental in the development of the *Shock of Reality* advertisements. One was Toscani's great respect for documentary photography and its ability to report on the human condition (inherited from his father, a documentary photographer by trade). The other was the way in which Toscani took from the avant-garde in art, exploiting the potential of the ready-made as a disruptive strategy and appropriating relevant iconography, not just from the avant-garde as with his 'quotations' from Warhol's repertory of motifs – *The Electric Chairs* (1962–1963), *Burning Cars* (1963), and *Gangster Funeral* (1963) – but also in the use of more traditional iconographies such as the referencing of the *pietà* in the AIDS advertisement.[15] With this advertisement in particular, there was a clear shift from a standardised and somewhat idealised view of the body to the body seen in dystopian terms, a signifier of disease or mortality.

There are also a number of less explicit Benetton advertisements that have a certain claim to the abject. Again, these advertisements function in a way that is associated with art rather than with consumerism, confronting the viewer with problematic and unpalatable realities and requiring him or her to take up a critical position. They also have clear thematic counterparts in contemporary art that similarly reference sex, sexuality, abuse and disease.

One AIDS-related advertisement shows the inscription 'HIV-positive' as a tattoo on the skin close to those parts of the body that are the conduits of infection, the inner arm, the pubic area and the buttocks. Here, there is a vivid association to be made with the tattooing of numbers on the forearms of concentration-camp victims that has now become a potent signifier of human abuse. A similar device was employed, with a similar message of abuse and dehumanisation, by Jenny Holzer in her *Lustmord* ('sex murder') series (1993). In this case, the inscription on the skin refers to the violent abuses to women in the war in Bosnia told from three points of view: the victim's, the perpetrator's and observer's. The messages were written in ink on different parts of women's bodies and initially published in a German magazine, *Süddeutsche Zeitung*. The cover of the magazine showed a text in blood as well as ink, which proved contentious because of the current concerns in Germany about AIDS-contaminated blood.[16] In rejecting the wholesome, closed body of conventional advertising, Toscani also drew close to the sort of abject art that represents the vulnerability of the body in terms of its fluids and openness, the seepages of milk, semen or faeces in a number of Kiki Smith's figures, for example. The incorporation of the open and vulnerable into the lexicon of both art and advertising was a vital move, helping to redress idealised media stereotypes of the 'contained' body. In short, Toscani's work not only represents the abject but – by showing fluids, transgressed boundaries and diseased bodies – is itself abject.

The Benetton images all but stand alone in the way that artworks do, the only concession to sales rhetoric being the inclusion of the green Benetton logo. Moreover, the logo may be seen as a puncturing device which, rather than making a tear in the spectacle and returning it to the real, as Foster has claimed for Warhol's misregistrations, serves to connect or insert the real into the spectacle of consumerism. In effect, the *Shock of Reality* advertisements still exemplify what Foster has described as a shift from realism as an effect of representation to the real as a thing of trauma, a shift that he sees as symptomatic of a crisis in the symbolic ordering of society and its representations.[17] Kristeva similarly identifies 'a grave moment in the history of aesthetic consciousness and practice', where the turn to the abject in art reflects a state of crisis and fragmentation in the culture. The crisis is in the difficulty that exists in relation to the work of art, as well as the problems caused by the general tenor of media discourse which, for Kristeva,

is too banal to do justice to the pain of fragmentation. As does Foster, she recognises, although does not name, a reality 'behind these objects, objects which work with the impossible, with the disgusting, the intolerable'.[18]

Foster, for his part, has attempted to specify the reality behind the fascination with trauma and abjection, suggesting that there were particular dark forces at work in society in the mid 1990s: 'despair about the persistent AIDS crisis, invasive disease and death, systematic poverty and crime, the destroyed welfare state, indeed the broken social contract'. Moreover, it is for these reasons that the truth for many in contemporary culture lies in the diseased or damaged body and, ultimately, the corpse in which 'the politics of difference are pushed to indifference... to nihility.'[19] Fascination with the corpse as subject matter for contemporary art is exemplified by the large Cibachrome photographs of dead bodies that Andreas Serrano took for his *Morgue Series* (1992), or by Ron Mueck's half-life-size but almost super-real, *Dead Dad* (1996–1997).

As others have observed, AIDS did indeed arrive at a time 'when the New Right were mixing a potent brew of religion and familialism, when feminism and lesbian and gay rights were under attack, when welfare facilities were facing an unprecedented attack'.[20] In other words, the disease was ripe for stigmatisation on a number of fronts, feeding prejudice against homosexuality, disapproval of sexual freedom and experimentation and fuelling deeply held attitudes towards sexually transmitted disease as shameful. AIDS made discourses of pollution visible, rendering the body abject and alienating.[21] Debates about the disease were waged publicly and its representation became an issue of moral concern for many. As AIDS activist and writer Simon Watney has argued, the media representation of the disease colluded with dominant perceptions of AIDS as a social scourge, showing people with AIDS isolated in the last throes of the illness, usually hospitalised and in a state of extreme physical debilitation, exhibiting particularly disfiguring symptoms. People with AIDS (PWA) were often depicted as non-people, victims and outcasts.[22] A contentious example of this sort of representation was the exhibition of Nicholas Nixon's photographic portraits of people with AIDS, held in 1988 at the museum of Modern Art in New York, which occasioned a manifesto from the AIDS Coalition to Unleash Power (ACT UP) who felt that the images privileged white gay men and showed them in negative terms.[23] The manifesto called for recognition of the plight of other people with AIDS, such as women

and people of colour, and for 'the visibility of PWAs who are vibrant, angry, loving, sexy, beautiful, sitting up and fighting back'.[24]

It is no wonder then that a number of artists felt the need to publicly counteract the misplaced media versions of the experience of AIDS. Indeed, activism was for many the most appropriate way of representing the disease. Watney, for instance, chided artists that developed a more personal response, accusing them of sentimentalising the subject and berating them for embedding the subject in the clichéd terms of martyrdom or saintliness, strategies that can only lead to false consolations and which are basically insulting to those who have struggled to improve the reality in which AIDS is lived.[25] Douglas Crimp made similar observations and a similar call for activist approaches, seriously questioning the effectiveness of the art gallery, in which art ultimately becomes a commodity and in which AIDS-related art would ultimately follow the same course.[26] These criticisms quickly impacted on the approaches taken to AIDS in art. A number of artists and activists prioritised the public arena and the more individual, gallery-based work that was subsequently done in the 1990s was more varied in approach. A diaristic approach, for example, can be seen in William Yang's *Allan from Sadness: A Monologue with Slides* (1990), a text/image slide show which poignantly manages to capture both the good and bad days of the last stages of his friend's life as a person with AIDS. In contrast, Carl Tandatnick's screenprint *AIDS Virus on White Blood Cell* (1993) turns the agent of infection into a compellingly beautiful and decorative image, while Derek Jarman photocopied one of the most reprehensible pieces of AIDS reportage for *Blood* (1992), covered it in blood-red paint and simply inscribed the word blood across the surface over and over again. Lastly, Lynn Sloan's *Faces of AIDS* photographs seem to go some way to meeting the demands of ACT UP's manifesto, showing a whole range of people that were HIV-positive, none of whom displayed the visible signs of the disease and none of whom appeared as victims, but, simply sad on many occasions.[27]

However, although these examples signalled clear progress in the representation of the disease, they were limited to the spaces of the gallery and still did not meet Watney's call for interventionist approaches. This was to be met by the activist work that got into the public arena, although as we shall see shortly this work does not necessarily exclude individual expression or personal subject matter. ACT UP, formed in 1987, has been

the most prominent AIDS activists group in the USA, mounting numerous demonstrations and poster campaigns, as well as showing work in galleries. The group included a number of commercial designers, advertising creatives and artists who frequently used and adopted strategies that were more in line with those of advertising than of art: typically a blend of the straight-talking, hard-sell techniques of traditional advertising and the dogmatic or declarative tone of traditional propaganda, purely typographic posters for example.

Notable alternatives were the posters produced by Gran Fury, the name taken by the group of guerrilla designers who originally formed the propaganda wing of ACT UP; and those by artists such as Keith Haring, who became a successful and established artist in the 1980s and who I will discuss in a later chapter in relation to the advertisement for Absolut Vodka. Haring began working in the public realm when he started to draw over the black sheets of paper that covered unrented poster spaces on the New York subway (some 5,000 between 1978 and 1985). Here, he developed his signature style: reducing figures and motifs to simplified diagrammatic two dimensional gestalts, reminiscent of children's drawings. These androgynous humanoid figures signify everyman and enact the numerous scenarios of contemporary living while dealing with themes of technological, institutional, media and political control (Haring's work for galleries has often been more sexually explicit, although executed in the same simplified style). Needless to say, his style suited the purposes of ACT UP perfectly, and he collaborated on the *Silence = Death* campaign of 1989, producing posters, silkscreens and T-shirts.

Gran Fury were responsible for some of the most memorable posters in AIDS activism, for example, *WOMEN DON'T GET AIDS – THEY JUST DIE FROM IT* (1991). Here, the two parts of the main message are spelt out in upper case above and below a block of informational copy giving statistics of the 65 per cent of women who become ill and die from chronic HIV-related infections that 'don't fit the Centre for Disease Control's definition of AIDS' and are consequently excluded from healthcare. Ironically, both strap-lines and copy are superimposed over a photograph of a line-up of beauty queens. More famously, however, they caused an upset with their *KISSING DOESN'T KILL: GREED AND INDIFFERENCE DO* posters mounted on the sides of buses (1989). As David Deitcher, writing for *Artforum*, has noted, these posters are a direct parody of the Benetton United Colors campaign, featuring pleasant-looking

young people of mixed races, evenly spaced against a white background.[28] What was different about them was the use of same-sex couples (something that Benetton were to catch up with later) and the anti-consumerist, wake-up-to-reality message. They parodied the never-never land of racial harmony suggested in all but a few Benetton advertisements up to that date, although to be fair there were some notable exceptions: advertisements which read more ambiguously and created mixed reactions in the Benetton portfolio. These included the advertisement showing a black woman breastfeeding a white baby and the advertisement showing two male hands handcuffed together, one black, one white. Drawing from Roland Barthes' famous essay, 'Myth Today', which showed how the mythical language of the dominant culture (advertising, for instance) homogenises the sign and empties it of its historical relevance, David Deitcher showed how the Gran Fury poster turned this process on its head, using the language of 'the oppressor' to speak on behalf of 'the oppressed'.[29] Furthermore, in using the tactic of appropriation for serious social and political ends, the poster returned what had long since become a mannered avant-garde strategy to the original subversive intent of early twentieth-century avant-garde appropriationists such as John Heartfield.[30]

I have already noted that appropriation from documentary or reportage photography was the driving force behind the 1991–1992 *Shock of Reality* campaign in which, almost as if to deliberately up the ante, Toscani restored the consumer sign to some sort of historical specificity by deploying recordings of real events as a way of 'using advertising budgets to do something a little more useful'.[31] Moreover, in addressing social issues in a direct and contentious way through images that circulated in the public arena, the *Shock of Reality* campaign – and the advertisement depicting David Kirby in particular – came to function as activist art. Because of the contradictions and the estrangement involved, the work was even more successful in calling attention to important social issues than the often more functionalist messages that were delivered in activist posters. With these less obvious approaches in mind, I want to examine the so-called Benetton AIDS advertisement in relation to two artworks that are closely linked in their representation of AIDS.

In the case of the Benetton advertisement, Toscani not only changed the character of the original image, but also incorporated visual strategies used in baroque painting. In emancipating the image of David Kirby on his deathbed

from its original supplementary role in *Life* magazine, Toscani gave it almost exclusive command of the picture surface (logo excepted). In another highly strategic move, the image, as I have already noted, was converted from black and white into colour, making the means of representation more immediate and emotive. In addition to this and further extending the purchase of the image, Kirby's face was altered to make it resemble traditional images of the dead Christ, adding enormously to the rupture that this image caused in the spectacle of consumerism. The photograph was also rendered with a chiaroscuro effect that has been likened to Caravaggio's baroque use of tonal contrasts.[32] Other pictorial characteristics of baroque painting come into play in the breakdown of the barriers between picture space and spectator space. The foreshortened angle of the bed implies a continuation beyond the picture plane and the arm that enters into the picture on the left seems to project into spectator space as much as to lead the viewer in. These complex spatial relations were further complicated by the picture within the picture on the wall behind Kirby, in which the beckoning hand of Christ seems to puncture that picture plane and stretch out into the deathbed scene it accompanies. While the spatial arrangement of the image was due to the choices made by the original photographer, Frare, rather than Toscani, and the picture within the picture was probably an unplanned but fortuitous element, Toscani has to be credited for the way that he has knowingly chosen an image with these elements and orchestrated them to his own expressive ends.

What was selected and what was reframed was the poignant and intimate scene of a family experiencing the death of one of its members. This poignancy is in part effected by a visible chain of touch between the male figures, from the painted image of Christ the Son of God, the bottom of which fuses with the head of Kirby's father, who in turn leans his head against his son's, wrapping his arm around it from the back. Kirby's hand in turn links with that of the priest, the agent of God the Father, whose arm enters the picture on the extreme left. This group forms a dark tonal opposition to the mother and daughter on the right of the picture who are locked in a separate embrace, thus setting up a variation on the iconography of the *pietà*, in which it is usually the Virgin Mary who grieves over her son. The effect of seeing the father emotionally caught up in the traditional female role is powerful as the contrast between the emaciation of the dying Kirby and the physical bulk of the rest of the family.

The contrast between this image and the usually more functionalist AIDS activist posters is, therefore, enormous and the Benetton advertisement brings far more visual and emotional complexity to the representation. The image of Kirby with his family also contrasts with common photojournalistic practices, which, as I've previously noted, tended at that time to isolate and victimise the person with AIDS. Yet what also made this image so stunning and so controversial was that it was ultimately an advertisement for fashion-wear. A boundary of propriety was transgressed by representing disease and death in this arena. At the time, disease and death were expected to be the preserve of public health or charity advertisers who were usually far more tactful in their representation of disease. Public health posters aimed at raising AIDS awareness either represented death abstractly and symbolically or took the healthy, sometimes eroticised, heterosexual body as the medium through which the message was spread, avoiding the stigmatisation of homosexuals, but also excluding them. What is interesting from this point of view is that the exclusions in these posters received comparatively little reaction from AIDS organisations while the Benetton advertisement brought out immediate and hostile reactions from AIDS pressure groups.[33] The contrast between Benetton's approach and the approach employed in this sort of advertising can be seen clearly when the advertisement featuring David Kirby is compared to a public awareness advertisement which came out two years later for the Multiple Sclerosis Society. This advertisement also adopted the iconography of the *pietà*. In contrast to the stark realism of the Benetton advertisement, however, this image was made visually seductive through the use of high-contrast monochrome that had an aestheticising effect on the already well-formed, conventionally attractive bodies that represented the disease. While this rhetoric of sensual pleasure and beautification was presumably employed to humanise the person with multiple sclerosis and to avoid alienating potential patrons of the charity, it had nowhere near the powerful emotional effect of Benetton's interventionist and alienating gesture.

The Benetton advertisement showing David Kirby on his deathbed, then, went way beyond conventional advertising to become activist art of a rare and powerful order, matched only on equally rare occasions in art itself. One example of a work that has a similarly moving effect is AA Bronson's *Felix, June 5th, 1994* (1994; fig. 17), which has been displayed as a billboard as well as in museums and galleries. Again, the subject matter and the image itself were

17. AA Bronson, *Felix, June 5th, 1994* (1994). Courtesy: AA Bronson.

intensely personal, showing Bronson's partner, Felix Partz, dying from AIDS. Bronson and Partz had formed part of a group of three gay artists who had maintained a three-way partnership in both their personal and professional lives (the third member, Jorge Zontal had also died of AIDS in 1994). The three had come together in 1969 to work collaboratively as a conceptualist group, working with ideas of infiltration, subversion and dissemination and calling themselves General Idea.[34] The arrival of AIDS into their lives, coupled with their already politically and socially critical work, led to a number of AIDS-related works from the late 1980s to the mid 1990s, culminating in *Felix, June 5th, 1994*, based on a photograph taken on the day of Felix's death. The earlier AIDS-related works showed a hybrid blend of sources and approaches. One example is the *AIDS Wallpaper*, where the letterforms of one of Robert Indiana's 1960s text-based paintings, *Love*, were used to spell out 'AIDS' as the decorative motif of the wallpaper. Another, combining the wallpaper with even broader cultural references, is *Infe©ted Mondrian # 1* (1994), in which a reproduction of one of Mondrian's diamond shaped neo-plasticist works is superimposed on some of the AIDS wallpaper. The language used is that of modernist design and a reference to its relationship to pop culture is built in by a trademark colour, 'infe©ted green', which in this case infiltrates the image in the bottom corner of the borrowed Mondrian where the original yellow triangle has been replaced by General Idea's signature green. (Interestingly, green is also the corporate colour used in Benetton's logo.)

Felix, June 5th, 1994, stemmed from another set of works begun in the 1980s, a series of self-portraits in advertising formats. The photograph was taken by Bronson to deliberately distance himself from Felix, 'to take his death and return it to the public sphere... to place my relationship with Felix, as the living to the dead, on view to a public, to those who would bear witness to us'.[35] In fact, the piece was first and foremost intended as a billboard piece. Bronson wanted it to be not only about Felix's death and not only about AIDS but also about the universality of death and 'the death which each of us must face, our own death'. More recently, the work has been shown in the 2002 Whitney Biannual and in a bold curatorial project at the Ikon Gallery in Birmingham (March 2003), where it formed the only piece in the exhibition, speaking without the intrusion of the urban environment or even of other artworks. In these conditions, it was possible to experience the full power of the image, which is also reminiscent of baroque art. In effect, the photograph seemed to come off the wall and impose its presence physically in the room. Bronson himself has described the piece as a *fin de siècle* work and likened it to the work of a Viennese artist from the previous *fin de siècle*, Gustave Klimt, because of its combination of rich colour and patterns with the imaging of death and decay.[36] The overload of colour and pattern had been orchestrated by Felix himself who had become more and more elaborate in his clothing and in the choice of the soft furnishings that surrounded him as he grew increasingly frail and wasted in his illness. As Bronson put it, it was a sort of coming out, not in terms of his sexuality but of his aesthetic.[37]

Like the deathbed image of David Kirby in the Benetton advertisement, the deathbed image of Felix Partz represents 'a moment of absolute trauma', but trauma that is mitigated by the deep love that is represented in each case. On the one hand, David Kirby was visibly surrounded by his grieving family and, on the other, Felix's portrait was conceived and constructed as an act of love which Bronson remembers poignantly as 'a sort of terror mixed with intimacy and love, a sort of tenderness coated in crushed glass'.[38] Bronson's love for Felix is expressed primarily in the eye contact he established when taking the photograph. The directness of Felix's gaze may also be said to be the most affecting part of the image for the viewer, rendering the relationship with Felix more immediate and constituting the rupture in the screen that returns it to the real, while at the same time forming an ironic contrast to the spectacle of colour and pattern with which Felix had decked himself out.

Similarly, love for a dead partner was behind the third example that I want to discuss, Felix Gonzales-Torres' billboard, *Untitled*, that was displayed in twenty-four locations in New York in 1991 (fig. 18). This billboard also presented an image of a bed, in this case unoccupied but obviously slept in – the bed, in fact, that had been shared by Gonzales-Torres and his recently deceased long-term lover. As in the previous two cases, Gonzales-Torres' billboard works on two levels – the personal and the political – and because of its allusions to the sexual politics of AIDS and its conditions of production and reception, can also be classified as activist art. For his part, Gonzales-Torres has defined activist art as 'A type of art that has a preoccupation with giving different voices a chance to be heard and valued; a type of art that is concerned with trying to make this place a better context for the larger group.'[39] In exposing the private to the public as he did with this particular billboard, Gonzales-Torres gave voice to a marginalised and stigmatised social group by calling attention to contradictory attitudes towards privacy

18. Felix Gonzales-Torres, *Untitled* (1991). Billboard, New York.

that had been highlighted by the case of Bowers v Hardwick. Heard in the Supreme Court in 1986, the case resulted in the prosecution of two consenting men for a sexual act that had taken place in the privacy of their own home. Scandalously, for Gonzales-Torres, the bed, which is normally the most private of spaces, was put under public scrutiny and shown to be under public control: 'It was ruled that the bed is a site where we are not only born, where we die, where we make love, but it is also a place where the state has a pressing interest, a public interest.'[40] In short, Gonzales-Torres had been affronted by the way that the Court could declare certain sexual practices between consenting adults illegal (in this case it was sodomy between two men) and the billboard was a means to publicly challenge this sort of judgementalism. However, while clearly an attempt to legitimise a stigmatised and marginalised social group, it also bore urgent and poignant witness to a personal tragedy.[41]

In contrast to the more detailed image of David Kirby and the more decorative portrait of Felix, there is something almost minimalist in the simplicity of this essentially monochrome image that shows the upper end of the surface of the bed in close-up. However, a defining feature of minimalism was the undermining of the boundaries between work and spectator, achieved in this instance by the scale and closeness of the image to the picture plane. In this respect, the spatial organisation of Gonzales-Torres exhibits a form of theatricality that is associated both with baroque art and with minimalism.[42] However, while baroque art usually overloads the image and spectator with visual detail, minimalism generally operates on the 'less is more' principle so that the overwhelming of the viewer is effected by an enormous sense of absence rather than an excess of presence. While the subject matter of each one of these three representations ostensibly fits into the category of the abject, the result of this overwhelming of the viewer in the formal presentation of all three of the works, particularly in terms of scale and in the undermining of the barrier between picture space and real space, takes that which is abject into the realm of the sublime. Gonzales-Torres' work has already been linked to Jean-François Lyotard's definition of the postmodern sublime in an article by Mónica Amor, who argues that the sublime is most commonly seen as a state arrived at when imagination fails to provide a representation equal to the concept. In Gonzales-Torres' billboard representation of the bed, the unpresentable (in this case AIDS and death) is

expressed through the lack of specific detail in the image and its consequent openness to multiple interpretations.[43]

In recognising the impossibility of representing the unpresentable, Lyotard drew from the eighteenth-century German philosopher Immanuel Kant, for whom the sublime signified a state of mind/soul in which the subject comes to realise his/her own human limitations. Faced, for instance, with the unquantifiable magnitude of nature, the subject feels pain at not being able to conceive of nature's 'totality' or finality but also has the pleasure of self-knowledge, to be able to conceive of not being able to conceive things beyond the reach of the human mind. The sublime, therefore, is not in nature itself but in the unique self-realisation that results from the confrontation with concepts beyond our reach, such as nature, or, as is the case in this discussion, death itself.[44] Lyotard takes this notion of the unpresentability of nature and applies it to abstract art:

> To make visible that there is something which can be conceived and which can neither be seen nor made visible; this is what is at stake in modern painting. But how to make visible that there is something which cannot be seen? Here, Kant himself shows the way when he names 'formlessness, the absence of form', as a possible index to the unpresentable.[45]

However, rather than hinging his discussion on the notion of the sublime as an agent of self-realisation, Lyotard saw the sublime in the refusal of the kind of narrative closures of traditional art that are effected by abstraction, whereby art is opened up as a field in which the unpresentable might become known.[46]

While figurative rather than abstract, Gonzales-Torres' bed seems to embody this definition of the sublime, not only because of the absence of specificity and minimalist presentation but also because of the relative formlessness of the image. Lack of closure is now a recognised characteristic of postmodernism and may be said to apply equally, although differently, to Benetton's image of David Kirby and Bronson's portrait of Felix, in which the subject is poised precariously at the point of the unknowable. But the specificity of these two images obviously does not fit the model provided by abstraction in the way that Gonzales-Torres' imaging of his bed does,

invoking instead another version of the sublime, defined by Paul Crowther as the existential sublime. In Crowther's scenario, the extremities of pleasure and pain that drive the sublime make it a much-valued experience, even in contemporary society. This is particularly the case because of what he feels to be a vast alienation caused by the monotonous conditions of labour and the lack of real stimulus in the products of mass culture.[47] According to Crowther, the sublime in popular culture is experienced through the thrills generated by packaged horror although, as he notes, there is much that is inauthentic about the consumption of the sublime through the mass media.[48] However, despite its lack of authenticity, the existential sublime, for Crowther, still follows the logic of the sublime as originally conceived in the eighteenth century. This time the version of the sublime that is co-opted is that spelt out by British philosopher Edmund Burke, who tended to be far more specific than Kant in his characterisation of the sublime. For Crowther, it was Burke's claim that a major function of the sublime was to intensify the sense of being alive through the awareness of mortality that was to have continued relevance for contemporary culture.[49]

In confronting the viewer with the horrors of death, then, and, anchored as they both were in the specifics of the real, the Benetton advertisement that depicted David Kirby on his deathbed and Bronson's portrait of the dying Felix offered the potential for an experience of the existential sublime. As it happened, the Benetton advertisement caused mixed reactions, with many unable to get past the idea that a product of advertising could deal with the theme of mortality. Although the use of the image in advertising might therefore be seen as degrading for David Kirby, the image of Felix, intended and received as a work of art from the start, encountered no such confusion and was more readily able to do the work of the sublime.[50] Gonzales-Torres' bed, of course, straddles both Lyotard's version of the postmodern sublime and Crowther's category of the existential sublime. Whichever way they are viewed, the unpresentability of death forms an important subtext to all three representations that works alongside an equally important subtext of abjection. Indeed, it may be argued that it is this combination of the sublime and the abject that makes all three of these works particularly potent and places them in a league of their own, regardless of whether they are art or advertising.

The close affinities that exist between these three works may be said to demonstrate not only the way that both art and advertising have a potential

for elasticity which enables boundaries to be stretched and correspondences and crossovers to form, but also that, when pressing, the cultural imperatives which underpin these practices are capable of overriding the conventions attached to them. All three of the above examples are symptomatic of a time in which disciplines and arenas of practice are more permeable, and are able to overlap and conflate. In their recognition of the significance of tragedies that are both personal and social, they are also representative of a Zeitgeist in which the public and the private are no longer regarded as separate spheres. While tabloid journalism and reality TV have been highly instrumental in the way that the private has become a questionable public spectacle, the political importance of the personal has been recognised in art since it became a slogan of feminist practice in the late 1960s and early 1970s. The Benetton advertisement featuring David Kirby, Bronson's portrait of Felix and Gonzales-Torres' billboard image of his bed all conflate the public with the private. And in addressing the theme of mortality and effecting a return to the real, they achieve a complex and highly compelling potency.

Chapter 5

Tony Kaye

Both Sides Now

My account of the relationship between contemporary art and advertising has so far explored a number of correspondences, overlaps and exchanges between cutting-edge practices in both fields. A broad picture is already emerging of the scale and complexity of the relationship, not only in terms of converging attitudes and approaches, but also in terms of certain practitioners and entrepreneurs, such as Oliviero Toscani and Luciano Benetton, who have been instrumental in closing the traditional gap between the two arenas. In this chapter, I will concentrate on one practitioner in particular, Tony Kaye, who emerges as a key figure for his substantial body of creative work in both fields, for the diversity of his overall cultural production, including film and music, and because he represents a way of moving fluidly between the disciplines which seems entirely postmodern. However, despite his varied practice, Kaye is a man of singular vision who is consistent in his aesthetic and who, in his advertisements, has addressed 'big' themes in 'big' ways that are more readily associated with art. In the account that follows, I will examine Kaye's aesthetic and show how it informs and underpins his work in both art and advertising and, in doing so, show just how flimsy the line that is drawn between the two arenas can become.

Working as he does across a range of disciplines and in a range of media, it makes sense to style Kaye according to the Renaissance model of the cultural producer as a man of 'varied talent and learning'. Kaye makes a clear distinction between his advertising work and his other more self-generated projects, claiming art, for instance, as a pure activity and advertising as somehow contaminated.[1] This returns to a point that I raised in the introduction concerning the relativity of people's ideas of art and the survival of dominant perceptions of what art is and what it is not. In this case, it is the survival of the essentially Romantic notion of the artist as the agent of feeling and imagination which is at stake, as opposed to the notion of the commercial or applied artist who practises a somehow 'lesser art', compromised in expressive freedom by the client or the marketplace.[2] For me, the paradigm offered by Romanticism is an attractive, even compelling, way of seeing the artist, if only because at the very least the heart is privileged over the head and the seductive ideal of individual self-fulfilment is inscribed in its philosophy. From this point of view, Kaye seems to embody the notion of the Romantic rebel in his approaches to both art and to advertising, kicking in each case against institutional forces and producing work that engages the feelings and subjectivity of the viewer. Indeed, what Kaye's work confirms is that, while distinctions can be drawn between the roles played in the marketplace by art and advertising, this is not necessarily to do with the aesthetic parameters and content of the work which, in several notable instances, particularly those cited in Chapters 3 and 6, are seen to correspond readily with one another. In other words, while belonging to different contexts of cultural production, art and advertising in such instances have come to operate with a similar degree of purchase in the symbolic economy of our times.

The resistance to institutional control, for instance, is evident in both Kaye's practice as an advertising creative and as a fine artist. Kaye's disregard for the views of the client in favour of his own expressive judgement has recently gone down in advertising history, where he has been described as 'an *enfant terrible* who was rumoured to do crazy things like fight on the set, conduct all-night shoots and refuse to show the client the rushes'.[3] The perception of Kaye within the advertising industry itself is, therefore, that of a creative who is able to call the tune and who produces advertisements that display particular vision and transcend the constraints of the product. Nik Studzinski, Creative Director at Publicis, is clear on this issue, speaking of

two types of creativity within the industry. The first modus operandi works more narrowly within the limitations set by the client and marketplace in a framework that appears to place advertising firmly within the tradition of patronage-led art. The second gives the creative director a much freer hand at developing the concept and visuals, as is the case with Tony Kaye; cited by Studzinski as a premier example of a creative able to operate in the more self-directed manner of the Romantic tradition.[4] Indeed, while Kaye considers his advertising work to be compromised in its creativity, he has frequently been able to operate in advertising with the sort of autonomy that a fine artist might expect in the production of supposedly more disinterested works. (See, for example, in his 1999 advertisement for the Vauxhall Astra for Lowe and Partners, where, mimicking a union gathering, the babies make demands for better conditions. In the interests of authenticity, Kaye insisted on the actual presence of 800 babies, having trenches built for parents/nannies to hold the babies in place.)[5] Consequently, he is able to produce a rare type of advertising that clearly draws its creativity from individual vision and from the ability to activate the imagination of the viewer in a way that has on notable occasions invoked the grander narratives of our culture rather than the everyday concerns of consumerism.

There is no doubt that Kaye's commercials are in a league which goes way beyond either the simplistic representation of a product or its brand identity and it would, indeed, seem that it is his greater artistic autonomy as a creative director that makes his advertising so successful. As the famously disturbing Dunlop Tyre TV commercial of 1994, *Unexpected* (for SP Tyres, agency: Abbot Mead Vickers; fig. 19), amply demonstrates, Kaye is not afraid to disorientate the viewer by entering strange, threatening, even uncanny territory when producing advertisements. The whole sequence, for instance, is characterised by sensual overload in which the visuals are accompanied by a quasi-hypnotic and equally sensual soundtrack, *Venus in Furs* by The Velvet Underground.[6] The intention from the outset was to make a radical departure from the run-of-the-mill conventions of tyre advertisements and, in doing so, Kaye created a fantastic world peopled with hybrid characters, exhibiting a sumptuous mix of splendour and grotesquery reminiscent of baroque carnival or masquerade. The strange and elaborate feel of the commercial is partly created by the setting, a landscape made unreal by the use of artificial colour laid over black and white footage, and by the wealth and sensuality of texture and materials.

19. Tony Kaye, *Unexpected* (1994). Courtesy: Tony Kaye.

However, this is part of a more complex cluster of signification. For example, there is a sense of decadence in the styling of the make-up and costume and there is also a lurking threat of devastation or destruction within the overall opulence, suggested by glimpses of dead vegetation and sporadically erupting flames. As with much of Kaye's work, the effect is achieved through dramatic contrasts, the tensions and contradictions of which are epitomised when, true to carnival's reversals of order, the world is graphically turned upside down and further destabilised by the motif of the falling grand piano, signifier of high culture and, ordinarily, an instrument of harmony.[7] Added to this threat of destruction is an element of taboo, provided not only by the sado-masochistic overtones of the imagery, but also by the choice of *Venus in Furs* for the soundtrack. Until that point, the song's lyrics had denied it radio airplay for twenty-seven years – it was a cult but not a commercial hit. As a major feature of Kaye's prime-time commercial, the song was resurrected and released as a CD single, making the lower reaches of the charts. So, while Kaye's commercial could be seen to have added to the popularity of the song

by acting as a sort of pop promo, the transgressive nature of the song, and of The Velvet Underground themselves, in return added significantly to the strangeness and somewhat forbidden nature of the visual imagery.

In this extravagant apology for the humble car tyre, we are, to all effects, transported to a land akin to Prospero's island, peopled by faerie spirits and dominated by a figure that could certainly give Caliban a run for his money. It is this otherness, along with the overwhelming of the senses and the allusion to catastrophe, that gives the commercial its primary impact. More to the point, Kaye avoids the more rudimentary sensory cravings that are so frequently evoked in conventional advertising by evoking a feel or mood of sensory excess in the sado-masochistic references. This sensual excess is suggested in the corseting and piercings of the Calibanesque main character and the rubber suit in which another character appears towards the end, the latter, of course, making a subliminal connection to the material that tyres are made of as well as suggesting a world of estranged sexuality. In the light of all of this artistry and extravaganza, the conventional distinctions and hierarchies between advertising and art are readily tested. Rather than providing some sort of exposition of the efficacy or benefits of the product, Kaye succeeds in transcending functionality to create a piece that uses the product as a pretext for the outlet of the imagination and which, in the spirit of Romanticism, extends the bounds of experience. In effect, the advertisement provides a means of access to a mysterious semi-dystopian world of otherness that suggests pleasure of an order completely different to and far more complex than those offered by conventional advertising. All of this is done with supreme visual fluency and economy, taking just a couple of minutes of film time to transport the viewer into an epic sequence of images which serve to imply an even larger, more mysterious narrative.

In short, Kaye's best-known advertisement, *Unexpected*, serves as a prime example of what seems to be a need or even compulsion to transcend or transform the mundanities of everyday life. This eschewal of the prosaic runs through all of Kaye's work, even in earlier far less outlandish pieces such as *Relax*, the Intercity commercial for British Rail (Saatchi & Saatchi, 1989) and *Furry Friends*, advertising real fires for the Chamber of Coal Traders (also for Saatchi & Saatchi, 1989). The train journey in *Relax* is artfully shot in a series of vignettes which carry middle- to high-brow cultural references such as a broadsheet newspaper, an Iris Murdoch novel and a game of chess. But, where

such references might have fallen down because of their obviousness, Kaye has managed a touch of magic and humour in the use of anthropomorphics in the animation of the relaxing penguin motif on the book, the sighing chess pieces and the stiletto heel curling up snugly onto itself. In addition, Kay extends the richness of his cultural references with the introduction of a cross section of social types and ages, complemented, as with many of Kaye's commercials, by a soundtrack which, in this case, colludes with the visuals to shore up the soporific tone of the work. Similarly, the far more potentially clichéd *Furry Friends* again shows Kaye's ability to disarm the viewer with anthropomorphism and with what is essentially the stuff of fairy tales or nursery rhymes. Here, the mundane is again translated into something magical: a cat seems to be doling out kisses to dog and mouse alike, before they all cosy up together in front of the fire. What might be a recipe for the more conventional sentimentality epitomised by Landseer's *Dignity and Impudence* (1839) is rescued by the fluency and economy with which the visuals are composed and the way that sentimental expectation is simultaneously exploited and disrupted through the choice of character over appearance in the dog and cat (cute but not too cute). Again the action is played out against and given extra purchase through an iconic pop song, in this case, the Shirelles' 1960 hit, *Will You Still Love Me Tomorrow?*

While even comparatively modest pieces such as these show Kaye's virtuosity and ingenuity, advertisements such as *Unexpected* access a level of complexity that firmly challenges the traditional hierarchical relationship between advertising and art. Indeed, this level of sophistication in the realm of mass-produced images could be seen as an outstanding vindication of the now famous claims made by Walter Benjamin in 1936 – not only that the art of the future would be experienced through photography and film, but also that the boundaries and perceptions of art would have to adjust in order to accommodate to a new set of potentials that these media bring.[8] Through works such as *Unexpected*, Kaye has been instrumental in a move that has taken advertising out of its conventional narratives and utopian framework; he has also given broad access to a level of creativity which might readily be called art. His commercials operate in the arena of mass reproduction and consumption but with as much accomplishment in terms of individual creativity as the unique work of art. In short, Kaye takes a form of practice that is frequently associated with the banal and the less than pure interests of

commercialism and uses it to produce extraordinary viewing experiences – all the more so for their gratuitous distribution in the popular arena.

Two more TV commercials testify to this ability to transform the normal tropes of consumerism: *Twister* (1996; fig. 20), a commercial for the Volvo 850T-5 (Abbot Mead Vickers, BBDO); and *God Bless the Child*, a commercial for the Volkswagen Passat (1990, BMP DDB Needham Worldwide). Examining these two works again supports the notion of Kaye as a latter-day Romantic artist. In both of them he deals with complex emotions and develops them through stock romantic devices, expressing, although differently in each case, a sense of loss, even melancholy which forms a stark contrast to the upbeat tone to be found in the majority of advertisements.

Twister sets the reliability of the Volvo 850T-5 against the ravages of a tornado and confronts the viewer with a number of poetically filmed images of destruction and displacement, accompanied by a calm, documentary-style commentary. The setting up of grandiose binary oppositions such as calm within the storm or the rationality of science and technology versus untamed nature is crucial to the impact that is made by the advertisement and is a recognisably Romantic strategy, found for instance in the work of Casper David Friedrich (1774–1840) or Joseph Mallord William Turner (1775–1851). The viewing experience is made especially complex, however, by the way in which these themes are given visual form in the commercial. While the narrative of the twister's devastation is played out with all of the rapid action and fast cuts associated with conventional action-film footage, it is interrupted at vital points by the introduction of some apparently static shots and a couple of strategically placed slow-motion sequences. The most extraordinary of these occurs approximately halfway through when, momentarily, an incongruous close-up of a man's head in profile is shown with a flower superimposed over the ear and neck, both motifs rendered in what seems to be their photographic negative.

In another instance, the ravages of the twister are briefly but effectively attenuated in a short, but highly significant, slow-motion sequence, allowing a fleeting moment of distance which produces a note of melancholy and a sense of loss that would have been missed had Kaye stuck consistently to fast-action shots. This sequence occurs in the second shot, in which a family is shown evacuating their house. Motion is slowed down to an almost pro-cessional speed and viewed side-on, as slow horizontal movement across the

20. Tony Kaye, *Twister* (1996). Courtesy: Tony Kaye, Agency: AMVBBDO.

screen from left to right, evoking the underlying solemnity and gravity of the situation rather than its immediate panic. In drawing from the fast-moving language of the action movie and punctuating it with less immediate takes, Kaye creates an unexpected viewing experience which, although ultimately promoting a product, again transcends the more functionalist or straightforward narrative structures of both conventional film and advertising.

These interruptions are both defamiliarising and poignant and, I would suggest, are artificially constructed versions of what Roland Barthes termed the *punctum*, that giveaway detail in the photographic image which 'wounds' the viewer by catching him or her unawares. In Kaye's work, the *punctum* literally becomes a punctuation in the narrative flow.[9] Other instances of similarly defamiliarising interruptions to the narrative flow include: static views of the same man's weather-beaten face that appeared in negative halfway through; the interior of a telescopic laboratory; and the momentary slowing down of the explosion of a house.

Yet these remain details within the whole, which is directed in terms of mood as much as in terms of narrative structure. Here, again, parallels can be drawn with Romantic art, for which one of the defining characteristics is the orchestration of mood. From the start, the viewer's experience is constructed in epic terms: the commercial opens with two foreboding landscapes that tap into the popular fallacy that nature reflects human emotion (more anthropomorphism) and create a sense of premonition through vast, dramatically lit skies.[10] The action of the twister is equally awesome in its ability to move the normally immovable (mature trees, a caravan, a huge steel drum) and to treat them as mere flotsam and jetsam. Add to this the aforementioned dramatic contrast of the immense power of nature and the calming force of technology (expressed by the reliability and manoeuvrability of the 'car you can believe in') and the result is little short of a piece of high Romantic art. Mood is further developed and crucially underpinned by a majestic and solemn musical score and by a particular manipulation of colour. *Twister* was, in fact, shot in black and white and then digitally coloured frame by frame.[11] This not only increased the emotional range of the colour which, at key moments, seems to make nature almost supernatural, again stretching the bounds of experience; it also made subliminal connections to the sense of nostalgia and ephemerality produced by colour-tinted period photographs.

All of this adds up to an impressive tour de force in which the formal and iconographic conventions of TV commercials are stretched and expanded. In this respect, Kaye takes his place amongst a small number of other such innovators. These include film director Ridley Scott (*Blade Runner*, *Alien*), who made groundbreaking use of dystopian footage in *1984*, his commercial for Apple computers, and Hugh Hudson, also director of a number of films (*Greystoke*, *Chariots of Fire* and *Revolution*), who made *Swimming Pool*, the first surrealistic television commercial for the Benson's Pure Gold campaign in 1979.[12] Moreover, despite the commercial context in which Kaye's advertising works are produced and despite the fact that they are ultimately tied to what are in the end fairly crass functional messages, it is already possible to detect a consistent personal vision at work. As I have shown, this vision both stems from and taps into the Romantic tradition and in developing it Kaye has reinvigorated some of Romanticism's central motifs such as man versus nature, the unpredictability of life or even the loss of innocence. While the functional message of *Twister* is simple and straightforward – buy this car

and you get enough high-powered reliability and manoeuvrability to cope in a situation of extreme hazard – through the rich formal overlay of thematic content, sound, image, texture and colour, it also provides the sort of excess and sublimation of feeling sought after in Romanticism.

The thematic content of *Twister* lies not so much in its storyline as in a sense of loss and melancholy that is evoked through the combination of a number of strategically deployed devices – poignant interruptions to the narrative, the elegiac nature of the music and emotive use of colour, for example. I would also argue that a similar sense of loss and melancholy is present, yet differently expressed, in the Volkswagen Passat commercial where, once again, a set of oppositions underpin the narrative, in this case, innocence versus worldliness and social discord versus social order. In contrast to *Twister*, loss and dismantlement are not overtly shown, the environment is not destroyed and nobody is brutally displaced from his or her home. However, there is a strong appeal to nostalgia through the use of black and white photography and, in particular, through the central motif of the small girl, who cuts an unmistakably sentimental and angelic figure. The key signifiers of the girl are her ringlets, coat and shoes, all of the sort worn in an earlier, now perhaps rose-tinted, era. The incorporation of a poignant and thematically relevant Billie Holiday song also has a crucial role to play, cutting in at a key point to underscore the subtext of the narrative. While the storyline shows the child being escorted through the city streets ready to be picked up by her (attractive, classy and well-to-do) mother, driving the necessary VW Passat, the narrative is that of a child witnessing the harsh textures of the city. These are the sort of fragmented experiences, the shocks and collisions of the amorphous crowd, that the nineteenth-century poet Charles Baudelaire rendered so eloquently, that the early twentieth-century cultural theorist Walter Benjamin later so astutely analysed and that the Russian experimental film-maker Dziga Vertov attempted to capture with his movie camera in 1929.[13] The child's experience is expressed through a series of disconnected vignettes that depict stock characters of urban life. These characters are also signifiers of disorder or disruption: the soapbox speaker, the streetwalker, the criminal, the enraged driver, all set against a backdrop of the noises of the city, voices, traffic, a siren, etc.

The viewer is disarmed in the very first shot by a close-up of the child's face, behind which floats a fugitive image of commercial city buildings. From this

point on, the child is followed through the city, which the viewer sees through her innocent and non-judgemental eyes. Although the city is presented as a potentially threatening environment, signified in the way that the child clasps the hand of her escort tightly, a more ambiguous narrative of wider social and moral culpability or responsibility is simultaneously developed. This is resonantly voiced by the words of the soapbox speaker: 'Are you ready for the judgement day?' and 'Have you prayed today?' These, of course, are questions which might apply to everyone and anyone but which are particularly pertinent in the context of the notion of 'haves and have-nots' that is conjured up in this commercial. This implicit questioning of the social hierarchies is not only further signalled by the visual juxtapositions of the privileged and the underprivileged, but by the theme of the song, conveyed in its opening line – 'Them that's got shall have'. The introduction of these lyrics coincides with two long-shots of the city (aerial view and long perspective shot of road). These strategically interrupt the narrative flow and crank up the sense of being overwhelmed before switching back to the storyline, in which the police are making an arrest and murder is being broadcast in a news headline on the LCD at the top of a tall commercial building. All of this leads up to a concluding sequence in which the mother draws up in the car, signalling a return to order for the child and ending the commercial in a rather more functionalist manner with the message 'If only everything in life could be as reliable as a Volkswagen'.

This commercial seems to tap into a subliminal yearning for a lost security, expressed primarily through a nostalgia for the innocence of childhood on the one hand and a nostalgia for an ordered society on the other. As has long been recognised, mainstream advertising conventionally trades on a fundamental sense of lack that is translated into desire for fulfilment through the promises of the product.[14] But there is a world of difference between the strategies of desire that are deployed in traditional advertising and the sort of longings that are developed in *Twister* and the Volkswagen Passat commercials. For the most part, advertisements do not suggest complexity of emotion. Rather, they exploit basic insecurities about whether the consumer has the right sort or the right amount of social and cultural capital. Kaye's advertisements, on the other hand, suggest a kind of narrative and emotional complexity that is more characteristic of literature, film or art and addresses themes that traditionally belong to 'high' rather than 'low' culture. Kaye's

ingenuousness, therefore, lies in the way that he not only addresses that which is needed for some sort of vicarious fulfilment (always there in the bottom line of the message), but also recognises that there are larger forces in our lives which are not easily represented by the conventional formulas of advertising. It is significant that the music that accompanies *Twister* and the Volkswagen commercial is, in both instances, elegiac, as if there is something to be mourned and as if what's on offer is perhaps consolation of some sort rather than gratification.

None of this is easy to package and it is, again, Kaye's indisputable command of the medium and his consummate ability to orchestrate and direct the emotions through visual means that gives the commercials their purchase. It is, in part, this ability to express complex thoughts and emotions with such virtuosity that links Kaye's work in advertising to his art. In one of his interviews for the Channel 4 *arthouse* documentary, 'Rebel with a Cause', Kaye expressed genuine appreciation for the visual fluency that his apprenticeship in advertising allowed him to develop, something which he saw as essential to the methodologies he needed to deploy in art. This ability to transfer from one arena to another without inhibition or undue snobbery towards the medium and its forms can be said to situate Kaye as a postmodernist. More than this, however, it shows how popularly understood approaches can be turned to complex ends, accommodating the viewing habits of contemporary audiences but also stretching them and asking more from them. The co-option of popularly understood conventions also situates Kaye firmly in the tradition of the politically radical strand of the historical avant-garde (Constructivists, Dadaists and Surrealists) who also willingly embraced the materials and methods of commercial art, seeing them as potentially far more effective than the then moribund forms of high art. For avant-gardists such as these, the project was to produce an *art-engagé* that would both involve the viewer and develop his or her political understanding. As I will show, several of Kaye's self-generated artworks also clearly invoke the ideals and methodologies of this faction of the historical avant-garde and, in notable cases, follow in its agitational traditions.

One method of disruption employed by this strand of the historical avant-garde was the technique of defamiliarisation (or estrangement), in which language is used in unexpected ways in order to effect a greater impact. This is true of the visual language deployed in many of Kaye's TV advertisements,

most apparently in work such as *Unexpected* and *Twister*, but is also the case in other pieces such as the commercial, *Success: It's a Mind Game* for Tag Heuer watches which, on the one hand, is replete with the sort of 'eccentric' or oblique shots that were the trademark of Constructivist or Bauhaus photography and which, on the other hand, turns on a number of surreal juxtapositions which are almost classic examples of dream association. There are also several defamiliarising techniques at work in Kaye's feature film *American History X* in a number of unexpected cuts and attenuations in the camerawork that belong to the tradition of avant-garde film. Indeed, the complex way that the film is structured as a whole also takes advantage of these visual surprises, introducing them in a non-sequential way, mimicking the subjective chains of association that memory follows while unravelling and underlining either decisive moments in the narrative and/or moments of emotional intensity. In discussing the TV advertisements, I have already argued that these differently filmed sequences often act as *punctums*, punctuating the narrative in a way that singles or even stretches out moments of poignancy.

A similar sensibility is therefore at work in directing both advertisements and film, which is deployed through similar defamiliarising and elegiac devices in either case. (Compare, for instance, the moody skies and elegiac soundtrack at the start and end of *American History X* with similar devices in *Twister*.) Although tied to a script and ultimately compromised by the studio's last say on the cut, Kaye's virtuosity with the visual language is clearly imprinted on the film, just as firmly as it is on his advertisements. The question that now remains is how the sensibility and aesthetic described in this sort of work fits with Kaye's self-generated artworks. Broadly speaking, this work has two sides: there is a body of paintings, drawings and photographs (reproductions of which Kaye intends to publish in book form) that Kaye has been working on over a period of some fifteen years and which he describes in terms of 'diary'. On the other hand, Kaye is better known to the art world and its followers for the sensationalist staging of works dealing with contentious or provocative subject matter that he produced during the years 1996–1998. These works were a consciously driven attempt to break into the art world and to establish Kaye as a significant player in the field. However, in contrast with the successful sensationalism that accompanied BritArt at the time, the surrounding hype seems to have worked against Kaye. There are, in effect, fundamental differences between Kaye's posturing and that of the current

generation of young British artists. As has often been noted, the contentious and provocative work of young British artists brought welcome publicity for the art world and for Charles Saatchi in particular. However, while some of the more prominent young British artists might be seen as cynical in their seemingly uncritical call upon themes of sex, violence and death, this is not, in my opinion, true of Kaye who engages with them as social issues. Moreover, Kaye was on notable occasions openly defiant towards such influential institutional forces within the art world as the Los Angeles Biannual and the UK's Turner Prize.

Lewis Blackwell has suggested that what Kaye did in his interventionist artworks was to expose the very nature of what art is today, which Blackwell sees as a matter of pointless and dull self-expression that may or may not strike a chord with something felt to be deeply true.[15] More to the point, however, I would argue that Kaye exposed the nature of the *art world* for what it is. The attempted installation of *Provocation* (1999) outside the first Los Angeles Biannual Exhibition is a fitting example of Kaye's confrontational tactics in action. As Kaye had not been invited to participate in the exhibition, he took it upon himself to produce a piece to sit outside the gallery. This was a deliberately confrontational work, which did nothing less than insult the sponsors of the exhibition, Absolut Vodka. The piece took the form of a street advertising stand, inside of which was a poster image of diseased liver-cells accompanied by the strap-line 'Absolute cirrhosis of the liver'. As an anti-establishment gesture, it seems that Kaye's piece was too close to the bone for the curators of the Los Angeles Biannual who demanded its immediate removal. Kaye's interventionist gesture exposed the hypocrisies of a world that pretends disinterest but is in the last instance governed by private interest.

A similar, although better tolerated, example is *Roger*, a living artwork who 'exhibited' outside the Millbank Tate Gallery in London in the mid to late 1990s (fig. 21). Again, it is easy to be cynical about the sort of gesture that Kaye was making by taking a homeless man from the streets and turning him into a sort of sideshow, not only because it was a self-confessed attempt to steal some limelight and further Kaye's artistic career, but also because patronage seemed, in this case, to verge on patronisation and exploitation. This view, however, assumes that Roger was some sort of passive victim of Kaye's self-promotional ambitions and that Kaye was motivated by this

21. Tony Kaye, *Roger* (1995). Courtesy: Tony Kaye.

ambition alone, neither of which were by any means the entire truth. It is clear, from footage taken for the Channel 4 *arthouse* documentary, that Roger developed a degree of agency and advocacy through his employment as a living artwork: he spoke out on issues of homelessness; he gained access to and took pleasure in art; and he ended up with somewhere to live and an income to survive on. He also clearly reflected upon his situation and made his own evaluations of it. Kaye for his part, while openly attempting to make an intervention into the art world that would gain him recognition as an artist, was equally clear in his intention that the work was to be socially relevant and that if he was to make his name, it was to be for something worthwhile. In effect, most of the self-generated works that have entered the public realm have addressed serious social themes and the work has met the conditions of an *art-engagé* both in form and content.

This desire to produce socially relevant artworks is evidenced in Kaye's consistent attachment to certain themes that raise complex moral debate, for example the way that health issues are perceived and managed in society, dealt with in one way in *Provocation* and in a completely different way in *Don't be Scared* (1996–1997). The latter was a touring exhibition that featured four

naked people with HIV/AIDS who sat on a sofa and interacted with the gallery visitors. Other forms of interaction were also made available for the visitors, who were provided with materials to express or record their own experience of the 'artwork', at the same time contributing to the artwork and making it literally an engaged experience. In its entirety, the work took the form of an interactive/performative installation that made full use of the gallery space and included 'generative music' by Brian Eno. Again, the significance and success of the work hinged on the way that Kaye orchestrated the thematic content of the work into a complex piece. For the people employed as the centrepiece of the work, it was not only a way of publicly raising the issues of HIV/AIDS, but also a way of coming to terms with the disease, for both themselves and some of their visitors. It is important that the 'models' were informally placed and touchable rather than being placed on display and it was also important that they were undressed, naked rather than nude. Nakedness, as John Berger famously noted, is to be oneself and to be without disguise, and this ability to be themselves was keenly appreciated by the four main participants.[16] For the visitors, however, it issued a challenge to the otherness of the disease, which, as several commentators have shown, had been subjected to a particularly pernicious mythologisation, especially in the popular press.[17] Set against this sort of misrepresentation, as well as the general tendency in art at the time to produce AIDS-related work that was thought to go too far in the opposite direction, stereotyping its subjects in tragic or sentimentalised terms, Kaye's piece humanised the person with HIV/AIDS and addressed the complexities and realities of actually living with the syndrome on a long-term basis.

While the same sensibility underpins both his art and his advertising, his ability to communicate large emotions has ironically served Kaye better in advertising than in art. In the end, Kaye is more remarkable for bringing an emotional complexity to advertising that is better associated with art. This state of affairs serves to highlight the inadequacies of the institutional theory of art that I outlined in the Introduction which, as Tiffany Sutton has argued, shows how a work of art is framed but fails to address the issue of how the work is interpreted or evaluated.[18] As I have shown, it is possible to analyse Kaye's advertisements as if they were autonomous works of art and it is more than possible to align them with his more personal artworks in terms of approaches and sensibility. Conversely, the less personal, simultaneously

self-promotional and 'socially-motivated' artworks seem to approach the conditions of advertising in which a message of a more instructional nature forms the keystone of the work. All in all, Kaye not only demonstrates the difficulties of trying to separate art from advertising, but also the fallibility of the classificatory systems that govern the reception of both art and advertising in our times.

In foregrounding Kaye as a figure whose work not only spans both art and advertising, and as a practitioner who can move from one context of representation to another with ease, 1 have shown how the relationship between art and advertising has been played out in terms of the work of one individual. In the next chapters, 1 will also discuss the achievements and leadership of another individuals: Dan Wieden, whose advertising agency has transformed the practices of advertising in a way that brings it closer to contemporary art.

Chapter 6

Wieden+Kennedy and Nike Advertising

I have mapped out a number of shifts in context and shifts in approach that have brought art and advertising closer together in the last twenty-five years. This chapter will take a closer look at what might be termed shifts in attitude in the advertising industry. As I will show, the practices resulting from these shifts in attitude are readily comparable to a number of approaches taken in contemporary art and further demonstrate the increasing fluidity of the boundaries that have traditionally separated art and advertising. More generally, changing attitudes and approaches in advertising tend to reflect the spread of postmodernity into popular culture. The ability to think outside of the frame that this postmodernity brings has proved fundamental to cutting-edge practices. The cultural practices that inform these new approaches are wide and include film, street culture and the media, and their influence can be detected in campaigns for fashion companies such as Levi Strauss, Pepe and Diesel. However, I would like here to focus on the American agency Wieden+Kennedy as the primary vehicle for the issues of attitude and approach. In several ways and on several levels, their work more readily corresponds to key preoccupations and practices in contemporary art.

Based in Portland, Oregon, Wieden+Kennedy has proved to be a vital force in the evolution of new approaches in advertising over the last fifteen

years. Significantly, Wieden+Kennedy is also an agency that not only shares its premises with the Portland Institute of Contemporary Art (PICA), but also encourages interaction between themselves and the institute. As importantly, Portland is also the home-town of Phil Knight, founder of the Nike empire and it is Wieden+Kennedy's long-standing account with Nike that has sustained the agency and given the creatives the opportunity to develop innovatory approaches. Knight is an independent-minded businessman with a strong individual vision, which has impacted on the style of advertising that Wieden+Kennedy have developed. He is upfront about his attitudes towards sport, which, for him, 'isn't about truth and accuracy. It's the central unifying culture of the United States and the stuff of romance and dreams.'[1] This attitude was also to underpin the style of advertising that Knight was prepared to buy into. In fact, when he first employed Wieden+Kennedy in 1982, he was a reluctant client, clinging to the notion that if the product is good enough then it will sell itself.[2] However, in Dan Wieden, co-founder of Wieden+Kennedy, Knight was to meet a kindred spirit, someone who 'never liked advertising' and had wandered into it after trying his hand as a beat poet.[3]

Knight was, however, to be persuaded otherwise and Wieden+Kennedy were able to eschew functionalist approaches and develop the image of the product in terms of a non-mainstream yet highly contemporary cultural ethos, to the extent that the agency is now credited as a leading force in the postmodernisation of advertising.[4] The first TV commercial for Nike trainers to express this ethos was *Revolution* (1987), a title which, as Warren Berger has noted, neatly signalled the new approaches which Wieden+Kennedy were to develop in advertising.[5] The title came from the soundtrack to the commercial, a version of The Beatles' famously anti-establishment number of 1968. *Revolution*, with its pioneering use of 'anti-advertising' techniques, was one of the most innovative commercials of its time. It was rivalled only by a few similar groundbreaking precedents such as Ridley Scott's slightly earlier, *1984*, for Chiat/Day, advertising Apple Computers, or Wieden+Kennedy's own *cinema-verité*-style commercial for Honda Scooters (1984). The latter was by the same director as *Revolution*, Jim Riswold, and, this time, the visuals were not only accompanied by Lou Reed's *Walk on the Wild Side*, but also featured Reed himself. The revolution in *Revolution* was to feature a largely disconnected series of fast cuts of the feet of runners on a track, shot on coarse-grained film in a seemingly ad-hoc manner, the complete antithesis to

mainstream advertising practices of the time. In its 'inappropriate' – and for some an objectionable – appropriation from The Beatles, the most popular of sixties rebels[7] and, in its disregard for the aesthetic protocols of conventional advertising, this amounted to quite a radical gesture.

Yet, while this constituted a fairly revolutionary development in advertising, anti-aesthetic approaches and appropriations from popular culture had long been features of avant-garde practice in art, dating back to the early twentieth century with the anti-art of Dada and the appropriation of popular forms and iconography in movements as diverse as Cubism and Surrealism. However, by the 1980s, a shift in the relationship between art and popular culture had also occurred whereby artists not only appropriated the subject matter and forms of mass culture but also began to mimic their modes of production. As I have already noted in Chapter 2, several key artists of the 1980s expressed an ambivalent relationship with mass media such as film and photography. As Lisa Phillips has observed, they 'were media-literate, both addicted to, and aware of the media's agenda of celebrity making, violence mongering, and sensationalism', so that 'many became increasingly cynical about the real possibility of maintaining an oppositional position'.[8]

In other words, many artists of this generation developed an ambiguous relationship to the media, examples of which can be seen in Cindy Sherman's film stills, c.1977–1987 or Nan Goldin's ongoing *Ballad of Sexual Dependency*. Begun in 1978, the latter is one of the few contemporary artworks to incorporate iconic music in the form of pop songs, using them, as many advertisers do, to shore up the emotional effect of the piece.[9] Such works were strange and possibly confusing hybrids, made out of borrowings from the mass media and mass culture and lying somewhere between pastiche and parody, works that 'that combined the crowd-pleasing strategies of entertainment with the spirit of critical investigation'.[10] In effect, both the arenas of art and advertising can be characterised as mobile territories, peopled by plunderers and, at the same time, open to plunder. The difference is that artworks such as these tended to be shown in or recuperated by the gallery system whereas the advertisements of the same era almost always did their work in the public realm.

Although similar, these comparisons do not repeat those made in Chapter 2 concerning the more direct correspondences, exchanges and parodies effected by artists such as Barbara Kruger, Jenny Holzer and Les Levine. In the case of artists such as Sherman or Goldin, boundaries are not as such crossed

or deliberately subverted; rather, they become less distinct, producing works that are somehow neither fish nor fowl – or perhaps both at once. Sherman's 'film stills', for instance, position us according to the conventions of film spectatorship, but at the same time allow for critical reflection on those conventions. The postmodernity of such works lies in this fusion of viewing practices and the ambivalence of their demands. When similar fusions occur in advertising – as in the case of *Revolution*, or in one of Wieden+Kennedy's latest examples, *Tag* (also for Nike in 2002, written by creative team Mike Byrne and Hal Curtis; fig. 22) – a similar note of ambivalence is struck, although, of course, under slightly different conditions. Indeed, despite its role and origin in mass culture, it may be argued that *Tag* looks far more like a work of art than it does a conventional TV commercial. Here, I am thinking of certain video art pieces that make similar calls upon the psyche through a related genre, such as Douglas Gordon's *24 Hour Psycho* (1993; fig. 23). Despite clear

22. Wieden+Kennedy, *Tag*, TV/ cinema advertisement for Nike (2002). Production: Gorgeous Enterprises. Director: Frank Budgen.

23. Douglas Gordon, *24 Hour Psycho* (1993). Video Installation. Photo: Heidi Kosanuik. Courtesy: Lisson Gallery, London.

differences in the conditions of production and reception of these works, for the viewer they operate in a similar representational register, that of the suspense movie, that gives them a common territory and a shared aesthetic.

Certainly, the formal differences between the two pieces are quite marked. *Tag* is sixty seconds long and is made up of a number of short cuts; *24 Hour Psycho*, as the title implies, is Alfred Hitchcock's famous 1960 horror film, *Psycho*, stretched out into slow motion to last for twenty-four hours. While *Tag* is action-packed and carries you along with a fast moving narrative (which turns out to be nothing more than a game of tag), *24 Hour Psycho* demands that you follow sequences at such an excruciatingly slow pace that it is impossible to become immersed in the film in terms of its narrative flow. On this level, the two works are almost diametrically opposite, yet both require their viewers to adjust their viewing habits and both depend on the viewer's familiarity with the genres of sci-fi or horror or, in the case of *24 Hour Psycho*, an iconic film of its genre. *Tag* demands a frisson of fear that is not part of the normal remit of advertising and it evokes a state of paranoia

characteristic of sci-fi/horror. In *Tag*, the main character finds himself in city streets that empty at his appearance. Every time he catches up with someone, other people panic and it seems that they can't wait to get away from him – as if he were carrying a contagious disease or constituted an overwhelming threat of some sort. To achieve these effects, the commercial is made up of long-shots of empty streets that emphasise the isolation of the main character. The shots in *24 Hour Psycho*, although stretched beyond the limits of their narrative function, rely equally on familiarity with the horror genre and the sort of suspense associated with Hitchcock. It is this familiarity with the original film and its enormous cultural cachet that offsets the fact that you might have happened along to view *24 Hour Psycho* during one of its less thrilling moments. There is a vestige of the sort of vicarious experience the film normally provides which combines with the viewer's own recall of his or her previous experience of the film and compensates for the way that the film has been rendered in 'longhand'. *Tag*, on the other hand, moves in the opposite direction and relies on people's knowledge of the genre in order to create a shorthand version.

While so different in structure and so different in context, both *Tag* and *24 Hour Psycho* are put together from the same deep reservoir of fluid and mobile signs accumulated by film in western culture. Moreover, both are retro and both share a sense of cult status. Here, I would argue that both simultaneously draw from and add to the viewer's sense of cultural capital and it is primarily this fact, rather than their status or context as advertising or art, that gives them their aura. This is not to deny that *24 Hour Psycho* might assume an aura of art when placed in and authenticated by the gallery. However, once inside the gallery, some sense of the darkened auditorium of the cinema is approached which works to undercut its status as a self-contained artwork, bringing it closer to the type of viewing experience that *Tag* would involve when played to cinema audiences. (A different set of conditions obviously govern its TV viewing, as is the case with any film or video.) In the gallery, as in the cinema, the viewing of video works tends to take place in subdued lighting. The image is projected onto a large screen that, in the case of *24 Hour Psycho*, approaches the actual size of small cinema screens of the 1960s. While the fact that people can move around at will prohibits the more captivating conditions of cinema and, indeed, television whereby the body is fixed in front of the screen and almost an

extension of the illusion, the distance between viewer and video work in the gallery is nevertheless shortened. In the viewing of *24 Hour Psycho*, the medium threatens the boundaries between spectator space and real space, creating the sort of theatricality and undermining of autonomy criticised by Michael Fried in relation to minimalist sculpture's encroachment of spectator space.[11] While *24 Hour Psycho* is the work of a media artist and *Tag* a work of mass-media creatives, each has developed in ways that have brought them together. When compared with one another, they exemplify indeterminacies of categorisation that have become characteristic of contemporary western culture and demonstrate a consequent shifting in the terms of engagement with cultural products such as advertisements and artworks.

As I have suggested, it is a desire to engage reflexively and playfully with the media that has driven the work of so-called media artists. A similar drive has been identified in *Tag*, but it is also important to note that this is not just a one-off example and that, between *Revolution* and *Tag*, a media-conscious, cross-disciplinary approach has been a consistent aspect of the work done at Wieden+Kennedy. On a number of occasions, the agency has produced advertisements that take media awareness to another level, whereby the viewer is both inside and outside of the representation at the same time. Such advertisements have both parodied and owned up to the conceits of conventional advertising, creating an ambivalence similar to the ambivalence found in the work of media artists such as Sherman and Goldin.

Key examples of this strategy are *Boys in the Barbershop* (1993) or the *Bo Knows* commercial that features comedian, actor and director Dennis Leary (1993). *Boys in the Barbershop*, for instance, shows a group of men watching a Nike commercial while idling their time in conversation in the barbershop. The commercial they are watching appears to be the latest in the *Bo Knows* campaign, but turns out to be too straight, compared with previous examples, causing the men to launch into a critical commentary that betrays not only a reflexive knowledge of advertising strategies but an understanding of the pleasure value of advertisements over their functionalism. They want to know, for instance, what's happened to the dancing girls and singing, and one knowingly misses the montage-style that is common to advertising: 'It's just Bo in a gym.'[12] Here, it is the aesthetic experience, the pleasure that knowingness brings that counts for the viewer, not information about the product.

The commercial featuring Dennis Leary also sent up advertising techniques but, further, it created a knowing postmodern reflexivity in viewers by directly addressing them. In the first instance, the commercial parodies the technique of celebrity endorsement which Nike ads have consistently deployed by once again inserting a mock advertisement into the commercial, showing a crude juxtaposition of product and star. In the second instance, Leary, with his bad-boy image, was brought in as spokesman for the basketball superstar Bo Jackson, who was undergoing intensive rehabilitation after a hip injury. The strategy was to shame the viewer by directly challenging his/her passive role in the spectacle. Leary looks directly through the screen, demanding to know 'And what are you and your good hip doing right now?' and at the same time supplying the answer: 'WATCHING COMMERCIALS!' The viewer is caught up short by this unexpectedly blunt form of address and exposed as a couch potato in comparison to Bo Jackson's dedicated struggle to regain his proactive powers. The jolt is even more pronounced when, at the end of the commercial, Leary rudely knocks on a sheet of glass in front of the lens, giving an illusion of physical proximity that threatens the integrity of the spectator's space.[13]

Again, I would like to make a particular comparison with the work of a media artist, this time Tony Oursler's *Talking Heads* series although, once again, I am not by any means trying to claim a direct equivalence. 'The Most Beautiful Thing I've Never Seen' (1995), the talking head that forms part of Tate Modern's permanent collection is a fitting example of Oursler's preoccupation with the mass media, its mechanisms and its effects. In this piece, the couch potato is physically shrunken and literally squeezed under the couch, calling out 'help' in an equally small and plaintive voice. In this installation, the boundary between the viewer and the talking head is undermined by the fact that the filmed head is projected onto a doll-like figure under a sofa that, although an installation, creates the illusion of an extension of real space in the way that film and video do. The tableau setting and the voice-over solicit the viewer's attention in a way that matches the direct challenge to media passivity issued by Dennis Leary in the Nike commercial. Both threaten the normally 'safe' space of spectatorship and both expose the conceits of the media, criticising the insidious nature of its influence and its tendency to render the viewer passive and immobile.

In effect, Nike advertising has come to operate in a similar register to certain forms of contemporary art that address the human psyche directly

and subjectively, bypassing the isolating framing mechanisms that objectify pre-minimalist and pre-conceptual art. There are many works of this kind that could be cited, but representative artists include Tracey Emin, Ron Muek and Richard Billingham on this side of the Atlantic and artists like Nan Goldin, Mike Kelley and Paul McCarthy on the other side of the water. In the end, all of these artists work from a personal and subjective viewpoint that is now reflected in the work of many contemporary advertisers, but exemplified in particular by the producers of Nike advertisements. As other examples show, there is clearly a side to the advertising produced at Wieden+Kennedy that demonstrates a focus on the viewer's subjectivity by addressing issues of identity and identity politics. Robert Goldman and Stephen Papson, for instance, demonstrate that a substantial portion of Nike advertising is built on a relationship with the viewer that recognises his or her personal sensibilities and aspirations rather than their material needs.[14] In these advertisements, viewers are addressed in a way that treats them as intelligent peers, speaks respectfully and builds a sense of parity. The famous slogan/strap-line of the 'just do it' campaign, for instance, assumes both aspiration and capability in the viewer, while other Nike commercials 'speak the voice' of marginalised groups and their relationship to the community, for example, the 1997 basketball-based television commercial which starts 'Nobody owns us man...'

On other occasions, such as in the *Mars* campaign, black viewers are invited to collude with and laugh at their own stereotypes. Here the highly respected black film director Spike Lee assumes the role of Mars Blackmon from his 1986 film *She's Gotta Have It*, a character who won't take off his sneakers even during lovemaking. The Mars Blackmon of Nike commercials is also a caricature of the consumer dupe who needs symbolic goods to confirm his/her sense of identity and status, wanting to know whether the shoes are the key factor in Nola Darling's admiration for basketball star, Michael Jordon. At the same time, Lee is sending up the type of advertisement that suggests that the product will transform your life, stopping in one particular commercial to shout, 'Hey shut up! I'm doing a commercial here' out of the window.[15] Needless to say, a commercial such as this also sends out a message about stereotyping to white viewers. On the one hand, it shows the stereotype for the superficial typecasting that it is and, on the other, it defuses the threatening image that the stereotype carries. Rather than following the usual logic of advertising and consumerism, Nike advertising treats its viewers as if engaging

them in critical discourse, centring on cultural values instead of the material benefits of the product. While noting the contradictions between Nike's actual business practices and their public image, Goldman and Papson have attributed the success of Nike advertising to its ability to fill a moral void and to provide a symbol of moral fibre, or a means towards a moral recentring.[16]

In this sense, the advertisements once again act out a role that art normally plays in the culture. The work of Chris Ofili, for example, sets up a similarly humorous and satirical look at racial stereotyping to that of the Mars commercials. Not so far from the strategies adopted by Nike advertisers, Ofili has used the forms and images of popular culture to deal with similar issues of racial stereotyping, drawing from hip-hop and blaxploitation movies. His character Captain Shit, for example, parodies blaxploitation stars and black comic-book heroes to the point where ridicule is turned back on the viewer, exposing the crudeness of the act of stereotyping rather than merely offering the cliché up for amusement.

The ways in which these kinds of cultural politics engage the viewer on a personal level has parallels in art. This is most clearly expressed in the Nike advertisements that address gender issues aimed principally at women. The most striking feature of Nike's advertisements for women is less that they resist the objectification of women, than the way in which they do it. As Goldman and Papson have observed, this is achieved through empathy and the 'legitimisation of the subjective experiences of growing up female in a predominantly male-defined world'.[17] The female creatives at Wieden+Kennedy have taken one of the central tenets that informed feminist art to heart – that the personal is political. And, like many examples of feminist and post-feminist art, these advertisements speak of women's personal narratives. An early example of this is given by Goldman and Papson, who quote from the text of the advertisement:

> All your life you are told the things you cannot do. All your life
> they will say you're not good enough or strong or talented enough.
> They'll say you're the wrong height, the wrong weight or the wrong
> type to play this or be this or achieve this... THEY WILL TELL YOU
> NO, a thousand times no until all the no's are meaningless. All your
> life they will tell you no, quite firmly and very quickly. They will tell
> you no. And you will tell them yes.[18]

Significantly, this appeal to resistance recognises the daily pressures on women to conform to an ideal (one that is, in fact, regularly assisted by both the advertising and editorial content of women's magazines) rather than to be themselves. The advertisement recognises that many women find validation in their personal lives and can by this token be aligned with a type of women's art that is characterised by autobiography or anecdote. An example of this is Nike's *Empathy* campaign (1991), which was predicated on the idea of talking to women in the way that women would normally talk to each other. Here, the advertisements were presented as a commentary on women's formative experiences, tapping into women's propensity for introspection and self-analysis. For example, the 1991 print advertisement, *YOU DO NOT HAVE TO BE YOUR MOTHER* (fig. 24), encapsulates the issue of self-determination. It speaks in the second person but instead of the usual commanding imperatives of advertising – 'buy these trainers' – the advertisement almost speaks in the voice of the therapist, reminding the viewer that she is in control of her own destiny and that the only person she is destined to be is the one she decides to be. The text is accompanied by a period photograph of a mother

YOU DO NOT HAVE TO BE YOUR MOTHER UNLESS SHE IS WHO YOU WANT TO BE. YOU DO NOT HAVE TO BE YOUR MOTHER'S MOTHER, OR YOUR MOTHER'S MOTHER'S MOTHER, OR EVEN YOUR GRANDMOTHER'S MOTHER ON YOUR FATHER'S SIDE. YOU MAY INHERIT THEIR CHINS OR THEIR HIPS OR THEIR EYES, BUT YOU ARE NOT DESTINED TO BECOME THE WOMEN WHO CAME BEFORE YOU, YOU ARE NOT DESTINED TO LIVE THEIR LIVES. SO IF YOU INHERIT SOMETHING, INHERIT THEIR STRENGTH. IF YOU INHERIT SOMETHING, IN-HERIT THEIR RESILIENCE. BECAUSE THE ONLY PERSON YOU ARE DESTINED TO BECOME IS THE PERSON YOU DECIDE TO BE.

24. Wieden+Kennedy, *YOU DO NOT HAVE TO BE YOUR MOTHER,* for Nike (1991). Photo courtesy: Janet Champ.

and daughter which is more compelling than the usual family photograph because of the absence of smiles on both faces and because of the sturdy eye contact both mother and daughter make with the viewer.

A similar kind of biographical approach underpins the work of a number of female artists, for example Tracey Moffatt and Tracey Emin. Of the two, Moffatt's work is closest in form and appearance to the *Empathy* campaign, although distinguished from it by its unsettling fusion of the autobiographical with the more general experiences of women. Her work is not only informed by the more universal shared female experiences articulated in the *Empathy* campaign; it is equally a coming to terms with her childhood experience as an aboriginal adopted into a white family. In her series of photographs with accompanying text *Scarred for Life* (1994), Moffatt creates a sense of biographical documentation, using a similar combination of text and image to that adopted in the *Empathy* campaign, although the text is much shorter and far more poignant and speaks of an experience of a far more damaging order. To provide a foil for this, the voice is more neutral, describing the scene in the third person. 'Birth Certificate, 1962' (fig. 25), for instance, is a photograph of a crouching woman leaning head and arm against a hand basin accompanied by the commentary, 'During the fight her mother threw her birth certificate at her. This is how she found out her real father's name.' 'Useless, 1974' shows an adolescent girl cleaning a car with the accompanying words, 'Her father's nickname for her was useless.' As well as using similar approaches in the construction of narratives through the use of photographs and narrative text, the *Empathy* campaign can be likened to *Scarred for Life* in its allusions to personal memories within a larger framework of shared female experiences. While the *Empathy* campaign incorporates identity politics of this sort into the mass media, *Scarred for Life* is, conversely, informed by Moffatt's experience of pop culture and television as an adolescent and her subsequent studies in visual communications at the Queensland College of Art.[19]

Of the Nike television advertisements directed at women, *If You Let Me Play* (1995) stands out for the disturbing effect that is produced when a number of young girls recite the reasons why they should be given the opportunity to play. The commercial is shot in a playground where the girls interrupt their play to speak directly to the camera, expressing a knowledge, beyond their years, of the consequences of not being allowed to play. For example, 'If you let me play, 1 will be 60% less likely to get breast cancer. 1 will suffer less

Birth Certificate, 1962 During the fight, her mother threw her birth certificate at her. This is how she found out her real father's name.

Tracey Moffatt

25. Tracey Moffatt, 'Birth Certificate, 1962', *Scarred for Life* (1994), Courtesy: Paul Morris Gallery, New York.

depression. If you let me play sports, I will be more likely to leave a man that beats me. If you let me play, I will be less likely to get pregnant before I want to.'[20] The language is adult rather than childlike and the words are spoken without expression, so that there is a discrepancy not only between the age of the girls, the context in which they are filmed and what is being said but also in the way that it is being said.

Again this piece has its counterpart in art. A similar play on adulthood and childhood and a similar discrepancy between speaker and spoken word are disconcertingly produced in Gillian Wearing's *10–16* and *2 into 1* (both 1997).

In both pieces, however, there is an actual transfer of voice. In *10–16*, adults deliver monologues, lip-syncing children's voices; in *2 into 1*, mothers and sons exchange voices. In the transferring of voices, the play between adulthood and childhood is made both uncanny and unnerving and Wearing's piece clearly departs from *If You Let Me Play* in this respect. While playing childhood off against adulthood, *10–16* and *2 into 1* also differ from *If You Let Me Play* through the use of personal and confessional voices. In *10–16*, for example, the speakers voice the secret thoughts and inner anguish of adolescents on topics such as tree-house hideouts, obesity and acne, the illicit consumption of alcohol and loathing for a parent's unorthodox lover.[21]

While Wearing's art has the potential to cut deeper than its counterpart in the *Empathy* campaign, she nevertheless produces work that a wider audience finds it easy to identify with.[22] Indeed, Wearing has had cause to complain about the unapproved appropriation of her work in advertising on a couple of occasions, most recently when the lip-syncing of *10–16* (now owned by Charles Saatchi) was emulated in an M&C Saatchi advertisement for SkyDigital. Before that, *Signs that say what you want them to say not signs that say what someone else wants you to say* (1992–1993) was closely imitated in a Volkswagen advertisement. As Michael Newman notes, Wearing's work 'has not only drawn from everyday life and the mass media, but also fed back into these spheres'. For Newman, the unselfconscious accessibility of Wearing's art fits the cultural ethos generated by New Labour which is not so much socialist as demotic, that is to say of the people. It is also idiomatic, speaking the language of a particular group or individual.[23] In effect, her work 'embodies very well both the strengths and weaknesses of a certain kind of savvy, street-aware art that wants to claim a place for itself in popular culture and engage with the everyday lives of "ordinary people".[24]

Importantly, Wearing's work operates in the realm of the vernacular and touches on the commonplace and, here, Wearing's art seems to gather some of the broader-based communicative powers of advertising which lend themselves to the production of an *art-engagé*, an art which, for Newman, produces a new politics for the arts, not explicitly political but nevertheless bearing a 'strong and sympathetic political impulse'.[25] To my mind, by far and away the most poignant of her works is *Prelude*, which was exhibited in the Tate Gallery's *Intelligence* exhibition and is closely related to the lip-sync works. This is one of the parts of a three-screen piece, *Drunks*, in which

participants were allowed their own voices, although the effect was still one of estrangement because of the slurring and pauses and slowing down caused by alcoholism. In *Prelude*, however, the speaker is not the person on screen but her twin sister whose voice is obviously out of sync, despite an uncannily convincing match between voice and face. Lindsay, who is the visible subject of the video had, in fact, died of sclerosis of the liver and the voice-over relates the twin sister's vivid description of hearing the news of the death and coming to terms with her grief. Obviously a piece such as *Prelude* goes far beyond the range of emotions and politics of identity dealt with in the Nike *Empathy* campaign, which did not seek to bring deeply troubling subject matter into advertising. However, as was seen in Chapter 4, this sort of subject matter has not been altogether excluded from contemporary advertising, and is to be found primarily in the work of Olivier Toscani, creative director of the Benetton *Shock of Reality* campaign.

In its involvement in cultural politics and its play with the politics of representation, Nike advertising may be said to have moved well into realms of critical practice that are normally the territory of non-commercial art forms. As in so many contemporary advertisements, references to the product and its material value are muted in favour of a brand image, which in this case attaches itself to values of another order that are concerned with the politics and problems of everyday life. As in so much contemporary art, what is at stake is the functionality of the self in a world that, despite notable advances, still denies agency and control to certain subcultures and social groups. What brings these advertisements closer to art is the fact that they are discursive and invite reflectivity and critical engagement from the viewer. Clear parallels and correspondences of this sort in contemporary art have been identified in the examples discussed above, but specific appropriations from artworks have not been a noticeable feature. The reason for this may be that the brand image is streetwise and savvy enough in itself not to need the extra capital that such borrowings would bring or perhaps that Nike advertising has already established itself on the back of another form of cultural capital by featuring celebrity sports figures such as Bo Jackson and Michael Jordan.

However, a more recent commercial – which has had the ad world and media critics buzzing – produced by Wieden+Kennedy's London branch, has pushed the connections with art even further, to the point of accusations of plagiarism.[26] The advertisement this time is a commercial

that Wieden+Kennedy made for the Honda Accord rather than Nike. (This is an interesting coincidence, since it was Jim Riswold's advertisement for Honda Scooters that first set Wieden+Kennedy on the track of 'alternative' approaches in 1984, creating the illusion of coming full circle.) *Cog* (*Honda: The Power of Dreams*) (2003; fig. 26) is a technical tour de force that sets up an ingenious chain reaction between Honda Accord car parts, set off by the rolling of a small cog. The movement of each part has a knock-on effect on the next and the two-minute sequence ends with the whole car being rolled

26. Wieden+Kennedy, *Cog (Honda: The Power of Dreams)*, TV/cinema commercial for Honda (2003). Courtesy: Weiden+Kennedy, London.

off a steel seesaw. The result is compelling, with many of the actions seeming almost impossible, for example the way that the windscreen wipers scuttle across the floor or the way that the tyres roll uphill. The advertisement has a clear attachment to Honda's brand ethos, 'The Power of Dreams', and it delivers psychological satisfaction in its tag line, 'Isn't it nice when things just... work?'

Yet above and beyond this more obvious associative content, *Cog* represents advertising of quite a different order, operating in a strange space between the sleight of hand of the magician and the kind of *trompe-l'oeil* illusionism

that is the traditional stock-in-trade of art. In fact, the advertisement was six months in the making, and it took six hundred and six shots to get it right without any use of trick photography.[27] While the initial pleasure is in the suspense created in waiting to see what happens as these objects set up a sequence of cause and effect, the longer-lasting pleasure is being able to marvel at the artifice that has gone into the placement of the parts, which the viewer is, of course, invited to do repeatedly. Indeed, the length of the commercial, coupled with its craftsmanship, indicates that it was produced with a view to holding the viewer through its aesthetic and entertainment value. A free DVD copy of the advertisement was distributed in conjunction with a full-page printed advertisement in *The Guardian* on 10 May 2003, working on the assumption that 'advertisers must now produce commercials that viewers will actively choose to watch.'[28] A recognition perhaps of the fact that people expect to find the texts and images of advertising pleasurable in their own right, despite their underlying attachment to a consumer product.

This same effect of suspense and of innocent pleasure in anticipating what might happen next is to be found in a very similar artwork by Swiss artists Peter Fischli and David Weiss, *The Way Things Go* (1987). The similarities are so great, in fact, that Fischli and Weiss have accused Wieden+Kennedy of plagiarism. As with *Cog*, it is the principle of a chain reaction that underpins the work and makes it compelling to watch. However, both the iconography and theme of the two works are notably different. *Cog* is ultimately a purposeful piece of work in which the craftsmanship involved in setting up the chain reaction combines with the engineered precision of the car parts to create the Accord as a symbol of mechanical excellence. *The Way Things Go*, on the other hand, is more surreal in effect and uses more disparate parts so that:

> the artists concoct a secret life for such common objects as string,
> soap, Styrofoam cups, rubber tires, plastic pails, balloons, and
> mattresses, which, in combination with fire, gas, and gravity, set off
> a domino-like chain reaction that unfurls in a seemingly endless and
> mesmerizing progression of controlled chaos.[29]

While quirky, there is also something rather apocalyptic about *The Way Things Go* – things are overturned, split, ignited and exploded and, as Arthur Danto

has noted, the work seems to have 'meanings that touch on waste, violence, pollution, exhaustion, and despair'.[30]

In the end, both *Cog* and *The Way Things Go* live up to their names. The commercial *Cog* does exactly what the cog in the commercial does: it mobilises a chain reaction that has a knock-on effect in a larger system of commodity production and distribution and it also mobilises a system of symbolic production and distribution. The chain reaction in *The Way Things Go* creates a seemingly insular microcosm of both the inevitability and the arbitrariness of life (although as a published artwork it does, of course, belong within a system of commodity production and distribution as well as a system of symbolic production and distribution).

That all of the advertisements discussed above have their counterparts in art is a token of the in-house attitudes towards creativity at Wieden+Kennedy. The agency has made a key contribution to the development of new approaches in advertising that have often mirrored attitudes and approaches found in contemporary art. The advertising for Nike in particular has pushed the boundaries between the two fields, giving a sense of agency to the consumer and contributing to his or her self-reflectivity.

Chapter 7

Celebrity

The Art of Branding
and the Branding of Art

In the 1990s, certain artists, most often patronised by Charles Saatchi and known popularly as the young British artists, became media fodder. Through the media, the work of these artists became a form of entertainment and they themselves became celebrities. It is clear by now that advertisements are frequently consumed for their added value as art or entertainment, where the experience is primarily aesthetic and/or a matter of amusement. This emphasis on the aesthetic and/or the entertaining in advertising is largely due to a surplus in production and a glut of competing, often interchangeable, products in the marketplace. This excess requires consumer choices to be made not so much on the basis of the use or exchange value of the product, but on the basis of its worth in terms of symbolic value or cultural capital.[1] I have already shown how the symbolic value of advertisements has been foregrounded in a number of cutting-edge approaches to contemporary advertising, resulting in advertisements that look, function and are consumed more like artworks than the promotional exercises that they nominally constitute. In this final chapter, however, I am more concerned with the correspondences between art and advertising in terms of the production and consumption of a particular

type of cultural capital, namely the ways in which cultural status is conferred and commanded through branding and celebrity.

Cultural capital may be defined as the accumulation of knowledge, competencies and goods that have been acquired in order to mark out a position in the rankings and hierarchies of society. Art, with its connotations of genius and exclusivity, has long been a signifier of this sort of capital, allowing those with a knowledge, appreciation or ownership of 'good' and 'great' works to foster a sense of distinction by proxy. Cultural capital has also, of course, been a key component of the subject matter and content of much traditional advertising, usually expressed in the idea that if you buy this product, you will acquire the associations that it brings, and such advertisements often rely on the distinction conferred by high culture by introducing clear references to it. For example, a reference to a famous artist or famous work of art would, by association, upgrade both the social status of the product and the social status of the consumer, an early instance of which is the appropriation of Sir John Everett Millais' *Bubbles* for the advertising of Pears soap in the 1870s.[2] However, as the boundaries between high and low have become more fluid and as social formations have become increasingly mobile and pluralistic, a shift in ethos has taken place, whereby cultural capital has come to be measured in terms of the ability to take up a knowing position in a far more expansive field of cultural capital that includes niche and subcultural groups. In this larger field, people are able to select from varying and variable arenas of cultural production in order to construct their social and cultural status and identity. In such a society, the cultural capital acquired through consumption is no longer necessarily a display of classic taste nor an issue of class or economic status. Instead, it is a matter of selecting and combining elements from the wide range of cultural products that are on offer with a view to gaining credibility within any number of social contexts (which may only be distantly related to the mainstream, although usually dependent on it for a foil).[3] This shift in ethos can also be expressed as a move away from a consumer culture that validates through the notion of material possession – 'to have is to be' – towards a consumer culture which is based on 'savoir-faire' in which 'self-identity is a kind of cultural resource, asset, or possession'.[4]

The ability to respond to and negotiate brands for the purposes of social positioning is not a simple matter but is highly dependent on media literacy and the acquisition of cultural knowledge or capital through the media. In

a seemingly endless circulation of signs, the media feed off real-life events and occurrences as much as people incorporate the representations provided by the media into their lives. Yet, rather than end up as a vicious circle, this situation allows for a degree of fluidity and flexibility, making it possible to acquire a greater range of cultural capital in and across a number of contexts and through exposure to a greater diversity of models. Some of these models and contexts, for a variety of reasons, not least the amount of media exposure involved, have greater command than others. The importance of the role played by the media in all of this extends to the ongoing relationship that has developed between the media and contemporary art, with many contemporary artists owing their 'brand identity' to the attention that the media, including advertising, has given them. With this in mind, I will now focus on a particularly widespread and influential preoccupation of the media: the cult of celebrity, which has had an extensive effect upon the production of cultural capital and which has had a significant role to play in the popularisation and commodification of art. Indeed, it could be argued that the cult of celebrity has become a key form of collective experience that both advertisers and artists now need to harness in order to connect effectively with the public and in order to sell their goods.

The celebrity base of contemporary culture has not only effected changes in the role of the artist and the way that certain artists are perceived; it has also influenced the way that products are branded and given status, with the effect that many leading brands have now attained a celebrity status and may even be said to play the role of a cultural 'hero'. Additionally, while many major brands have acquired 'star status' for the consumer, many artists have acquired brand status through their celebrity.[5] In fact, certain contemporary artists in the UK have become a branded products, known commonly as young British artists (yBas), which is (mistakenly) seen to represent a generic identity. This brand image has been fostered in the UK by the yBas identified with Charles Saatchi, but is also associated with the broader brand image of 'Cool Britannia' that was forged in the re-branding of Britain in the 1990s. In the USA, the branding of art has a longer and more fragmented history but the seeds for the artist as celebrity may be said to have been sown in the US by a number of artists who actively sought celebrity and developed what might be called 'brand personalities'. The process perhaps started with Jackson Pollock, but was most certainly established as a strategy for gaining

attention by Andy Warhol, who provided the model for the larger-than-life media personalities of artists such as Jeff Koons and Julian Schnabel.

While the preoccupation with celebrity status in advertising and art certainly exploits the consumer's narcissistic impulses by suggesting or mirroring an idealised self, it is nevertheless also indicative of a major shift that began in the 1980s in the way that the consumer's subjectivity is addressed.[6] This shift takes into account the postmodern consumer's ability to see themselves as heroes or heroines in what are often self-generated narratives as well as the need for models to assist in this process.[7] In advertising this has amounted to a revision of marketing strategies in the 1980s and 1990s and the development of emotional relationships where the consumer connects with a brand ethos or brand persona rather than a product and its functional characteristics. Within this paradigm, subjectivity is not addressed through emotional blackmail or through traditional methods of subliminal persuasion but by the styling of the brand in a way that assists the consumer in his or her performance in the consumer spectacle, if not life itself. In some cases this has been achieved in a very obvious way through the co-option of a celebrity role model, such as Michael Jordon for Nike advertising. In others, such as the Absolut Vodka campaigns to be discussed shortly, the brand has developed a 'celebrity image' through the personification of the product and its journeying through and participation in a number of status-bearing cultural scenarios.

The importance of brand identity to contemporary culture has been discussed by Naomi Klein in her recent, highly critical account of the conditions of labour that underpin the production of consumer goods. Here, Klein argues that brands have come to dominate the cultural landscape to such an extent that there is no such thing as an unbranded space. She speaks of the tagging of the environment with brands, likening it to Norman Mailer's description of graffiti art which, he claims, acts as an invasive weapon by imprinting the writer's presence on the scene.[8] For Klein, the relentless visibility of brands in the environment is the end effect of a drive to scale up branding, not only in the volume of branded items produced and consumed, but also in the development of 'transcendental' brand names whose messages are received as deep and meaningful.[9] Brands have been expanded by the incorporation of key cultural themes and ideas to the extent that the brand often becomes the culture itself rather than the sponsor or representative of cultural values and icons, undermining the notion of culture as something that exists apart

from commerce.[10] The approaches and attitudes adopted in Nike advertising discussed in Chapter 6 fit this bill and, indeed, Nike is frequently singled out by Klein as a transcendental brand that is exemplary for the cultural potency of its themes and iconography. It is also an excellent example of a brand that, in its key slogan 'just do it', encourages the consumer in the performance of their self-constructed narratives.

While there are a number of brands that have achieved the status of hero or celebrity, the Absolut Vodka campaigns qualify for closer examination because the personalities and work of a number of contemporary artists have been co-opted to assist in the building of a celebrity image for the brand.[11] This alignment with art can be read in two ways. On the one hand, it was a way of conferring high cultural capital on the product; on the other, it assisted in the promotion or celebrity of a number of artists. When TBWA, a top-ranking but fairly young agency, took on the account in 1980, Absolut, a Swedish vodka, had only just entered the American market and had not only to compete with other more established types of liquor such as scotch or brandy, but also had to be defined against the preconception that Russian vodka was somehow more *authentic* than Swedish vodka.[12] The aim, therefore, was to develop a brand identity that would give Absolut added value and make it stand out from the competition. Initially this was tackled in terms of the development of the distinctive bottle, with careful attention to detail and styling. The bottle was, for instance, given a short neck in the style of a medicine bottle and a slight buckle on the rear that, despite the bottle's mass production, gave it the appearance of being hand-blown and the impression of a unique identity. Moreover, a further sense of a 'true' or 'authentic' identity was created by inscribing the product details into the bottle itself rather than pasting it on as a paper label.[13] Having in effect been endowed with a personality through its distinctive appearance, the bottle moved on to become a centre-stage performer in a wide range of cultural settings and scenarios devised by the creatives at TBWA.

What followed was a set of trademark campaigns. The key device of representing the bottle as the main protagonist of the advertisement was initiated in *Absolut Perfection* (1980) and has remained the strategy of almost all of the campaigns that have followed. In this advertisement by Geoff Hayes and Graham Turner, the bottle is represented in the strait-laced style of a traditional studio shot, but topped by a halo and tagged by the strap-line,

'Absolut Perfection', spelt out in upper-case letters beneath the bottle. The advertisement was straight talking, a simple statement of the superior quality of the vodka. However, by giving the bottle a halo, its 'personality' was given particular characteristics, its perfection obviously being likened to that of a saint or holy person. The campaign went on to show the bottle in a number of guises, all of which underscored the superiority of Absolut. For instance, the bottle sprouted angel wings in *Absolut Heaven*, was presented as a blue ribbon winner in *Absolutely*, as alluring in *Absolut Attraction* and as a work of art in *Absolut Masterpiece*.[14] The campaign ran in this same format, using superlative character attributes for four years before a change was needed and various surrogates were brought in to take the place of the bottle. It is at this point that cultural associations began to be built in, in *Absolut Stardom*, for example, where the shape of the bottle is made up of what look like Broadway theatre lights or *Absolut Harmony*, which featured the whole of the New York Choral Society posing in the shape of the bottle in front of the Rockefeller Christmas tree. The most relevant for the fusion of art and advertising at this point is *Absolut Landmark*, in which the outline of the bottle actually became a work of land art, planted by land artist Stan Heard in a thirty-acre field outside of Lawrence in Kansas.[15]

In effect, the creatives at TBWA were feeling their way towards a complex brand image that would soon gather a host of character attributes and cultural references. Absolut was clearly developing an iconic status, emblematically masquerading in the next campaign, for example, as an identifying feature of a number of major cities.[16] The first in this campaign was *Absolut LA*, which showed a swimming pool in the shape of the bottle; others included *Absolut New Orleans*, where the keys of a trumpet assumed the bottle shape, and *Absolut DC*, in which the bottle, which had temporarily been eclipsed by a number of famous cultural signifiers, returned to the forefront only to be 'gagged' in the red tape that characterises America's seat of government, Washington, DC. However, the real conflation of product, celebrity and culture in Absolut advertising came with the *Absolut Art* campaign, the first in the series being *Absolut Warhol* (1985; fig. 27). *Absolut Warhol* was not only an (approved) appropriation of a Warhol painting and a form of celebrity endorsement, it also upped the ante by marrying the artist's fame and notoriety to a brand that was already well on the way to becoming a cultural icon.

27. Andy Warhol, *Absolut Warhol* (1985). Courtesy: Richard Lewis. Agency: TBWA, New York.

ABSOLUT WARHOL.

The circumstances surrounding Warhol's involvement with Absolut are recorded anecdotally as the outcome of a dinner conversation between the artist and Michael Roux, President of Carillon, the American import company that handles Absolut.[17] Roux had already met Warhol and had already commissioned an artwork from him that depicted another Carillon beverage, La Grande Passion. According to Roux, it was Warhol that suggested taking the Absolut bottle as a subject for a painting which seems, in its more decorative, hand-crafted illustrative style, to hark back to the commercial work that Warhol had produced as an illustrator in the 1950s. Warhol was paid $65,000 for the painting, and Roux immediately saw its potential for expanding Absolut's brand image and for developing the cultural capital of the advertising campaigns.[18]

The significance of Warhol for the conflation of art and advertising needs also to be seen in relation to a specifically American history of the relationship between the two arenas of practice, where the ideology of 'art for art's sake' was more vulnerable than in Western Europe. In effect, there was historically more ideological pressure to make socially relevant art in the USA, especially during the inter-war period when certain artists began to focus on the representation

of the American Scene and development of an American art that reflected the American Way.[19] The American Way was, of course, democratic, but was also bound up with an ideology of entrepreneurship, founded in turn on the notion of equal opportunity. This provided a major ideological impetus for American artists to reconcile the essentially elitist notion of high art with these democratising and commercial ideologies. A second impetus, of course, came from the impact of an ongoing commercial expansion, which needed an art to represent it that would go beyond the crude selling techniques of the nineteenth century, derived from the marketing of patent medicines, and that would, at the same time, provide a form of patronage for artists. As Michele H. Bogart has shown in her study of the relationship between art and advertising in America up to the 1960s, the issues raised by the commercialisation of the culture and its challenge to conventional notions of 'art for art's sake' in America were taken seriously by fine artists and commercial artists alike in the first half of the twentieth century, resulting in the emergence of artists who embraced advertising. As part of the Truth in Advertising movement, for example, Ernest Elmo Caulkins claimed art as 'the consummate means of communication' and saw it as a means of elevating advertising, which in turn democratised art and enlarged its spiritual mission. According to this model, artists could hold onto their integrity and feel that they were contributing to the spiritual enhancement of people's lives.[20] The notion that art could not only reach people more effectively through advertising but also build a shared public culture was shared by several other noteworthy American artists in the early mid-century, such as Stuart Davis, Maxwell Parrish and Rockwell Kent, although the latter was more sceptical about advertising's ability to work at a profound level.[21]

Yet by the 1950s, when Warhol began his practice as a commercial artist, the fine art advertisement had only achieved a presence in advertising in a few notable instances, such as the Pepsi Cola calendars of 1944–1948, which displayed reproductions of fairly conventional artworks or the Container Corporation of America's remarkable incorporation of modernism into advertising in the late 1930s.[22] The divide between advertising and art at this point had not narrowed as substantially as might have been expected, and two major factors contributed to the separation of the two fields of practice in the 1950s and 1960s. On the one hand, advertising was to cultivate its own creative strategies and develop creative autonomy through the innovations

brought by Bill Bernbach, the creative behind the highly playful and innovative Volkswagen Beetle campaigns of the 1960s.[23] On the other hand, another set of new approaches was introduced into advertising by the motivationalists, who sought to create a psychological dependency on the product rather than use it as a pretext for the dissemination of art (see Chapter 3). It should also be remembered that these changes in the practices of advertising took place in the face of a conscious effort to regain an autonomy for art on the part of influential members of the art world, represented by Clement Greenberg. Greenberg was a major champion of Abstract Expressionism and American Colour Field Painting, who drew a clear demarcation between high art and popular culture in his essay 'Avant-Garde and Kitsch', first published in 1939 but republished more influentially in 1960.[24]

In the light of these developments, Warhol can be seen as a special case in the history of the relationship between advertising and art in America because, as an artist, he worked against Greenberg's influential ethos and, as Bogart has noted, 'embraced the contradictions of being an artist in commerce'.[25] In effect, the embrace of popular culture and the mimicking of the imagery and processes of mass production in Warhol's art provided a clear challenge to the boundaries between high and low that Greenberg and others were trying so hard to fix, reconciling the tensions and narrowing the divide between the two. Moreover, working under the aegis of Pop Art, Warhol, of course, also had an influence on the narrowing of the gap between high and low in the UK.

By the early 1960s, Warhol had moved from decorative illustration work, which exhibited all of the technical skill traditionally associated with fine-art practice, to an art practice which appeared far closer to commercial than to fine art. As an illustrator, Warhol would have fitted into a well-established sector in the visual arts that valued traditional approaches and that included top-league illustrators such as Norman Rockwell. This sector also included a growing constituency of amateurs which, at one time, included Warhol himself. He claimed to have learnt to draw from Jon Gnagy's amateur classes, *You are an Artist/Draw With Me and Learn To Draw*, sponsored by Gulf Oil and broadcast on NBC television from 1946 to 1971.[26] However, in moving out of illustration into painting, Warhol was to position himself at the head of the vernacular tradition of the American Scene painters such as Stuart Davis and Edward Hopper, except that Warhol was to develop a more contemporary style, based on images of American subject matter provided by the media,

including advertising and packaging. Indeed, the iconic media-derived images of Marilyn Monroe, Jackie Onassis or Elvis Presley might be seen as having originally functioned as a form of packaging, as commonplace in their original contexts as the *Brillo Box* or the *Green Coca Cola Bottles* of 1962. Despite, or perhaps because of, their origins in the mass media, these works nevertheless expressed the idea of the American Way. Indeed, Warhol famously stated that America's greatness lay in the democratisation brought by mass consumption: 'A Coke is a Coke and no amount of money can get you a better Coke than the one the bum on the corner is drinking. All the Cokes are the same and all the Cokes are good.'[27]

Warhol's art initially thrived on the fame or renown of his subject matter, whether a commercial brand name or the 'brand' image of a celebrity. As Kynaston McShine has observed, Warhol's preoccupation with celebrity precedes the development of his mature 'trademark' style, for instance, in his 1950s drawings of celebrity shoes and in his crush on Truman Capote, whom he also drew, even before he met him.[28] Moreover, it appears that it was not enough for Warhol to represent the American Way as it had developed in consumerism, celebrity and the media, he also needed to live the dream and follow the rags-to-riches trope frequently personified by American celebrities. By the mid to late 1960s, the incorporation of celebrity into his work had brought just this sort of reward and had helped turn Warhol himself into a celebrity. The process was of course also assisted by the popularity of his studio, The Factory, which by the mid 1960s had become a notorious hangout for the rich and famous, from The Velvet Underground to figures such as Bobby Kennedy and Truman Capote. Warhol's fame expanded even further in 1968, when he made headlines after being shot and grievously wounded by a feminist writer, Valerie Solanas. This incident, and the high-profile press coverage it received, augmented and confirmed Warhol's celebrity status, forcing him to exhibit archetypal celebrity behaviour by becoming more reclusive and obsessed with security and by keeping his social intercourse within the confines of exclusive celebrity hangouts such as Studio 54. This 'enforced' retreat from the limelight also led to his firm embrace of the commercialisation of art. Warhol began to treat his studio, The Factory, more literally as a production line dedicated to what he referred to as 'Business Art'.[29]

By the time he was commissioned to do the painting that became the source for the *Absolut Warhol* advertisement in 1985, Warhol had become

both a celebrity artist and a successful businessman and it would have been hard to find a more suitable candidate for the fusion of art and commerce that was to be Absolut's new advertising ploy. The economic and political climate was also ripe for this sort of collaboration between art and advertising. The art market had picked up due to the monetarist policies of the Reagan administration and figurative painting enjoyed a timely renaissance. Economic prosperity had also facilitated the emergence of the sort of performative consumer previously discussed, a consumer who was able to make a display of cultural capital through the acquisition of upmarket branded goods, and these included works of art.[30] As Richard Lewis recalls, Absolut Vodka had become a fashionable brand that, through association with Warhol, was able to extend its reach and attract 'society people'. These included 'artists, Hollywood, the rich, the famous', who would be led to Absolut by Warhol as a sort of prophet.[31] That Warhol was already mixing with the rich and famous at Studio 54 was, no doubt, critical here and the marketing ploy was clear. The brand image was to rise from that of a fashionable product to that of a product with celebrity status and Warhol's art was obviously seen as part of the celebrity culture that could be tapped in order to achieve this goal.[32]

Warhol's role in relation to the *Absolut Art* campaign was not only that of a forerunner to the other artists employed on it but also that of a go-between, selecting and approaching other artists to take part. The first of these was the New York subway artist Keith Haring, who had developed a clear graphic signature style based on anonymous, one-dimensional outline figures and who, in addition to the public attention he was generating through his subway station works, was achieving recognition in the New York art world. The artwork produced by Haring for Absolut showed an outline of the upper two thirds of the bottle set against a golden yellow background, the top half of which radiated with graphically rendered rays of light or energy while the bottom half was filled with a crowd of figures with arms uplifted in appreciation/adulation (fig. 28). The work was 'signed' in the top right corner '© K. Haring 86', calling attention to its authentic artistic origins and counteracting the effect of its mass reproduction as an advertisement. And, lest any misapprehension should arise concerning the status of this advertisement as art, it was unveiled at a launch party at the influential Whitney Museum of American Art in New York in November 1986.[33] This choice of venue sits oddly alongside Haring's art practice, which not only

28. Keith Haring, *Absolut
Haring* (1986). Courtesy:
Richard Lewis. Agency: TBWA,
New York.

involved working in the public spaces of the subway but also extended to
the production of repeatable images on buttons and posters which were
handed out as if part of a promotional campaign. Haring also sold trademark
merchandise in the Pop Shop, which he opened in downtown New York in
1986, the same year as the *Absolut Haring* advertisement was launched.[34]
Over the next two years, several other high-profile artists were brought in to
produce advertisements in their names, including Kenny Scharf, who asked
unsuccessfully for a higher fee than the $65,000 paid to Warhol and who,
like Warhol and Haring, was also part of the cutting-edge New York East
Village art scene. For me, one of the most notable and evocative of these
advertisements was *Absolut Ruscha*, created by ex-West Coast Pop artist and
wordsmith, Ed Ruscha, which showed the shadowy image of a wolf howling
at the moon. Ruscha, incidentally, has gone down as the only Absolut artist
to refuse to renew his contract – he was allegedly 'just tired of seeing the ad
every time he picks up a magazine'.[35]

The synthesis of art and advertising in the *Absolut Art* campaign has
provided another, quite different example of a 'transcendental' brand name.

In co-opting art, Absolut advertising has tapped into the ethos of exclusivity and savviness that contemporary fine art carries and, moreover, has become a regular adjunct to the circulation of knowledge about contemporary art. As well as appearing in selected up-market society and general-interest magazines, the *Absolut Art* advertisements were placed on the inside back cover of leading art magazines *Artforum* and *Art in America*, month by month, without fail, from November 1988 to December 2002, although since then their placement has become more sporadic.[36] A consistent presence such as this in journals key to the recognition, understanding and interpretation of contemporary art blurred the boundaries between art and advertising.[37] Almost every other advertisement in these magazines was for an art exhibition, an art event or, occasionally, for art courses or art materials. These advertisements were usually rendered in one of two styles, the purely typographic 'tombstone' style, which speaks for itself, or a version of this in which the copy is accompanied by the reproduction of a representative artwork.[38] Although undeniably more creative and stylish, the format of the *Absolut Art* advertisements did not, in effect, differ too much from the illustrated version of this standard style. They were certainly not visibly out of place with the editorial content of the journals, effectively managing to bridge both types of content. As can be deduced from the above discussion of *Absolut Haring*, the *Absolut Art* advertisements are able to claim a dual status, both as works of advertising and works of art, and as such were easily integrated into a magazine package which serves not only to inform and comment on art but to house publicity information about where and when to find it.

The conflation of art and advertising in the context of the art magazine was to become even more complicated when, in 1988–1999, Jeff Koons constructed his own exhibition advertisements and placed them in *Arts Magazine*, *Artforum*, *Art in America* and *Flash Art*. Rather than represent his work, Koons decided to place himself centre stage, so that it is Koons in performative mode that is the subject of these advertisements, providing a clear demonstration of Koons's desire to be appreciated as an art star as much as an artist. Having said this, the advertisements also come across as a tongue-in-cheek expression of this desire, parodying the artist as celebrity performer and satirising his own image and reputation. For example, the advertisement that was placed in *Flash Art* shows Koons cheek to jowl with two quite animated pigs, both caught in what is known in portraiture as a

'speaking likeness'. Here, Koons picks up on his trademark theme of banality and uses it to pre-empt the popular criticism that he knew he would receive:

> I was there with two Pigs – a big one and a little one – so it was like breeding banality. I wanted to debase myself and call myself a pig before the viewer had a chance to, so that they would only think more of me.[39]

A second advertisement, placed in *Artforum* (fig. 29), shows Koons as a primary-school teacher, facing a highly engaged class of children, his back to the blackboard that displays the slogans, 'EXPLOIT THE MASSES' and 'BANALITY AS SAVIOUR'. In this instance, Koons claims to show himself indoctrinating very young children and exploiting their vulnerability with the intent to outrage *Artforum* readers, 'the people that hate me', in order to make them hate him even more, 'because I was taking away their future. I was getting at their future, the youth of tomorrow.'[40] Here, Koons is at once playing the petulant child and poking fun at the paranoid reactions that his work has provoked concerning the debasement of art. The advertisement also mimics or satirises Joseph Beuys' famous lecture tours, which relied to a large extent on teaching through the blackboard. Beuys had made himself into an artist of renown through his charismatic appearances in a lecture tour of America, successfully building an enticing mythology of shamanism

29. Jeff Koons, *Art Magazine Ads*, ad for *Artforum* (1989). Lithograph portfolio of four, 45 x 60 in (114 x 95 cm). Courtesy: Sonnabend Gallery, New York.

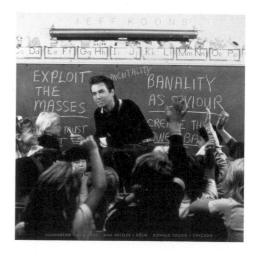

around himself that was equally matched by his skills as a showman. With his anti-capitalist, anti-materialist messages, which won widespread approval for their social and political integrity, Beuys, of course, forms an ironic contrast to Koons.

The advertisements which appeared in *Arts Magazine* and *Art in America* were of a slightly different order. In these, Koons seems to give himself over to the popular view of him as a lightweight playboy figure and, indeed, to be playing up to it. In one, he is apparently posing in front of a pool in an exotic location, wearing an initialled bathrobe and, in the other, he is seen in what seems to be a country setting accompanied, incongruously, by two glamour models, one bringing him an iced cake and one, bizarrely, holding the chin of a braying miniature Shetland pony. Kirk Varnedoe and Adam Gopnik have commented that these advertisements did not really look like advertisements at all, appearing to be 'amateurish tableaux of the artist with his objects, accompanied by models in bikinis', suggesting 'a thirteen-year-old's ideas of advertising'.[41] Yet this is entirely in keeping with the disingenuousness of Koons's work as a whole, in which objects and personalities are reproduced in a seemingly naive and unaffected manner, despite the sophistication of their materials and methods of production. As with many of Koons's works, the advertisements exude irony, presenting but also caricaturing Koons as an art star. In this, Koons seems to agree with a general perception of himself as a second-generation Warhol, an ultra-cool celebrity artist who either makes icons out of ready-made banal products of popular culture, such as vacuum cleaners, or makes representations of ready-made icons of popular culture such as the Pink Panther or Michael Jackson.[42] Like Warhol, Koons acquired a celebrity persona in several ways through the shock of the banal, through the representation of celebrities and through the construction of a distinctive personality and image; unlike Warhol, however, Koons's works do not appear to have a tragic side. Again like Warhol, Koons supported the notion of art as enterprise, and to this end Koons became adept at marketing himself as much as his work, attracting media attention and creating a persona that has been described as a 'well spoken, good-looking, sex symbol media superstar'.[43] But then, unlike Warhol, Koons enjoyed the limelight and rather than retreating from it, he inverted Warhol's position. Instead of being an alienated artist who mimics commodity relations, Koons himself became an authentic reified creation, a 'Superstar'.[44]

Koons's series *Made in Heaven* (1989; fig. 30), which serves ostensibly as a testament to Koons's sexual relationship with his (now ex-)wife – Italian porn star and politician la Cicciolina (Ilona Staller) – is also obviously connected to the realm of advertising. These are painted works that emulate billboards and again show Koons performing for the camera/viewer. This is most evident in the piece that actually became a billboard poster, *MADE IN HEAVEN*, which is constructed to look like a soft-porn movie advertisement, 'Starring Jeff Koons and Cicciolina'. Tellingly, this image shows Koons not fully engaging in the act but looking out, making eye contact with the viewer while la Cicciolina swoons in ecstasy, caught inside the internal dynamics of the representation. As with the *Art in America* advertisement that showed Koons with the two glamour models, there seems to be a play here on the use of sex in advertising, a crude mimicry of traditional sexual ploys that both

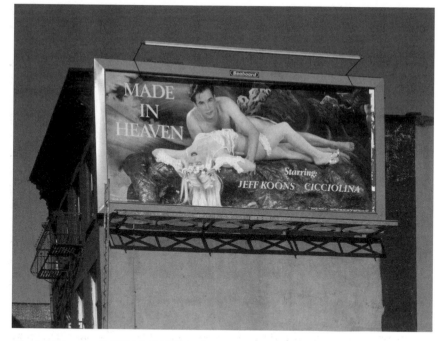

30. Jeff Koons, *MADE IN HEAVEN – Starring Jeff Koons & Cicciolina* (1989). Lithographed billboard, 125 x 272 in (318 x 691 cm). Courtesy: Sonnabend Gallery, New York.

exposes them and renders them transparent. This series caused a stir because of the explicit pornographic content of some of the works. I would argue that it equally signified what Jean Baudrillard sees as the pornography of information and communication, whereby:

> It is no longer the obscenity of the hidden, the repressed, the obscure, but that of the visible, the more than visible; it is the obscenity of that which no longer contains a secret and is entirely soluble in information and communication.[45]

While Koons's appropriation of advertising formats in *Made in Heaven* plays on the connection between advertising and seduction in the interest of Koons's ironic self-aggrandisement, it also signals an awareness of the often seductive nature of advertising in general, the consumption of which has become an uncritical activity for many consumers. Indeed, before embarking on *Made in Heaven*, Koons had already raised these issues by addressing advertising directly as part of the subject matter in an earlier body of work, *Luxury and Degradation* (1986). The central theme of this group of works is the consumption of alcohol, which Koons represents by simulating forms of advertising which have traditionally promoted hard liquor, as well as with reproductions of stainless-steel casts of the sort of decanters that people use to add symbolic trappings to their drinks. Koons's paintings of advertisements were super-realist renderings based on actual billboard advertisements and, like their accompanying decanters, were representative of the middle classes and their tokens of cultural capital.[46] *Aqui Barcardi*, for instance, is predicated on a game of dominos that is played by two pairs of well-manicured hands, the woman's sporting a classy diamond ring. *'I could go for something Gordon's'* depicts an elegant, classically 1980s couple on a beach in which the woman is engaged in *plein air* easel painting. *The Empire State of Scotch, Dewars* shows the whiskey bottle standing tall in a skyline of bottles, but also brings in an association with power through the connotations of empire. In *Stay in Tonight*, the message is almost purely sensual, suggestively superimposing the words onto an image of a flow of golden-toned liquid. The advertisements reproduced in these paintings were not only super-real, they also provided ready-made representative examples of the mainstream genre of Capitalist Realism discussed in Chapter 3.

In effect, Koons's choice of advertising images for *Luxury and Degradation* was both obvious and astute and, together with the decanters, seemed to deliver a critique of traditional advertising that supports Baudrillard's censorious view of the obscene promiscuity and proliferation of consumer signs. In reconfiguring the advertisements in paint and recontextualising them as works of art, Koons rescued them from their everyday circulation and held them up at a critical distance for new scrutiny – as Marcus Harvey and Sarah Lucas were to do with their appropriations from tabloid journalism. His keen eye, for instance, spotted a highly questionable advertisement for Hennessy Brandy, *Hennessy, The Civilized Way to Lay Down the Law*, which reads as a list of some of the most blatant and, in some instances, reprehensible tropes of traditional middle-class advertising. Upward mobility is signified through the young professionals who are taking a break from the man's study/work to enjoy a glass of Hennessy on ice. Prosperity and happiness are signified by the comfortable look of the big-city apartment and by the obvious well-being of the two smiling protagonists, who are bathed in a Rockwellesque benign light. A link between Hennessy and sex is implied by the bed that sits just off centre, radiating the golden light, which both bathes the couple in a pool of contentment and illuminates the bottle and poured glass in the bottom right-hand corner. Finally, as part of its evocation of middle-class gratification, the advertisement also seems to deliver an imperialist or neo-colonialist message – 'the civilised way' may be interpreted as implying doing things the Euro-American way. The general effect of these super-real paintings is not only to augment the hyperrealism behind this sort of representation to breaking point, but also to expose the questionable ideology behind such convincingly stated (Capitalist) Realist advertisements.

Ultimately, what emerged from the attitudes struck by artists such as Warhol and Koons was a model for the artist as celebrity. This model was readily taken up by some of the leading figures in the next generation of artists but, this time, the cultivation of a celebrity brand image occurred most notoriously in Tony Blair's Britain rather than Ronald Reagan's America. Although already germinating in the early to mid 1990s, this type of image-building was positively fostered in the climate created around the notion of Creative Britain, or as the phenomenon is more popularly known, Cool Britannia. That the notion of Creative Britain was a branding exercise in itself has been noted by Kate Tregaskis, who has mapped out the stages of the

Government's interest in and support for the creative industries. The 1997 Demos report, *Britain: Renewing our Identity*, for example, proposed that 'Britain plc' be redesigned and that Britain should be promoted as a 'Creative Island'.[47] The then Minister for Culture, Chris Smith, was to be instrumental in building this sort of agenda for the arts in the late 1990s, by recognising the potential for economic expansion through the creative industries and the importance of creativity as a transferable vocational skill. Significantly, this fostering of creativity involved an explicit appeal to the narcissism of Britain's creative producers:

> Imagine how good it feels to use your creativity, your skills and talent to produce a film, for example, or to edit a magazine. Imagine how good it feels to hear people cheering your performance on stage, or to see people wearing clothes that you designed. Are you there? And does it feel good?[48]

Damien Hirst and Tracey Emin have become the most infamous representatives of this new generation of artist-celebrities. Both have achieved lasting status as media stars and both have been key to the branding of British art in the 1990s and the consequent recognition of contemporary art as cultural capital. In both cases, a brand image was initially built on the tabloid-friendly nature of their work which, along with that of Sarah Lucas and Marcus Harvey, was easily puffed up into sensationalist news. In addition, Hirst and Emin both showed entrepreneurial and self-promotional talent of their own in the early stages of their careers, partly following the lead established by the artists Gilbert and George, who took pains to become publicly visible through live performances that intruded on other events both inside and outside of the confines of the art world in the early years of their career.[49] However, it was above all the tendency that Hirst and Emin have to behave publicly in a way that colludes with and plays up to media hype that ensured their impact on the public consciousness. In behaving outrageously in public, they may be said to have turned themselves, as much as their art, into commodities for public consumption, even if often negatively as 'folk devils' or notorious mischief-makers.[50] Both Hirst and Emin have reputations for 'bad-boy' or 'bad-girl' behaviour and for living it up socially in a manner more frequently associated with pop and film celebrities.[51]

Hirst exhibited transgressive behaviour when he was as young as sixteen by having himself photographed jokingly in a sort of double portrait with the severed head of a male corpse (fig. 31). Since gaining success and notoriety through his subject matter and Saatchi's patronage, he has often led a publicly dissolute lifestyle of drink and drugs (he is a regular at Britain's fashionable celebrity watering place, the Groucho Club). He has shown a propensity for indecently exhibiting his body, greeting Norman Rosenthal, Exhibitions Secretary at the Royal Academy, by playing the piano naked and upsetting a fellow diner in a Dublin Restaurant by inserting a chicken bone under the foreskin of his penis.[52]

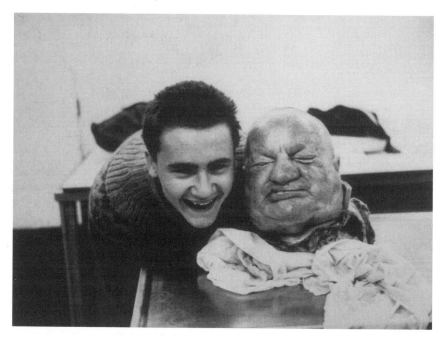

31. *Damien Hirst with Dead Head* (1991). Edition 15/15. Black and white photograph on aluminium, 22 1/2 x 30 in. © the artist. Courtesy: Jay Jopling/White Cube, London.

Emin also carried a reputation for drunkenness in the late 1990s at a time when she was receiving sponsorship from Beck's Beers and in receipt of free gin from Bombay Sapphire for appearing in their advertisements. Of the two, Emin is more television friendly, especially after having made a rather

glorious spectacle of herself on the Channel 4 post-Turner Prize discussion in 1997. She has subsequently been interviewed by Melvin Bragg and appeared on *Have I Got News For You*. Indeed, both Hirst and Emin seem to conform to a particular type of celebrity based on notoriety, which has precursors in the arts with personalities such as those of Lord Byron and Oscar Wilde. As Chris Rojek has pointed out, 'the figure of notoriety possesses colour, instant cachet, and may even, in some circles, be invested with heroism for daring to release the emotions of blocked aggression and sexuality that civilisation seeks to repress.'[53] Here, notoriety is seen as the exhibitionistic and conspicuous transgression of ordinary moral conduct and as something that taps into 'the surplus material and symbolic value that is inherent in the economic and moral frameworks governing everyday life'.[54] This suggests that celebrity operates in exactly the sort of consumerist framework that I described at the start of this chapter, in which surplus is organised as the sort of cultural capital that can be mobilised in the interests of performativity and savoir-faire. In turning themselves into media commodities, artists such as Hirst and Emin become cultural icons that speak to bohemianism and transgression and appeal to the rebellious side of the consumer while, at the same time, bringing a sense of cultural know-how for those who identify with them and the radical nature of their work.

From what has been said so far, it seems that alcohol has played a significant part in the cluster of relationships that involve celebrity, art and advertising, signalled initially by the *Absolut Art* campaigns and evident in promotional work done for alcoholic drinks by Hirst and Emin as well as in their legendary drunkenness. This seems to suggest some sort of relationship between art and alcohol as commodities that may ultimately lie in the compatibility of the pleasures that are offered, particularly in the removal of inhibition that alcohol facilitates. Certainly, a historical relationship can be traced between artists, musicians and writers and drink (or drugs for that matter), as was the case with Jackson Pollock and Dylan Thomas, for example. Whatever the reason, the promoters of drinks such as Absolut, Bombay Sapphire, Beck's and Stella Artois have all seen fit either to use art to endorse their products or to visibly sponsor art. Perhaps this is also an effect of the reconfiguration of Britain's identity and the development of the notion of creative industries which was to shift the funding base further in the direction of the commercial sector and to encourage commercial sponsorship rather than Government subsidy. Of the

sponsorship offered by the drinks industry, a particularly influential relationship is that of the involvement of Beck's Beer in the sponsorship and patronage of contemporary British art. Beck's, a German beer, began to develop a presence on the British art scene in 1985, when they sponsored *German Art in the Twentieth Century* at the Royal Academy and, shortly afterwards, Gilbert and George's retrospective at the Hayward Gallery (1987).[55] Since then Beck's have maintained a presence in British contemporary art through the sponsorship of drinks at exhibition openings throughout the country, a strategy advised by their advertising agency, Collett, Dickenson Pearce & Partners, according to which the product would be 'seeded' in 'the most influential bars and the hippest parties'.[56]

As importantly, Beck's have also developed a marketing strategy around the bottle, commissioning high-profile artists to create labels, the first of which was a limited edition of 2,000 by Gilbert and George for their 1987 exhibition at the Hayward. Emin again figures here, having posed in the bath for a label at the time of the 1999 Turner Prize, although other labels have been commissioned from well-known artists whose names are not usually associated with celebrity or brand imaging in the way that Emin is. These include Richard Long, Bruce McClean and Rachael Whiteread.[57] Whiteread did, of course, suffer uninvited sensationalist publicity when she won the 1993 Turner Prize with *House*. This work was built with the support of event/public arts commissioning agency Artangel and financed by Beck's (Whiteread also produced a label with a photograph of *House* for Beck's). As circumstances had it, *House* not only gained a public presence through the media coverage given to the Turner Prize but also gathered notoriety through a counter gesture by the K Foundation, who essentially blackmailed Whiteread into accepting their equivalent award of £40,000 for the worst body of art made that year on forfeit of burning the money if she did not accept.[58]

Since 2000, however, Beck's have turned their attention to supporting emerging talent in the art world through the annual Beck's Futures competition, held in partnership with the ICA. This move has established a clear position for Beck's in the contemporary art world, carving out a space for the company's patronage alongside that of the Turner Prize and of Charles Saatchi. Since its foundation in 1946, the ICA has maintained a reputation as a stylish and savvy venue for contemporary arts and has remained a leading showcase for artists from all over the world. In aligning themselves with

the ICA, Beck's ensured a credible presence in the contemporary art world as well as an advertising presence at the ICA's busy central London bar and café, which is frequented by the sort of consumers that would be considered market leaders. This is not to discredit the work done by Beck's Futures, which is judged by a panel of professionals from the art world and has filled a gap in the sponsorship and patronage of new talent that 'ensures that the medium it sponsors continues to grow and prosper'.[59] What it does point to, however, is the difficulties facing new artists in gaining a foothold in the art world and the fact that premier showcasing of emerging talent only seems possible when advertising meets art and business stumps up the money, a situation which, in the end, might well have encouraged a conflation of art and commodification and significantly contributed to the commodification of art.

Consumerism and consumer lifestyle have, moreover, figured in the work of several contemporary practitioners: for example, Swiss artist Sylvie Fleurie makes consumer desire the subject matter of much of her work, such as *Pleasures* (1996; referred to in Chapter 3); and German artist Olaf Nicolai's book, *Stilleben*, displays images of architectural spaces, 'fashionable' people and designer objects in a way that foregrounds issues of lifestyle and market forces.[60] Such works, while not stridently critical of consumerism, recognise its hold on the culture and set up a discursiveness around its forms and practices. However, the portrayal of art itself as a branded product falls to Swetlana Heger, who has effected a synthesis of the construction of brand identity and artistic production in her ongoing project, *Playtime*, begun in 1999. Essentially, Heger places herself at the centre of the artwork as the personification of a well-known brand such as Adidas, Levi or Hermes on the grounds that avant-garde art has become a matter of economics and the artist a branded commodity. In order to achieve this personification, Heger has herself photographed wearing costume and in scenes which display the attributes of the brand. In conflating herself with the brand but at the same time marking herself out as a unique work of art, Heger embodies the contradictions of consumerism, whereby the consumers simultaneously define themselves socially through brands and, paradoxically, seek to mark themselves out from the crowd by buying into the distinctiveness of a brand.[61]

Contemporary art, then, has become a recognised sign of cultural capital in the last twenty years or so (although, of course, it does not command

the same level of reverence as historically validated 'masterpieces'). Part of this recognition is due to the star status achieved by certain artists through the media, which has added to the cachet of their artworks. Through their frequently notorious and transgressive behaviour, artists such as Hirst and Emin have turned themselves into a form of publicity, which acts as an advertisement for their art. The sort of non-conformist behaviour that these artists have exhibited corresponds to a deeply embedded, romanticised view of the artist as a sort of outlaw, the history of which goes back at least as far as Michelangelo, followed by other legendary examples such as Van Gogh and Gauguin in the nineteenth century and Jackson Pollock in the twentieth. Indeed, it is often these names that are best known to people outside of the art world, suggesting that the artist's renown is valued at least as much as the work. Functioning in the context of an advanced consumer society, artists such as Hirst and Emin not only feed the ongoing appetite for this sort of myth-making, but also provide models for the postmodern consumer's desire to explore new tastes and possibilities in the shaping of their own 'self-generated narratives'.

In this scenario, the public identities of artists, along with their artworks, join a myriad flow of consumer signs that circulate in popular culture (not least the signs of advertising), functioning almost as brand identities among numerous other brand identities. Art and artists can be said to have become part of the spectacle of consumerism: part of a simulated world of dreams, fantasies and desires rather than the 'real' world. However, it would be a mistake to think that this world of spectacle and simulation is an autonomous realm. The boundaries between what is real and what is fiction are notoriously permeable and people tend to negotiate their own relationship between the two. Moreover, the fact that contemporary artists develop brand images and advertise themselves through their behaviour, which is then talked up by the media, does not necessarily result in a devaluing of their art. That the media spectacle can influence the 'real' to the good and be of benefit to art is perhaps best demonstrated by the huge increase in exhibition attendance for contemporary art, showing it to have become considerably less of an elitist product, even if only a relatively small number of people can actually afford to buy it.

Conclusion

The relationship between art and advertising now seems richer and more complex than ever. My account of this relationship has been wide ranging, showing a multifaceted relationship that operates in various ways, including shared practices, appropriations, exchanges, encounters, overlaps, crossovers and convergences. However, in mapping out this complexity, I do not want to create the impression that advertising and art are by any means one and the same thing or to gloss over fundamental differences. There are essential distinctions between the two fields of practice and we need to establish a sense of the limits of what I have shown to be a highly elastic relationship. It is neither the differences not the similarities that count, but the fluidity that has begun to take hold between different arenas of cultural production, of which the relationship between art and advertising is a clear example. In my opinion, this cultural fluidity, which has been talked about for some time, is not only a means of enriching the culture – it also has the potential to be of vital importance for the continued dismantling of deeply embedded social hierarchies.

To begin with, there are still clear differences in the way that each arena of practice is perceived with art, in particular, surviving as a cherished cultural category. One reason for this is that its stars, and the work they produce, are firmly entrenched in an economy that needs to maintain the integrity of art

as a separate cultural arena. For its part, and in spite of arguments to the contrary that emphasise the purely textual pleasures that advertising affords, advertising is still by and large seen in terms of its mission to persuade or to create wants and desires in a way that prompts the purchase of a product. Indeed, a classificatory divide between art and advertising may even be seen to work to the advantage of both when, for example, advertising calls upon art to give status to a product or when art calls upon the forms and spaces of advertising to communicate in a framework that is more immediately understood by the public at large. That the classifications nevertheless hold firm is perhaps most evident in the production and display of billboard art, which, despite its often extremely close affinity with advertising, still retains a special status as art, constituting rather than representing a product.

Clear differences also apply to the conditions of production and reception that surround both sets of practice. For example, it is obvious that, unless dealing with a highly prescriptive commission, artists have far more control over the content of their work, no matter how much that control may be affected when the work begins to circulate in circumstances that take it beyond the artists' jurisdiction. Advertising, on the other hand, is produced to meet a brief and serve a designated purpose and, from that point of view, usually far more compromised in the initial stages of production. Accordingly, art is seen as the more 'authentic' of the two, an assumption that is supported by the fact that artworks are more often authored, as opposed to advertising where it is difficult to track down the individuals that actually create the works. The rare exceptions, as might be expected, are those advertising creatives who have moved away from functionalist approaches and have adopted similar themes and approaches to those found in art (Oliviero Toscani and Tony Kaye, for example). The issues of authenticity and authorship are intimately connected and their association with art, rather than advertising, endorses the aura of uniqueness and preciousness artworks carry by dint of their initial circumstances of production.

Furthermore, one of the implications to be drawn from the closing discussion in the last chapter is that the distinction between art and advertising is partly compounded by the way that art is received on a wider scale through the media and by the fact that the same work of art can now play both an exclusive and a popular role in the culture. Yet, despite the fact that reproductions of artworks and advertisements circulate in the

same arena of consumer spectacle, there is still a fundamental difference between the photographic or digital reproduction of a work of art and an advertisement. Reproductions of artworks still retain the work as the referent and, with the suspension of disbelief, are treated as surrogates for the real thing. Advertisements, on the other hand, are not serialised substitutes for a single original work, but may essentially be said to be many versions of the 'original' work, which is mass produced rather than mass reproduced. This volume of production distinguishes advertisements from the uniqueness conventionally associated with works of art. Those works could, nevertheless, be said to provide a more authentic viewing experience than reproductions of works of art, since they address the viewer directly in the context and form intended. To complicate matters even further, it can also be said that advertisements, although not unique works of art, still carry an aura of a sort since the role of the advertisement is to suggest that the product it promotes is both special and unique among others of its kind. As a corollary to this, it is also worth considering a distinction between art and advertising in relation to their status as commodities. While the logic of consumer culture is played out in both cases and while both are implicated in the reign of the commodity in that culture, the work of art is most often produced as a commodity to be bought and sold and is an integral part of the transaction. The advertisement is not a commodity in the same sense and people do not usually go out and buy the advertisements they consume. Like the work of art, the advertisement can function aesthetically, but it is given freely and in great quantities and is not as a rule owned or considered a piece of private property.

From this vantage point, consumer advertising seems to qualify as a more socially grounded art, although it rarely carries the same sort of social and political messages of the *art-engagé* of the early twentieth-century avant-garde. This is left to charity advertising, social cause advertising and political advertising. The same can be said for contemporary art, where the political work has been left to activists or interventionists, and the majority of artists have engaged with a wider audience only by adopting the familiar forms and subject matter of the mass media or by gaining a presence and influence through the mass media. To a large extent then, the idea of a socially engaged art that is heroically capable of changing the world has been lost to the early years of the twenty-first century. Nevertheless, as my research has revealed, much of the cutting-edge work that is being produced in both

fields has a critical purchase and has the potential to make real shifts in the preconceptions of the viewer, often through one form or another of subversion or defamiliarisation. Moreover, an exciting ethos of fluidity and exchange has now become an established feature of cultural production which, rather than serving to reduce culture to its most common denominator, has the potential to create a way forward that really could transcend the notions of 'high' and 'low', to enrich people's lives in new ways. What is required for this to be achieved across the board in society is not just changes in practice that break down cultural hierarchies and cross-cultural boundaries, but a social and economic repositioning that allows for equal or equivalent access to and participation in the culture. Of course, if this reformation of culture is to work it needs to be supported by the creation of a more evenly resourced or egalitarian society. And there's the rub.

Notes

Introduction

1. See Brian Sewell, *The Reviews that Caused the Rumpus and Other Pieces* (London: Bloomsbury, 1994), 273, 199, 159–60.
2. Immanuel Kant, *The Critique of Judgement* (1790; Oxford: Oxford University Press, 1952), 61–4, 82–9.
3. Ibid. 110–11.
4. Nicolas Bourriaud, *Relational Aesthetics* (Dijon: Les Presses du Réel, 1998; trans. 2002), 13–14.
5. Arthur C. Danto, 'The Artworld', in Neill and Reilly (eds.), *The Philosophy of Art: Readings Ancient and Modern* (New York: McGraw-Hill, 1995), 205–10.
6. Ibid. 209.
7. George Dickie, *Art and the Aesthetic* (Ithaca, New York: Cornell University Press, 1974), 34.
8. Jean Baudrillard, 'Mass Media Culture' (1970), in *Revenge of the Crystal: Selected Writings on the Modern Object and its Destiny* (London and Concord, Mass.: Pluto Press, 1990), 91.
9. For example, over 800 complaints were sent to the ASA against the newborn baby poster in late August 1991, and several petitions were organised. See Melinda Wittstock, 'Protests Double over Tasteless Adverts: Consumers Quick to Complain', *The Times*, 9 March 1992.
10. Benetton's net group profits increased by 23 per cent in 1991, after remaining stable from 1986; see 'Profile: Not with a Bomb, but a Jumper: Luciano Benetton, Salesman Extraordinary', *The Independent*, 4 April 1992.

11. This is illustrated by the numerous press articles generated by *The Shock of Reality*. The complexity of the issues thrown up by Benetton's campaign was demonstrated in an article by Alexander Garrett, 'We Only Like Rose-Tinted Babies: Outrageous Advertisers? No, More a Case of Public Hypocrisy', *The Independent*, 4 September 1991.

12. This is not to say that there are no previous radical changes to be taken into account, and the impact of modernism on graphic design as a whole in the inter-war period is not to be dismissed. It is simply that the dominant practices in the 1950s and 1960s were underpinned by the motivational school of thought in psychology and mainstream advertisements tended to assume a behaviouralist response from the consumer. See Dr Ernest Dichter, *The Strategy of Desire* (London and New York: Boardman, 1960) and Vance Packard, *The Hidden Persuaders* (1957; Harmondsworth: Pelican Books, 1962).

13. Mica Nava has shown how difficult it is to divest advertising theory from orthodoxies which over-determine the relationship between advertising and the capitalist economy of production in 'Framing Advertising', in Mica Nava et al., *Buy this Book: Studies in Advertising and Consumption* (London and New York: Routledge, 1997), 34–50. For Yannis Stavrakakis, the desires created by advertising capitalise on a fundamental sense of lack in the human psyche that is never actually satisfied by the product, enabling more promises of fulfilment to be made, more advertisements to be created and more products to be purchased: see 'On the Discourse of Advertising: A Lacanian View', *Third Text*, 51 (Summer 2000), 85–90.

14. Baudrillard, 'Mass Media Culture', 91; Jean Baudrillard, *The System of Objects* (1968; London and New York: Verso, 1996), 172, 177.

15. Kant, *The Critique of Judgement*, 12–13.

16. Foucault's work on the ordering of knowledge and social practices is well known through the histories he has drawn of sexuality, medicine, criminal discipline and insanity. Here, I refer more specifically to the methodological advice given in *The Archaeology of Knowledge* (1969), trans. A.M. Sheridan Smith (London: Routledge, 1992), 21–40, 178–95.

Chapter 1

1. It is worth noting, however, that there has been a noticeable decline in the use of long body copy. See Michael Johnson, 'Words Work: Every Picture May Tell a Story but Michael Johnson Thinks Words Can Tell It Better', *Design Week*, 17, 42 (17 October 2002), 19.

2. More extensive discussion of the use of words in early twentieth century art is given in Simon Morley, *Writing on the Wall: Word and Image in Modern Art* (London: Thames and Hudson, 2003).

3. J. Abbott Miller, 'Word Art', *Eye* (1993), 38–9.

4. Ibid. 41.

5. Russell Holmes, 'The Work Must be Read', *Eye* (1998), 41.

6. Ibid.

7. Adrian Dannatt, 'Towards the Mot Juste: The Political Alternative to Advertising', interview with Holzer, *Art Newspaper*, 12/117 (September 2001), 46–7.

8. Holzer's relationship with literature is documented in a list she drew up for the 'Artist's Choice' section of David Joselit et al., *Jenny Holzer* (London: Phaidon Press, 1998), 102–12.

9. No direct influence is implied here. Holzer herself states that her mysteries come from 'other sources'. See Dannatt, 'Towards the Mot Juste', 47.

10. Martin Jay, *Downcast Eyes: The Denigration of Vision in Twentieth Century Thought* (Los Angeles: University of California Press, 1994), 149–209.

11. Remy de Gourmont, 'The Dissociation of Words', in Henri Dorra (ed.), *Symbolist Art Theories: A Critical Anthology* (Berkeley, Los Angeles, London: University of California Press, 1994), 302–4, first published in *Mercure de France*, 33 (January 1900).

12. A full alphabetical list of *Truisms* (1977–1979) is given in Joselit et al., *Jenny Holzer*, 116–25.

13. Jennifer Wicke, *Advertising Fictions: Literature Advertisement and Social Readings* (New York and Guildford, Surrey: Columbia University Press, 1988), 123.

14. Bloom earns his living through advertising, and it is through Bloom that Joyce creates a sense not only of the banality of advertisements, but also of the way that, in their simplicity, they can carry complex ideological messages, as, for instance, with the *House of Keys* advertisement.

15. Wicke, *Advertising Fictions*, 144.

16. Ibid. 140.

17. Colin MacCabe, *James Joyce and the Revolution of the Word* (London and Basingstoke: Macmillan Press, 1978), 79–81.

18. Ibid. 80.

19. See Barbara Reich Gluck, *Beckett and Joyce: Friendship and Fiction* (London: Associated University Press, 1979).

20. Daniel Katz, *Saying I No More: Subjectivity and Consciousness in the Prose of Samuel Beckett* (Evanston, Illinois: Northwestern University Press, 1999), 132–3.

21. Ibid.

22. Judith Williamson, *Decoding Advertisements: Ideology and Meaning in Advertising* (London and New York: Marion Boyers, 1978), 60–3.

23. Ludwig Wittgenstein, *Philosophical Investigations* (3rd revised edition, Oxford: Blackwell, 2001), sections 66–91.

24. Vincent Labaume, 'Bruce Nauman, Are You Roman or Italic?', in *Bruce Nauman*, exhibition catalogue (London: Hayward Gallery, 1998), 42.
25. This raft of theory really is huge and encompasses the work of Jean-François Lyotard, Roland Barthes, Michel Foucault and Jacques Derrida, to name but a few of the leading lights.
26. Robert Storr, 'Beyond Words', in Joan Simon (ed.), *Bruce Nauman* (Minneapolis: Walker Art Centre, 1994), 49.
27. Ibid. 50.
28. Cited in ibid. 55.
29. Adrian Searle, 'Me, me, me, me', *The Guardian*, 22 April 1997.
30. Neal Brown, 'God, Art and Tracey Emin', in *Tracey Emin: I Need Art Like I Need God* (London: Jay Jopling, 1998).
31. Adrian Searle, 'Ouch! Tracey Emin's New Show Is Full of Trauma. But There's More to Art than Pain', *The Guardian*, 12 November 2002; and Charles Darwent, 'Come Here and Say that to Me: Tracey Emin, Modern Art Oxford', *The Independent on Sunday*, 17 November 2002.
32. See essays by Katherine and Michael McCoy and Hugh Aldersley-Williams in *The New Cranbrook Design Discourse* (New York: Rizzoli, 1990), 14–19, 20–6; see also Ellen Lupton, 'The Academy of Deconstructed Design', *Eye* (1991), 44–52.
33. Katherine and Michael McCoy, in *The New Cranbrook Design Discourse*, 14.
34. Rick Poyner, 'Here is me!', in *Obey the Giant: Life in the Image World* (London: August Media, 2001), 65–7. Poyner worries that 'the desire for self-expression goes hand in hand with a deep reluctance to take up a position, to say anything definite about anything...'
35. Lewis Blackwell, P. Scott Makela and Laurie Haycock Makela, *WHEREISHERE* (London: Laurence King Publishing, 1998).
36. Edward M. Gomez (series ed.), *New Design London: The Edge of Graphic Design* (Mass.: Rockport Publishers, 2001), 70.
37. Tomato, *Process: A Tomato Project* (London: Thames and Hudson, 1996), unpaginated.
38. Rick Poyner, 'Information', *Eye* (1994), 29.
39. Ibid. 30.
40. Ibid. 34.
41. Ibid. Poyner's view is given further credibility by the fact that Tomato themselves use this quotation from Poyner in *Process: A Tomato Project*.
42. Lewis Blackwell and David Carson, *David Carson: 2ndsight – Grafik Design After the End of Print* (London: Laurence King Publishing, 1997), unpaginated.
43. Marshall McLuhan, *The Medium is the Massage* (Harmondsworth: Penguin Books, 1967), unpaginated.

44. Blackwell and Carson, *The End of Print: The Grafik Design of David Carson, Second Edition* (London: Laurence King Publishing, 2000), unpaginated.
45. Ibid.
46. László Moholy-Nagy, 'The Future of the Photographic Process' (1929), in *Creative Camera*, June 1986. The influence of new media has been an issue of particular concern in the USA, as is shown by the Carnegie Counsel on Adolescent Development's 1992 study, 'Fateful Choices'. This examined the problems of addiction and violence that American teenagers face and recommended that media literacy be taught in schools to counteract what is thought to be the negative influence of media such as television and advertising.
47. Walter Benjamin, 'The Work of Art in the Age of Mass Reproduction', in Hannah Arendt (ed.), *Walter Benjamin: Illuminations* (1936; London: Fontana, 1992), 211–44.

Chapter 2

1. This was part of Kosuth's attempt to break with painting. Laura Stewart Heon et al., 'Putting the Show on the Road', in *Billboard: Art on the Road, a Retrospective Exhibition of Artist's Billboards of the last 30 Years* (Cambridge, Mass.: MIT Press, 1999), 61.
2. 'Joseph Kosuth and Felix Gonzales-Torres: A Conversation', *Art and Design*, 9 (January/February 1994), 76. In fact, Kosuth used a range of 'public media' c.1968, including anonymous works in magazines, newspapers, billboards, bus advertising, handbills dropped from an aeroplane and 30-second TV slots; see page 77.
3. It should be noted that modernism is a problematic term that encompasses a wide range of practices, examples of which are found in Heon et al., 'Putting the Show on the Road', 12–22.
4. Richard Bolton, 'Enlightened Self-Interest: The Avant-Garde in the 1980s', in Grant H. Kestner (ed.), *Art, Activism, and Oppositionality: Essays from Afterimage* (Durham and London: Duke University Press, 1998), 24–8.
5. Lisa Phillips, 'Image World and Media Culture', in *Art and Design International*, 6 (Feb 1990), 84.
6. Bolton, 'Enlightened Self-Interest', 44.
7. A discussion of social advertising in post-revolutionary Russia can be found in Heon et al., 'Putting the Show on the Road', 66–72. Christina Lodder discusses the replacement of the notion of fine art with the categories of agit-prop, laboratory and production art in *Russian Constructivism* (New Haven and London: Yale University Press, 1983). The rejection of fine art was not exclusive to Russian Constructivism: a similar dismantling of hierarchies between disciplines occurred

in Germany, at the Bauhaus and in Holland, with the members of De Stijl, where philosophies had developed in relation to the notion of the *gesamtkunstwerk*, the total work of art.

8. Vance Packard, *The Hidden Persuaders* (1957; Harmondsworth: Pelican, 1962), 9.

9. Sandy Nairne, *State of the Art: Ideas and Images in the 1980s* (London: Chatto and Windus in association with Channel 4, 1987), 190.

10. Hayward Gallery, *Art in Revolution*, February–April (London: Shenval Press, 1971). The exhibition was accompanied by a season of Soviet films at the National Film Theatre.

11. Victor Burgin, 'Socialist Formalism', *Studio International*, March/April 1976, 148–54, part of a themed issue on art and social purpose.

12. Ibid. 149.

13. Ibid. 150.

14. Ibid.

15. Ibid.

16. Ibid. 154.

17. Ibid. 150.

18. Nairne, *State of the Art*, 184.

19. Ibid. 185; and Burgin, 'Socialist Formalism', 150.

20. See William Owen, *Magazine Design* (London: Laurence King Publishing, 1991), 31–6. As Owen notes, *AIZ* was created as a foil to bourgeois magazines such as *Berliner Illustrierte* with the intention of producing a photomagazine that would provide relevant images for the working, rather than middle, classes.

21. In Nairne, *State of the Art*, 187.

22. Ibid. 188.

23. Heon et al., 'Putting the Show on the Road', 9.

24. The issue of the aura of the unique work of art and the implications of its mass reproducibility were discussed in a seminal assay by Walter Benjamin, 'The Work of Art in the Age of Mass Reproduction' (1936), in Hannah Arendt (ed.), *Walter Benjamin: Illuminations* (1992). See also John Walker, *Art in the Age of Mass Media* (London: Pluto Press, 2001) for a more recent general discussion of this issue.

25. Jack Burnham, 'Les Levine: Business as Usual', *Artforum International*, April 1970, 42–3.

26. Ibid. 40.

27. Ibid. 42.

28. 'Extracts from a Conversation Between Les Levine and Declan McGonagle, ICA London, 8th September, 1985', in *Blame God: Les Levine Billboard Projects*

(London: ICA in association with the Artangel Trust and the Orchard Gallery, Derry, 1985), 42.

29. Ibid. 43.

30. Ibid.

31. See extract from *City Limits*, in Levine and McGonagle, 'Extracts from a Conversation Between Les Levine and Declan McGonagle', 25.

32. Ibid. 29.

33. It should also be remembered that the sort of move from billboard 'advertisement' to collectable work of art that was effected with the *Blame God* campaign is not new and that advertising posters have been collected and treated as works of art since the late nineteenth century. Advertisements have also recently featured in a number of exhibitions at prestigious art venues. For example, *High and Low: Modern Art, Popular Culture* was held at the Museum of Modern Art, New York in 1990–1991. There have been several more significant exhibitions both in Europe and America dealing with the theme of art and advertising.

34. It was Artangel's support which enabled the purchase of commercial sites. Levine and McGonagle, 'Extracts from a Conversation Between Les Levine and Declan McGonagle', 53.

35. Ibid.

36. Karrie Jacobs, 'Barbara Kruger', interview, *Eye* (1991), 8–12. See also, Steven Heller, 'Barbara Kruger, Graphic Designer?', in *Barbara Kruger: Thinking of You* (Los Angeles: Museum of Contemporary Art, 1999–2000), 109–16.

37. Reprinted in Jeanne Seigel (ed.), *Art Talk: The Early 80s* (New York: Da Capo Press, 1988), 299–311.

38. Ibid. 302–3.

39. Liam Gillick, 'Barbara Kruger: Peasant Uprisings in Seventeenth Century France, Russia and China, Barbara Kruger and the De-Lamination of Signs', in *Afterall: A Journal of Art, Context and Inquiry*, 5 (2002), 44; and Carol Squiers, 'Who Laughs Last? The Photographs of Barbara Kruger', in *Barbara Kruger: Thinking of You*, 140.

40. Gillick, 'Barbara Kruger: Peasant Uprisings', 41.

41. Jo Anna Isaak, *Feminism and Contemporary Art: The Revolutionary Power of Women's Laughter* (London and New York: Routledge, 1996), 33–46; Carol Squiers, 'Diversionary (Syn) Tactics', *ARTnews*, February 1986, 80.

42. Isabelle Graw, 'Barbara Kruger: Freedom versus Function', in *Afterall: A Journal of Art, Context and Inquiry*, 5 (2002), 30–1.

43. Jacobs, 'Barbara Kruger', 8–12.

44. Thyrza Nichols Goodeve, 'The Art of Public Address', *Art in America*, September 1997, 97.

45. The leitmotif of Benjamin's essay was a clear call for art to shed its autonomy and for artists to take up a stance in the class struggles of the day. 'The Author as Producer' is reproduced in Brian Wallis (ed.), *Art After Modernism* (New York and Boston: New Museum of Contemporary Art in association with David R. Godine, Publisher, Inc., 1984).

46. Christina Lodder, *Russian Constructivism* (New Haven and London: Yale University Press, 1983), 50–3 (agit-prop), 7 (laboratory art) and 101–3 (production art).

47. Most famously, for example, Vladimir Tatlin's project for a *Monument to the Third International* (1920, unrealised).

48. David Joselit et al., *Jenny Holzer* (London: Phaidon Press, 1998), 55.

49. Ibid.

50. Ibid. See also Marc Augé, *Non-Places: An Introduction to the Anthropology of Supermodernity* (London and New York: Verso, 1995), 75–115.

51. Mike Featherstone, *Consumer Culture and Postmodernism* (London, Newbury Park and New Delhi: Sage Publications, 1991), 98.

52. See ibid. 95–111 for lengthy discussion of this issue.

53. Ibid. 124.

54. Henri Lefebvre, *The Production of Space* (1974), trans. Donald Nicholson-Smith (Oxford: Basil Blackwell, 1984).

55. Ibid. 164–8, 362–3, 373–9, 389, 410–11.

56. Simon Sadler, *The Situationist City* (Cambridge, Mass.: MIT Press, 1999), 17–19, 108–10.

57. Michel de Certeau, 'Making Do: Uses and Tactics', in *The Practice of Everyday Life: Living and Cooking* (Minnesota: University of Minnesota Press, 1998).

58. Rosalyn Deutsche, 'Breaking Ground: Barbara Kruger's Spatial Practice', in *Barbara Kruger: Thinking of You*, 77–8.

59. Mark Thompson (ed.), *Social Work: Saatchi & Saatchi's Cause-Related Ideas* (London: Saatchi & Saatchi, 2000).

60. Ted Gott, 'Where the Streets Have New Aims: The Poster in the Age of AIDS', in Gott (ed.), *Don't Leave Me This Way: Art in the Age of AIDS* (London and New York: Thames and Hudson, 1994), 187–8.

61. Ibid. 188–9.

62. Naomi Klein, *No Logo* (London: Flamingo, 2001).

63. 'Irreverent britart.com', an advertising story published by D&AD in association with Royal Mail, www.t4w.co.uk/_content/knowledgepool/-cases/britart.pdf. Mother were given the gold award for their britart.com campaign by D&AD (British Design and Art Direction) in 2001.

64. See www.t4w.co.uk/_content/knowledgepool/-cases/britart.pdf.

65. Ibid. Other examples included the issuing of 'Preview Specs' onto which cut-

outs of britart.com paintings could be placed and viewed against different backgrounds and the 'TV Paintings', five minutes frozen viewing of a piece of britart.com art. By the middle of 2001 the number of monthly hits on britart.com had risen from 40,000 to 300,000.

66. Benjamin, in *Illuminations*.

Chapter 3

1. Caroline A. Jones, *Machine in the Studio: Constructing the Postwar American Artist* (London and Chicago: University of Chicago Press, 1996), 25–7; Erica Doss, *Benton, Pollock and the Politics of Modernism: From Regionalism to Abstract Expressionism* (London and Chicago: University of Chicago Press, 1991); and Jonathan Harris, 'Modernism and Culture in the USA, 1930–1960', in Paul Wood, Francis Frascina, Jonathan Harris and Charles Harrison, *Modernism in Dispute: Art since the Forties* (New Haven and London: Yale University Press and Open University Press, 1993).

2. Clement Greenberg, 'Avant-Garde and Kitsch', *Partisan Review* (1939), in Charles Harrison and Paul Wood (eds.), *Art in Theory, 1900–2000: An Anthology of Changing Ideas* (Oxford: Blackwell, 2002), 539–49.

3. Lesley Jackson, *The New Look: Design in the Fifties* (London: Thames and Hudson, 1991).

4. Advertising, in America, had actually begun to be viewed as a legitimate arena of artistic expression and dissemination in the first half of the century, causing boundaries to erode. Michele H. Bogart, *Artists, Advertising, and the Borders of Art* (Chicago and London: University of Chicago Press, 1995).

5. Brian Wilson Key, *Subliminal Seduction* (New York: Signet Books, 1973).

6. Vance Packard, *The Hidden Persuaders* (1957; Harmondsworth: Pelican, 1962); and Dr Ernst Dichter, *The Strategy of Desire* (London and New York: Boardman, 1960).

7. Michael Schudson, *Advertising, the Uneasy Persuasion: Its Dubious Impact on American Society* (1984; 2nd edn., London and New York: Routledge, 1993). For discussion of predominant codes in this period, see William Leiss, Stephen Kline and Sut Jhally, *Social Communication in Advertising: Persons, Products and Images of Well Being* (London: Routledge, 1990), 205–18. Andreas Huyssen, *After the Great Divide: Modernism, Mass Culture, Postmodernism* (Basingstoke: Macmillan, 1988), 161, has noted that visual montage techniques favoured by many early twentieth-century avant-gardists survived in advertising, but I would argue that these were divested of radical signification in this context and usually subservient to the motivational message.

8. Other terms included: Nouveau Realisme, Pop Art, Common Object Painting, Know-Nothing Genre and New Vulgarismus. See Martin Hentschel, Konrad Lueg

and Gerhard Richter, 'Living with Pop: A Demonstration on Behalf of Capitalist Realism', in Christoph Grunenberg and Max Hollein (eds.), *Shopping: A Century of Art and Consumer Culture* (Frankfurt and Liverpool: Hatje Cantz and Tate Liverpool, 2002), 179.

9. Schudson, *Advertising, the Uneasy Persuasion*, 214–15.

10. Ibid. 218–220.

11. Robert Storr, *Gerhard Richter: Forty Years of Painting* (New York: Museum of Modern Art, 2002), 33.

12. David Campbell, 'Plotting Polke', in David Thistlewood (ed.), *Sigmar Polke: Back to Postmodernity* (Liverpool: Tate Gallery Liverpool and Liverpool University Press, Critical Forum Series, 1996), 27–32.

13. From George Maciunas, 'Neo-Dada in Music, Theatre, Poetry, Art', text presented for the Little Summer Festival: After John Cage (Wuppertal, 1962), quoted in ibid. 32.

14. Peter Burger, *Theory of the Avant-Garde* (Manchester: Manchester University Press, 1984), 47–54.

15. Hal Foster suggests that it is mistaken to speak of the failure of the avant-garde to destroy the institutional mechanisms of art, seeing the neo-avant-garde (e.g. Marcel Broodthauers and Daniel Buren) as, more realistically and more successfully, seeking to deconstruct its boundaries. Hal Foster, *The Return of the Real* (Cambridge, Mass. and London: MIT Press, 1996), 8–25.

16. Scott Lash, *Sociology of Postmodernism* (London and New York: Routledge, 1990), 4–5; see also 158–167. The attack on autonomy and the aura lay in alternative methods of representation, the use of found images and objects, photography, photomontage, collage, all of which were considered 'low' forms that resisted the then still prevalent notion of the hand-crafted unique work of art. In the case of Neue Sachlichteit, the attack was in the form of an often savage critique of the sort of social political and economic conditions which supported the notion of auratic art. Cubism was also seen to have played a part with its mixing of motifs from high and low culture.

17. Michael Newman, 'Revising Modernism, Representing Postmodernism: Critical Discourses of the Visual Arts', in Lisa Appignanesi (ed.), *Postmodernism: ICA Documents* (London: Institute of Contemporary Arts, 1989), 104–11.

18. See Leiss et al., *Social Communication in Advertising*, 15–33, for a summary of Marxist-style criticisms. For me, the most notable are John Kenneth Galbraith, *The Affluent Society* (1958; 4th edn., Harmondsworth: Penguin, 1987); Packard, *The Hidden Persuaders*; Burger, *Theory of the Avant-Garde*; and Williamson, *Decoding Advertisements*.

19. Leiss et al., *Social Communication in Advertising*, 304–7; and Sean Nixon, *Hard*

Looks: Masculinities, Spectatorship and Contemporary Consumption (London: UCL Press, 1997), 77–102.

20. Warren Berger, *Advertising Today* (London and New York: Phaidon Press, 2001), 126.

21. The 1976 Code was an amendment to the fifth edition of *The British Code of Advertising Practice* (1974), which had, in turn, developed from an earlier code of practice established by the Independent Television Authority in 1962, prior to the banning of cigarette advertisements on television in 1965.

22. *The British Code of Advertising Practice*, first reprint of fifth edition, incorporating amendments of 'The Cigarette Code' (London, January 1976), 59–60. Restrictions on the enhancement of feminine charm or sexual success were not added until the amendments of 1983, accompanied by restrictions on those which suggested that smoking could be socially advantageous.

23. As Jobling and Crowther have pointed out, the correlation between cigarette advertising and consumption is hard to prove and even the introduction of a complete ban might not necessarily result in a reduction in smoking; see Paul Jobling and David Crowther, *Graphic Design: Reproduction and Representation since 1800* (Manchester: Manchester University Press, 1996), 258.

24. *The Late Show*, BBC 2, 14 March 1990. Report by Tim Kirby on the effects of tougher health warnings and further restrictions on cigarette advertising as the European Parliament debated a complete ban on cigarette advertising throughout the EU.

25. Ibid.

26. Jobling and Crowther, 256–66.

27. Ibid. 260.

28. These forms of representation are named in Andre Breton, *L'Amour Fou*, trans. Mary Caws (Lincoln and London: University of Nebraska Press, 1987), 19.

29. Jobling and Crowther, 261–2.

30. Ibid. 264.

31. Fredric Jameson, *Postmodernism, or The Cultural Logic of Late Capitalism* (London: Verso, 1991).

32. Ben Highmore, *Everyday Life and Cultural Theory* (London and New York: Routledge, 2002), 134.

33. This is not to say that the contents of the unconscious are not also historically and culturally compromised, only that the process of revelation can be more or less compromised. For an insightful account of several Freudian aspects of Surrealism, see Briony Fer, 'Surrealism, Myth and Psychoanalysis', in Briony Fer, David Batchelor and Paul Wood (eds.), *Realism, Rationalism, Surrealism: Art Between the Wars* (New Haven: Yale University Press in association with Open

University Press, 1993), 170–249.

34. Martin Davidson, *The Consumerist Manifesto: Advertising in Postmodern Times* (London and New York: Routledge, 1992), 135.

35. Ibid. 136.

36. David Lodge, *Nice Work* (London: Secker and Warburg, 1988), 154–5. Extended quotation by kind permission of David Lodge.

37. See John Docker, *Postmodernism and Popular Culture: A Cultural History* (Cambridge: Cambridge University Press, 1994), 168–218, for a good general account of carnivalesque in popular culture in the late twentieth century.

38. Sigmund Freud, *Jokes and their Relation to the Unconscious* (1905), Penguin Freud Library, 6 (Harmondsworth: Penguin, 1991), 127–33, 215–38.

39. 'Silk Cuts and Purple Tears', *Jim Hagart's Semi Subliminal Worlds*, www.subliminalworld.org/silkntrs.htm.

40. Alistair McIntosh, 'From Eros to Thanatos: Cigarette Advertising's Imagery of Violation as an Icon into British Cultural Psychotherapy', www.alastairmcintosh.com/articles/1996-eros-thanatos.htm; first published as an occasional paper for Human Ecology, Faculty of Science and Engineering, University of Edinburgh (1996).

41. Jacques Derrida, 'Structure, Sign and Play in the Discourse of the Human Sciences', in David Lodge (ed.), *Modern Criticism and Theory: A Reader* (London and New York: Longman, 1988), 108–23.

42. One of Hassan's eleven 'definiens' of the postmodern; see Ihab Hassaan, 'Pluralism in the Postmodern Perspective', in Charles Jencks (ed.), *The Postmodern Reader* (London and New York: St Martins Press and Academy Editions, 1992), 198.

43. Derrida, 'Structure, Sign and Play', 108–22; Dick Hebdidge, *Subculture: The Meaning of Style* (London and New York: Routledge, 1979), 102–6.

44. Mike Featherstone, *Consumer Culture and Postmodernism* (London, Newbury Park and New Delhi: Sage Publications, 1991), 35.

45. Pure Gold won a Design Council award in 1978 not only for their creativity, but also because they aroused curiosity and created a talking point. See John Walker, *Art in the Age of Mass Media*, 53.

46. Julian Stallabrass, 'Shop until you Stop', in Grunenberg and Hollein (eds.), *Shopping*, 222.

47. Daniel Salvioni, 'McCollum and Koons', *Flash Art*, 131 (December 1986–January 1987), 66–7.

48. Peter Nagy, 'From Criticism to Complicity', *Flash Art*, 129 (Summer 1986), 46–8.

49. Le Corbusier, *Essential Le Corbusier: L'Esprit Nouveau Articles* (Oxford: Butterworth Architecture, 1998).

50. Schudson, *Advertising, the Uneasy Persuasion*, 215.

51. John Caldwell, 'Jeff Koons: The Way We Live Now', in *Jeff Koons* (San Francisco: San Francisco Museum of Modern Art, 1992–1993).

52. Giorgio Verzotti, 'Object, Sign, Community: On the Art of Haim Steinbach', in *Haim Steinbach*, exhibition catalogue (Castello di Rivoli Museo d'Arte Contemporanea, Milan: Edizioni Charta, 1995), 57.

53. Nagy, 'From Criticism to Complicity', 49.

54. Raymond Williams, 'Advertising: The Magic System' (1962), in *Problems in Materialism and Culture* (London: New Left Books, 1980), 185.

55. Jean Baudrillard, *The System of Objects* (1968; London and New York: Verso, 1996), 173–4.

56. Immanuel Kant, *The Critique of Judgement* (1790), trans. J.C. Meredith (Oxford and New York: Oxford University Press, 1973), 12–13.

Chapter 4

1. Although the most extreme from the point of view of the abject, Benetton were by no means alone in the shift in emphasis from the increasingly glossy and sophisticated images of the mid to late 1980s to images which showed a recognition of the realities of life. Clothing companies such as Gap, Esprit and Workers for Freedom had already made use of 'ordinary' people instead of fashion models in their promotional material. See Helen Fielding, 'Cashing in on a World of Woe: Advertising', *Sunday Times*, 29 December 1991. Howell, Henry, Chaldecott, Lury (HHCL) adopted the same strategy in their television campaign for Fuji film which was meant to undermine stereotypes by the use of marginalised social constituencies, such as pensioners, Asians and the mentally handicapped; see Kate Muir, 'On the Banned Wagon: Life and Times', *The Times*, 6 June 1991.

2. See Lorella Pagnucco Salvemini, *United Colors: The Benetton Campaigns* (London: Thames and Hudson, 2002), 86–109, for a full range of 'found' images, and, for a summary of the mixed responses to the campaign, 86–7, 90–1. The newborn baby advertisement, although life-affirming, not tragic, still generated over 800 complaints to the Advertising Standards Authority, increasing the number of complaints received on the grounds of indecency by 100 per cent.

3. See Julian Stallabrass, *High Art Lite: British Art in the 1990s* (London and New York: Verso, 1999), 201–2.

4. Hal Foster, *The Return of the Real* (Cambridge, Mass. and London: MIT Press, 1996).

5. Ibid. 127–44. The discussion is of course far more complex and convoluted in Foster and occupies a number of pages.

6. Tamotsu Yagi, Emiko Kaji and Hiroshi Shogi, *Global Vision: United Colors of*

Benetton (Tokyo: Robundo Press, 1993), section on advertising, unpaginated.

7. Richard Dormant, 'Sensation? What Sensation?', *Daily Telegraph*, 17 September 1997, in Stallabrass, *High Art Lite*, 205.

8. Ibid. 207–8.

9. Whitney Museum of American Art, *Abject Art: Repulsion and Desire in American Art* (New York, 1993).

10. Tate Gallery, *Rites of Passage: Art for the End of the Century* (London, 1995).

11. Ibid. 22.

12. Foster, *The Return of the Real*, 148–9.

13. Ibid. 152–3.

14. Not published in Britain or the USA.

15. Salvemini, *United Colors*, 88, 91.

16. Waldman, *Jenny Holzer*, 24–5.

17. Foster, *The Return of the Real*, 146, 157, 165.

18. Tate Gallery, *Rites of Passage*, 21.

19. Foster, *The Return of the Real*, 166.

20. Jeffrey Weeks, 'Post-modern AIDS?', in Tessa Boffin and Sunil Gupta (eds.), *Ecstatic Antibodies: Resisting the AIDS Mythology* (London: Rivers Oram, 1990), 133.

21. See Susan Sontag, *Illness as Metaphor* (Harmondsworth: Penguin, 1977). The revised edition (1991) includes an additional essay on AIDS and its metaphors.

22. Simon Watney, 'Photography and AIDS', in Carol Squiers (ed.), *The Critical Image: Essays in Contemporary Photography* (London: Laurence and Wishart, 1990), 177–83. People with AIDS (PWA) is a term commonly used in the USA to avoid the negative connotations of terms such as 'AIDS sufferers' or 'AIDS victims'.

23. To offer another point of view, Lisa Phillips, *The American Century*, 327, sees Nixon's photographs as an attempt to give a more balanced picture of people living with, rather than only dying from, AIDS.

24. Gott (ed.), *Don't Leave Me This Way*, 220–1.

25. Ibid. 180.

26. Douglas Crimp (ed.), *AIDS: Cultural Analysis/Cultural Activism* (Cambridge, Mass. and London: MIT Press, 1987), 6–7.

27. For these and other examples, see Gott (ed.), *Don't Leave Me This Way*.

28. 'David Deitcher on the United Colors of Benetton', in the Billboard column of *Artforum*, January 1990, 20–1.

29. Roland Barthes, 'Myth Today', in *Mythologies* (1957; London: Vintage Press, 1993).

30. Ibid.

31. These are actually the words of Company Director Luciano Benetton, quoted

in Topaz Moore, 'Benetton Defiant over its Images of Reality: A Clothing Firm Rejects Allegations of Exploitation in its Advertising', *The Independent*, 20 February 1992.

32. Salvemini, *United Colors*, 91.

33. Public Health AIDS posters are discussed in Sander Gilman, *Health and Illness: Images of Difference* (London: Reaktion Books, 1995), 115–20. The criticism from AIDS pressure groups prompted a conciliatory gesture from Benetton who published a brochure on safe sex in *Spin* magazine. Gilman noted that there were no morbid images in the brochure, ibid. 118–19.

34. Michael Ellis, 'General Idea' (exhibition review), *Art Monthly*, July/August 1988, 28.

35. 'Matthias Herrmann Interviews AA Bronson', in Ikon Gallery/Art Metropole, *AA Bronson: Felix, June 5th, 1994* (Manchester: Cornerhouse Publications, 2003), unpaginated.

36. Ibid.

37. Ibid.

38. Ibid.

39. Felix Gonzales-Torres, 'Practices: The Problem of Divisions of Cultural Labour', *Art and Design*, 9 (January–February 1994), 83.

40. Ibid. 91.

41. Nancy Spector, *Felix Gonzales-Torres* (New York: Solomon R. Guggenheim Museum, 1995), 25.

42. Michael Fried, 'Art and Objecthood', in Charles Harrison and Paul Wood (eds.), *Art in Theory, 1900–2000: An Anthology of Changing Ideas* (Oxford: Blackwell, 2002).

43. Mónica Amor, 'Felix Gonzales-Torres: Towards a Postmodern Subliminity', *Third Text*, 30 (Spring 1995), 77–8.

44. Immanuel Kant, *The Critique of Judgement* (1790), trans. James Creed Meredith (Oxford, New York, Toronto: Oxford University Press, 1952), 119.

45. Jean-François Lyotard, 'The Sublime and the Avant-Garde', in Thomas Docherty (ed.), *Postmodernism: A Reader* (1993), 43–4, or (longer version) in *Artforum*, April 1984, 36–43.

46. Jean-François Lyotard, *The Postmodern Condition: A Report on Knowledge* (Minneapolis: University of Minnesota Press, 1984), 77–9.

47. Paul Crowther, *Critical Aesthetics and Postmodernism* (Oxford: Clarendon Press, 1993), 125–6.

48. Ibid. 130–1.

49. Ibid. 126–7. See also, Kant, *The Critique of Judgement*, 109–14; and Edmund Burke, *A Philosophical Enquiry into the Origin of our Ideas of the Sublime and the Beautiful* (1757; Oxford and New York: Oxford University Press, 1990), 35–6.

50. Tamotsu Yagi, Emiko Kaji and Hiroshi Shogi, *Global Vision: United Colors of Benetton* (Tokyo: Robundo Press, 1993), unpaginated. See also Topaz Moore and Ian Katz, 'AIDS Victim's Family Approves Poster', *The Guardian*, 25 January 1992. Some of the cynicism felt towards Benetton's appropriation of this image is understandable as the company had previously refused to give a donation to the Terence Higgins Trust. Oliviero Toscani argued that the extent of these debates concerning the probity of the advertisement demonstrated the good that the advertisement was doing by generating awareness at a popular level and went on to collect and publish a hundred of these mixed responses, from 'students, mothers of families, teachers, priests and nuns' in a book entitled *Cosa C'Entra L'AIDS Con I Maglioni? (What Has AIDS To Do With Sweaters?)* (1993). See also Salvemini, *United Colors*, 86–7.

Chapter 5

1. From a conversation with Tony Kaye, Los Angeles, 5 December 2002. *The New Shorter Oxford English Dictionary*, 4th edn. (1993) defines 'Renaissance man' as above.
2. William Morris, 'The Lesser Arts', in Asa Briggs (ed.), *William Morris, 1834–1896* (Harmondsworth: Penguin, 1962) – one of the earliest texts to challenge the hierarchies between fine and applied arts. As previously noted, there are many works of art in the history of western art that are regarded as individually authored 'masterpieces' which were, in fact, patronage led and market driven when conceived and executed. Moreover, it may be argued that the expressive passion and virtuosity of the artist can be just as vital to this sort of art and that, while conditions of production and reception can be a constraining factor from the individual artist's or even the individual consumer's point of view, it does not necessarily mean that art made through the demands of the client or the marketplace is of a lesser order, simply that it has been generated in different framework of production and reception.
3. Jeremy Myerson and Graham Vickers, *Rewind: Forty Years of Design and Advertising* (London: Phaidon Press, 2003), 267.
4. Interview with Nik Studinzki at Saatchi & Saatchi, London, 29 October 2002.
5. The conditions of production were confirmed by Kaye when I spoke with him directly in December 2002.
6. Myerson and Vickers note that *Unexpected* was the first TV commercial in the UK to feature artificial colour and give the source for the soundtrack; see *Rewind: Forty Years of Design and Advertising*, 346.
7. Here, I refer to carnival's traditional function as an arena in which order is allowed to become disorder and the normal hierarchies are frequently reversed,

for example the king who becomes the fool for a day and vice versa. For a substantial account of the carnivalesque in popular culture, see John Docker, *Postmodernism and Popular Culture: A Cultural History* (Cambridge: Cambridge University Press, 1994), 168–284.

8. Walter Benjamin, 'The Work of Art in The Age of Mass Reproduction', in Hannah Arendt (ed.), *Illuminations* (London: Fontana Press, 1992), 211–44.

9. Roland Barthes, *Camera Lucida* (1980; London: Flamingo, 1984), 25–28.

10. Will Vaughan, *Romanticism and Art* (London: Thames and Hudson, 1994).

11. Warren Berger, *Advertising Today* (London and New York: Phaidon Press, 2001), 140.

12. Claire Cozens, 'We're Only Here for the Beer', *Media Guardian*, 3 February 2003.

13. Walter Benjamin, 'On Some Motifs in Baudelaire', in Arendt (ed.), *Illuminations*, 162–76.

14. See, for instance, Williamson, *Decoding Advertisements*, 65–7.

15. 'Rebel with a Cause', *Arthouse*, Channel 4, 1999.

16. John Berger, *Ways of Seeing* (Harmondsworth: Penguin, 1972), 53–5.

17. For mythologisation of AIDS, see Susan Sontag, *Illness as Metaphor* (Harmondsworth: Penguin, 1991). For representation of AIDS in the popular press, see Simon Watney, 'Photography and AIDS', in Carol Squiers (ed.), *The Critical Image: Essays in Contemporary Photography* (London: Laurence Wishart, 1990), 173–92.

18. Tiffany Sutton, *The Classification of Visual Art: A Philosophical Myth and its History* (Cambridge: Cambridge University Press, 2000).

Chapter 6

1. Quoted in Jackie Krentzman, 'The Force behind the Nike Empire', *Stanford Magazine*, January–February 1997.

2. Ibid.

3. Warren Berger, *Advertising Today*, 148.

4. Ibid. 146–81.

5. Ibid. 151.

6. Ibid. 154.

7. Ibid. 148.

8. Lisa Phillips, 'Image World: Art and Media Culture', *Art and Design*, 6 (January–February 1996), 83.

9. Douglas Crimp, 'Pictures', in Brian Wallis (ed.), *Art after Modernism: Rethinking Representation* (Boston: Godine, 1984), 175–87.

10. Ibid.

11. Michael Fried, 'Art and Objecthood', in Charles Harrison and Paul Wood (eds.),

Art in Theory, 1900–2000: An Anthology of Changing Ideas (Oxford: Blackwell, 2002).

12. For an insightful and lengthier analysis of this and other commercials that show media referentiality, see Robert Goldman and Stephen Papson, *Nike Culture* (London and New Delhi: Thousand Oaks and Sage Publications, 1998). The account of *Boys in the Barbershop* is on 41–2.

13. Ibid. 86–7.

14. Ibid. 33–40.

15. Ibid. 48–9, 76.

16. Ibid. 10.

17. Ibid. 119–20.

18. Ibid. 120.

19. Lynne Cooke, 'Tracey Moffatt: Free Falling', essay for exhibition *Free Falling* at DIA Centre for the Arts, New York, 1997.

20. Goldman and Papson, *Nike Culture*, 133.

21. Nancy Princenthal, 'Gillian Wearing at Jay Gorney', *Art in America*, January 1998.

22. Michael Newman, 'The Demotic Art of Gillian Wearing', *Parachute*, 102 (2001), 98.

23. Ibid. 92.

24. Ibid. 98.

25. Ibid. 99–100.

26. Claire Cozens, 'Acclaimed Honda Ad in Copycat Row', *The Guardian*, 27 May 2003.

27. Alok Jha, 'Did They Really Make that Honda Advert in One Take?', *The Guardian*, 1 May 2003.

28. 'The New Honda Accord – Isn't It Nice When Things Just... Work?', *The Guardian*, 9 May 2003.

29. Press Release for *Peter Fischli and David Weiss: In a Restless World*, Walker Art Centre, Minneapolis, April 1996.

30. Arthur Danto, 'Play/Things', *In a Restless World*, Walker Art Centre, Minneapolis, April 1996.

Chapter 7

1. Drawing from the French sociologist Pierre Bordieu, Mike Featherstone has shown this to be a characteristic of the postmodernisation of consumer culture in *Consumer Culture and Postmodernism* (London, Newbury Park and New Delhi: Sage Publications, 1991), 84–5. See also Jonathan Bond and Richard Kirshenbaum, *Under the Radar: Talking to Today's Cynical Consumer* (USA and Canada: John Wiley & Sons Inc., 1998), 1–31, for similar points concerning

development of the new consumer seen from an advertiser's point of view.

2. This point has been made by Judith Williamson in her essay on the function of art in advertising, where she argues that '"Art" is a particularly appropriate system for ads: while appearing to be "above" social distinctions, it provides a distinct set of social codes which we all understand.' Here, Williamson is making an important point concerning the cultural capital of art for advertisers; as she also puts it, 'Unlike advertising, art has a reputation for being above things vulgar and mercenary, a form eternal rather than social whose appreciation springs from the discerning heart,' a reputation which, as Williamson also notes, is blatantly untenable the moment the commercial basis of the art market is remembered. Judith Williamson, '... But I Know What I Like: The Function of Art in Advertising', in *Consuming Passions* (London and New York: Marion Boyers, 1986), 68.

3. Dick Hebdige, *Subculture: The Meaning of Style* (London and New York: Routledge, 1979); and Jacques Derrida, 'Structure, Sign and Play in the Discourse of the Human Sciences', in David Lodge (ed.), *Modern Criticism and Theory: A Reader* (London and New York: Longman, 1988), 108–23.

4. Celia Lury, *Consumer Culture* (Cambridge: Polity Press, 1996), 8.

5. Jean-Marie Dru, *Beyond Disruption: Changing the Rules in the Marketplace* (New York: John Wiley & Sons Inc., 2002), 62–3. Dru proposes a shift from the consumer as the hero of the marketing scenario to the brand idea as hero.

6. For further discussion of the mirroring process in advertising, see Williamson, *Decoding Advertisements*, 60–3.

7. Featherstone, *Consumer Culture and Postmodernism*, 86.

8. Naomi Klein, *No Logo* (London: Flamingo, 2000), 73.

9. Ibid. 28. Klein's understanding of brands as deeply effective agents in the culture are echoed by the sort of approaches and claims that were concurrently being developed by advertisers themselves; see, for example, Daryl Travis, *Emotional Branding: How Successful Brands Gain the Irrational Edge* (Roseville, California: Prima Publishing, 2000); Bond and Kirshenbuam, *Under the Radar*; and Jean-Marie Dru, *Beyond Disruption*.

10. Klein, *No Logo*, 29.

11. Klein coins the term 'co-branding' in her observations of partnerships between celebrity people and celebrity brands. Ibid. 30.

12. Richard W. Lewis, *Absolut Book: The Absolut Vodka Advertising Story* (Boston, Mass.: Journey Editions, 1996), 4, 11.

13. See Carl Hamilton, *Absolut: Biography of a Bottle* (New York: TEXERE LLC, 1994), 189–206, for a highly anecdotal account of the development of the bottle.

14. Ibid. 12–27.

15. Ibid. 30–41.

16. Ibid. 46–61.
17. Ibid. 65, 274–91 give a detailed description of the network of promotion and celebrity centred on New York celebrity nightclub, Studio 54, that gave rise to the meeting between Warhol and Roux.
18. Ibid.
19. A summary account of the developments and tensions in American art during this period can be found in Jonathan Harris, 'Modernism and Culture in the USA, 1930–1960', in Paul Wood, Francis Frascina, Jonathan Harris and Charles Harrison, *Modernism in Dispute: Art since the Forties* (New Haven and London: Yale University Press and Open University Press, 1993), 3–41.
20. Michele H. Bogart, *Artists, Advertising, and the Borders of Art* (Chicago and London: University of Chicago Press, 1995), 207–12.
21. Ibid. 234–55.
22. Ibid. 290–2; for discussion of Pepsi Cola in relation to art and advertising, see 284–90; for the Container Corporation of America, see 259–69.
23. Bob Levenson, *Bill Bernbach's Book: A History of the Advertising that Changed the History of Advertising* (New York: Villard Books, 1987).
24. Clement Greenberg, 'Avant Garde and Kitsch'.
25. Bogart, *Artists, Advertising and the Borders of Art*, 300.
26. Ibid. 293–7.
27. Andy Warhol, *The Philosophy of Andy Warhol (From A to B and Back Again)* (New York: Harcourt Brace Janovich, 1975), 101.
28. Kynaston McShine, 'Introduction', *Andy Warhol: A Retrospective*, exhibition catalogue (New York: Museum of Modern Art, 1989), 14, 403. John A. Walker notes that the distinctive character of Warhol's work resembled a brand image rather than a signature style, a term which could be applied to the 1950s illustrations, John Walker, *Art and Celebrity* (London: Pluto Press, 2003), 216.
29. Andy Warhol, *The Philosophy of Andy Warhol*, 92.
30. For an effective but gruesome parody of the rampant nature of American consumerism in the 1980s, see Brett Easton Ellis, *American Psycho: A Novel* (London: Picador, 1991).
31. Lewis, *Absolut Book*, 66.
32. Celebrity patrons of Studio 54 included John Lennon, Mick Jagger, Bianca Jagger, Liza Minnelli, Paloma Picasso, Diana Vreeland, Margaret Trudeau, Truman Capote and Henry Kissinger.
33. Lewis, *Absolut Book*, 67.
34. Jonathan Fineberg, *Art Since 1940: Strategies of Being* (2nd edn., London: Laurence King Publishing, 2000), 457.
35. Lewis, *Absolut Book*, 71.

36. The distribution budget for the Absolut campaigns was initially small and placements were restricted to regional or special-interest magazines such as *New York*, *Los Angeles*, *The New Yorker* and, in 1985, *Interview*. Special cut-price deals had to be made for distribution in *The New York Times*; see Hamilton, *Absolut: Biography of a Bottle*, 275.

37. In its role as a leading art journal, *Artforum* is of special interest because of its more open agenda: not only did it have its finger firmly on the pulse of non-mainstream, cutting-edge and cross-disciplinary practices from the start, but it also made space in its monthly columns for discussion of non-fine-art practices, including advertising. For example, the New York based writer Glen O'Brien ran a column, 'Like Art', between 1985 and 1989, that was devoted to the discussion of advertisements and the artist Barbara Kruger also wrote regularly about television.

38. I am grateful here for the advice and information given to me by Natalie Clark of the Broadway-based advertising agency Gerngross and Clark, leading art-advertisers in New York. According to Clark, it is rare for art-advertisements to deviate from these two formats.

39. Jeff Koons, *The Jeff Koons Handbook* (London: Thames and Hudson, 1992), 90.

40. Ibid. 92.

41. Varnedoe and Gopnik, *High and Low*, 398.

42. Douglas Coupland, 'Jeff Koons: Getting it', http://www.eyestorm.com, 1 August 2001.

43. D.S. Baker, 'Jeff Koons and the Paradox of A Superstar's Phenomenon', *Bad Subjects: Political Education for Everyday Life*, 4 (February 1993), http://eserver. org/bs/04/Baker.html.

44. Ibid.

45. Jean Baudrillard, *The Ecstasy of Communication* (New York: Semiotext Foreign Agents Series, 1988), 22.

46. Daniela Salvioni, 'Jeff Koons's Poetics of Class', in *Jeff Koons* (San Francisco: San Francisco Museum of Modern Art, 1992–1993), 21.

47. Kate Tregaskis, 'Creative Britain Inc.', *Art Monthly*, 246 (May 2001), 52.

48. Department of Culture, Media and Sport and the Design Council and Arts Council of England, *Your Creative Future*, quoted in Tregaskis.

49. Walker, *Art and Celebrity*, 225.

50. This aspect of celebrity is discussed by Chris Rojek in *Celebrity* (London: Reaktion Books, 2001), 15.

51. See, for instance, Damien Hirst and Gordon Burn, 'The Naked Hirst', *The Guardian*, 6 October 2001; Melanie McGrath, 'Something's Wrong: Melanie McGrath on Tracey Emin', www.tate.org.uk/magazine/issue1/something.htm; and 'Show and

Tell', *The Observer*, 22 April 2001.

52. Gordon Burn, 'The Knives Are Out', *The Guardian*, 10 April 2000.

53. Rojeck, *Celebrity*, 15.

54. Ibid.

55. Chin=Tao Wu, *Privatising Culture: Corporate Art Intervention since the 1980s* (London and New York: Verso, 2002), 132.

56. www.becks.co.uk.

57. Fiachra Gibbons, 'Tracey Emin Gets in Bed with Beck's', *The Guardian*, 9 November 1999.

58. Wu, *Privatising Culture*, 146.

59. www.becks.co.uk.

60. Vincent Pécoil, 'Brand Art', *Art Monthly*, 265 (April 2003), 3–4.

61. Ibid. 4; and www.kw-berlin.de/de/swetlanaheger.htm. See also Stuart Comer, 'Swetlana Heger: Capitalist Neo-Realism', *Parkett*, 69 (2003).

Bibliography

Amor, Mónica, 'Felix Gonzales-Torres: Towards a Postmodern Subliminity', *Third Text*, 30 (Spring 1995)

Archer, Michael, 'No Politics Please We're British?', *Art Monthly*, 194 (March 1996)

Art and Design, 'Joseph Kosuth and Felix Gonzales-Torres: A Conversation', 9 (January–February 1994)

Augé, Marc, *Non-Places: An Introduction to the Anthropology of Supermodernity* (London and New York: Verso, 1995)

Baker, D.S., 'Jeff Koons and the Paradox of A Superstar's Phenomenon', *Bad Subjects: Political Education for Everyday Life*, 4 (February 1993), http://eserver.org/bs/04/Baker.html

Bakhtin, Mikhail, *Rabelais and his World* (1965; Bloomington, Indianapolis: Indiana University Press, 1984)

Barthes, Roland, *Camera Lucida* (1980; London: Flamingo Press, 1984)

Barthes, Roland, *Mythologies* (1957; London: Vintage, 1993)

Baudrillard, Jean, *The Ecstasy of Communication* (New York: Semiotext Foreign Agents Series, 1988)

Baudrillard, Jean, 'Mass Media Culture', in *Revenge of the Crystal: Selected Writings on the Modern Object and its Destiny* (1970; London and Concord Mass., 1990)

Baudrillard, Jean, *The System of Objects* (1968; London and New York: Verso, 1996)

Benjamin, Walter, 'The Author as Producer', in Brian Wallis (ed.), *Art After Modernism* (New York and Boston: New Museum of Contemporary Art and David R. Godine, Publisher, Inc., 1984)

Benjamin, Walter, 'On Some Motifs in Baudelaire', in Hannah Arendt (ed.), *Walter Benjamin: Illuminations* (London: Fontana, 1992)

Benjamin, Walter, 'The Work of Art in the Age of Mass Reproduction', in Hannah Arendt (ed.), *Walter Benjamin: Illuminations* (1936; London: Fontana, 1992)

Berger, Warren, *Advertising Today* (London and New York: Phaidon Press, 2001)

Berger, Warren, 'Just Do it Again', *Business 2.0,* September 2002

Berger, John, *Ways of Seeing* (Harmondsworth: Penguin, 1972)

Bickers, Patricia, 'Mind the Gap: The Concept of Critical Distance in Relation to Contemporary Art in Britain', in David Burrows (ed.), *Who's Afraid of the Red, White and Blue?* (Birmingham: Article Press, 1998)

Bickers, Patricia, 'Sense & Sensation', *Art Monthly,* 211 (November 1997)

Blackwell, Lewis, and David Carson, *David Carson: 2ndsight: Grafik Design after the End of Print* (London: Laurence King Publishing, 1997)

Blackwell, Lewis, and David Carson, *The End of Print: The Grafik Design of David Carson, Second Edition* (London: Laurence King Publishing, 2000)

Blackwell, Lewis, and P. Scott Makela & Laurie Haycock Makela, *WHEREISHERE* (London: Laurence King Publishing, 1998)

Bogart, Michele H, *Artists, Advertising, and the Borders of Art* (Chicago and London: University of Chicago Press, 1995)

Bolton, Richard, 'Enlightened Self-Interest: The Avant-Garde in the 1980s', in Grant H. Kestner (ed.), *Art, Activism, and Oppositionality: Essays from Afterimage* (Durham and London: Duke University Press)

Bond, Jonathan and Richard Kirshenbaum, *Under the Radar: Talking to Today's Cynical Consumer* (USA and Canada: John Wiley & Sons Inc., 1998)

Bourriaud, Nicolas, *Relational Aesthetics* (Dijon: Les Presses du Réel, 1998, trans. 2002)

British Code of Advertising Practice, The (London, January 1976)

Brown, Neal, 'God, Art and Tracey Emin', in *Tracey Emin: I Need Art Like I Need God* (London: Jay Jopling, 1998)

Burger, Peter, *Theory of the Avant-Garde* (Manchester: Manchester University Press, 1984)

Burke, Edmund, *A Philosophical Enquiry into the Origin of our Ideas of the Sublime and the Beautiful* (1757; Oxford and New York: Oxford University Press, 1990)

Burnham, Jack, 'Les Levine: Business as Usual', *Artforum International,* April 1970

Caldwell, John, 'Jeff Koons: The Way We Live Now', in *Jeff Koons* (San Francisco: San Francisco Museum of Modern Art, 1992–1993)

Campbell, David, 'Plotting Polke', in David Thistlewood (ed.), *Sigmar Polke: Back to Postmodernity* (Liverpool: Tate Gallery Liverpool and Liverpool University Press, Critical Forum Series, 1996)

Carroll, Noël, *A Philosophy of Mass Art* (Oxford: Clarendon Press, 1998)

Collings, Matthew, *Blimey! From Bohemia to Britpop: The London Artworld from Francis Bacon to Damien Hirst* (London: 21 Publishing, 1997)

Cooke, Lynne, 'Tracey Moffatt: Free Falling', essay for exhibition *Free Falling* at DIA Centre for the Arts, New York, 1997

Coupland, Douglas, 'Jeff Koons: Getting it', http://www.eyestorm.com, 1 August 2001

Cozens, Claire, 'Acclaimed Honda Ad in Copycat Row', *The Guardian*, 27 May 2003

Cozens, Claire, 'We're Only Here for the Beer', *Media Guardian*, 3 February 2003

Crimp, Douglas (ed.), *AIDS: Cultural Analysis/Cultural Activism* (Cambridge, Mass. and London: MIT Press, 1987)

Crimp, Douglas, 'Pictures', in Brian Wallis (ed.), *Art after Modernism: Rethinking Representation* (Boston: Godine, 1984)

Crowther, Paul, *Critical Aesthetics and Postmodernism* (Oxford: Clarendon Press, 1993)

D&AD (British Design and Art Direction), 'Irreverent britart.com', in association with Royal Mail, www.t4w.co.uk/_content/knowledgepool/-cases/britart.pdf

Danto, Arthur C., 'The Artworld', in Neill and Reilly (eds.), *The Philosophy of Art: Readings Ancient and Modern* (New York: McGraw-Hill, 1995)

Danto, Arthur, 'Play/Things', *In a Restless World* (Minneapolis: Walker Art Centre, 1996)

Darwent, Charles, 'Come Here and Say That to Me: Tracey Emin Modern Art Oxford', *The Independent on Sunday*, 17 November 2002

Davidson, Martin, *The Consumerist Manifesto: Advertising in Postmodern Time* (London and New York: Routledge, 1992)

De Certeau, Michel, 'Making Do: Uses and Tactics', in *The Practice of Everyday Life: Living and Cooking* (Minnesota: University of Minnesota Press, 1998)

De Gourmont, Remy, 'The Dissociation of Words', in Henri Dorra (ed.), *Symbolist Art Theories: A Critical Anthology* (Berkeley, Los Angeles, London: University of California Press, 1994)

Deitcher, David, 'David Deitcher on the United Colors of Benetton', *Artforum*, January 1990

Design and Art Directors Association of the United Kingdom, The, *The Copy Book: How 32 of the World's Best Advertising Writers Write their Advertising* (Switzerland: RotoVision, 1995)

Deutsche, Rosalyn, 'Breaking Ground: Barbara Kruger's Spatial Practice', in *Barbara Kruger: Thinking of You* (Los Angeles: Museum of Contemporary Art, 1999–2000)

Dichter, Dr Ernest, *The Strategy of Desire* (London and New York: Boardman, 1960)

Dickie, George, *Art and the Aesthetic* (Ithaca, New York: Cornell University Press, 1974)

Docker, John, *Postmodernism and Popular Culture: A Cultural History* (Cambridge: Cambridge University Press, 1994)

Dormant, Richard, 'Sensation? What Sensation?', *The Daily Telegraph*, 17 September 1997

Doss, Erica, *Benton, Pollock and the Politics of Modernism: From Regionalism to Abstract Expressionism* (Chicago and London: University of Chicago Press, 1991)

Dru, Jean-Marie, *Beyond Disruption: Changing the Rules in the Marketplace* (New York: John Wiley & Sons Inc., 2002)

Dannatt, Adrian, 'Towards the Mot Juste: The Political Alternative to Advertising', interview with Holzer, *Art Newspaper*, 12/117 (September 2001), 46–7

Ellis, Brett Easton, *American Psycho* (London: Picador, 1991)

Ellis, Michael, 'General Idea' (exhibition review), *Art Monthly*, July–August 1988

Featherstone, Michael, *Consumer Culture and Postmodernism* (London, Newbury Park and New Delhi: Sage Publications, 1991)

Fer, Briony, 'Surrealism, Myth and Psychoanalysis', in Briony Fer, David Batchelor and Paul Wood (eds.), *Realism, Rationalism, Surrealism: Art Between the Wars* (New Haven and London: Yale University Press in association with Open University Press, 1993)

Fielding, Helen, 'Cashing in on a World of Woe: Advertising', *The Sunday Times*, 29 December 1991

Fineberg, Jonathan, *Art Since 1940: Strategies of Being* (London: Laurence King Publishing, 2000)

Foster, Hal, *The Return of the Real* (Cambridge, Mass. and London: MIT Press, 1996)

Foucault, Michel, *The Archaeology of Knowledge* (1969; London: Routledge, 1992)

Freud, Sigmund, *Jokes and their Relation to the Unconscious*, Penguin Freud Library, 6 (1905; Harmondsworth: Penguin, 1991)

Fried, Michael, 'Art and Objecthood', in Charles Harrison and Paul Wood (eds.), *Art in Theory, 1900–2000: An Anthology of Changing Ideas* (Oxford: Blackwell, 2002)

Galbraith, John Kenneth, *The Affluent Society* (1958; Harmondsworth: Penguin, 1987)

Garrett, Alexander, 'We Only Like Rose-Tinted Babies: Outrageous Advertisers? No, More a Case of Public Hypocrisy', *The Independent*, 9 September 1991

Gibbons, Fiachra, 'Hirst Buys his Art Back', *The Guardian*, 27 November 2003

Gibbons, Fiachra, 'Tracey Emin Gets in Bed with Beck's', *The Guardian*, 9 November 1999

Gillick, Liam, 'Barbara Kruger: Peasant Uprisings in Seventeenth Century France, Russia and China, Barbara Kruger and the De-Lamination of Signs', in *Afterall: A Journal of Art, Context and Inquiry*, 5 (2002)

Gilman, Sander, *Health and Illness: Images of Difference* (London: Reaktion Books, 1995)

Gluck, Barbara Reich, *Beckett and Joyce: Friendship and Fiction* (London: Associated University Press, 1979)

Gomez, Edward M. (series ed.), *New Design London: The Edge of Graphic Design* (Mass.: Rockport Publishers, 2001)

Goldman, Robert and Stephen Papson, *Nike Culture* (London and New Delhi: Thousand Oaks and Sage Publications, 1998)

Gonzales-Torres, Felix, 'Practices: The Problem of Divisions of Cultural Labour', *Art and Design*, 9 (January–February 1994)

Goodeve, Thyrza Nichols, 'The Art of Public Address', *Art in America*, September 1997

Gott, Ted, 'Where the Streets Have New Aims: The Poster in the Age of AIDS', in Gott (ed.), *Don't Leave Me This Way: Art in the Age of AIDS* (London and New York: Thames and Hudson, 1994)

Graw, Isabelle, 'Barbara Kruger: Freedom versus Function', in *Afterall: A Journal of Art, Context and Inquiry*, 5 (2002)

Greenberg, Clement, 'Avant-Garde and Kitsch', *Partisan Review* (1939, republished 1960), in Charles Harrison and Paul Wood (eds.), *Art in Theory: An Anthology of Changing Ideas, 1900–2000* (Oxford: Blackwell Publishers, 2002)

Hagart, Jim, 'Silk Cuts and Purple Tears', in *Jim Hagart's Semi Subliminal Worlds*, www.subliminalworld.org/silkntrs.htm

Hamilton, Carl, *Absolut: Biography of a Bottle* (New York: TEXERE LLC, 1994)

Harris, Jonathan, 'Modernism and Culture in the USA, 1930–1960', in Paul Wood, Francis Frascina, Jonathan Harris and Charles Harrison, *Modernism in Dispute: Art since the Forties* (New Haven and London: Yale University Press and Open University Press, 1993)

Harris, Mark, 'Putting on the Style', *Art Monthly*, 193 (February 1996)

Harten, Jurgen and Michael Schirner, *Art Meets Ads*, exhibition catalogue (Kunsthalle, Düsseldorf: Edition Cantz, 1992–1993)

Hassaan, Ihab, 'Pluralism in the Postmodern Perspective', in Charles Jencks (ed.), *The Postmodern Reader* (London and New York: St Martins Press and Academy Editions, 1992)

Hatton, Rita and John A. Walker, *Supercollector: A Critique of Charles Saatchi* (London: Ellipsis, 2000)

Hayward Gallery, *Art in Revolution* (London: Shenval Press, 1971)

Hebdidge, Dick, *Subculture, The Meaning of Style* (London and New York: Routledge, 1979)

Heller, Steven, 'Barbara Kruger, Graphic Designer?', in *Barbara Kruger: Thinking of You* (Los Angeles: Museum of Contemporary Art, 1999–2000)

Hentschel, Martin, 'Konrad Lueg and Gerhard Richter: Living with Pop – A
 Demonstration on Behalf of Capitalist Realism', in Christoph Grunenberg and
 Max Hollein (eds.), *Shopping: A Century of Art and Consumer Culture* (Frankfurt
 and Liverpool: Hatje Cantz and Tate Liverpool, 2002)
Heon, Laura Steward et al., 'Putting the Show on the Road', in *Billboard: Art on
 the Road, a Retrospective Exhibition of Artist's Billboards of the last 30 Years*
 (Cambridge, Mass.: MIT Press, 1999)
Highmore, Ben, *Everyday Life and Cultural Theory* (London: Routledge, 2002)
Hirst, Damien and Gordon Burn, 'The Naked Hirst', *The Guardian*, 6 October 2001
Holmes, Russell, 'The Work Must be Read', *Eye*, 1998
Huyssen, Andreas, *After the Great Divide: Modernism, Mass Culture, Postmodernism*
 (Bloomington, Indianapolis: Indiana University Press)
ICA in association with the Artangel Trust and the Orchard Gallery, Derry, *Blame God:
 Les Levine Billboard Projects* (London: 1985)
Ikon Gallery/Art Metropole, *AA Bronson: Felix, June 5th, 1994* (Manchester: Cornerhouse
 Publications, 2003)
Isaak, Jo Anna, *Feminism and Contemporary Art: The Revolutionary Power of Women's
 Laughter* (London and New York: Routledge, 1996)
Jackson, Lesley, *The New Look: Design in the Fifties* (London: Thames and Hudson,
 1991)
Jacobs, Karrie, 'Barbara Kruger', *Eye*, 1991
Jameson, Frederic, 'Ulysses in History', in W.J. McCormack and Alistair Stead (eds.),
 James Joyce and Modern Literature (London: Routledge and Kegan Paul, 1982)
Jameson, Fredric, *Postmodernism, or the Cultural Logic of Late Capitalism* (London:
 Verso, 1991)
Jay, Martin, *Downcast Eyes: The Denigration of Vision in Twentieth Century Thought*
 (Los Angeles: University of California Press, 1994)
Jha, Alok, 'Did They Really Make That Honda Advert in One Take?', *The Guardian*, 1
 May 2003
Joachimedes, Christos, *A New Spirit in Painting* (London: Royal Academy, 1981)
Jobling, Paul and David Crowther, *Graphic Design: Reproduction and Representation
 since 1800* (Manchester: Manchester University Press, 1996)
Johnson, Michael, 'Words Work: Every Picture May Tell a Story but Michael Johnson
 Thinks Words Can Tell it Better', *Design Week*, 17 (17 October 2002)
Jones, Caroline A., *Machine in the Studio: Constructing the Postwar American Artist*
 (Chicago: University of Chicago Press, 1997)
Jones, Jonathan, 'The Beautiful and the Damned', *The Guardian*, 13 January 2001
Jones, Jonathan, 'He's Gotta Have It (Part Two)', *The Guardian*, 4 April 2003
Joselit, David et al., *Jenny Holzer* (London: Phaidon Press, 1998)

Kant, Immanuel, *The Critique of Judgement* (1790; Oxford: Oxford University Press, 1952)

Katz, Daniel, *Saying I No More: Subjectivity and Consciousness in the Prose of Samuel Beckett* (Evanston, Illinois: Northwestern University Press, 1999)

Key, Brian Wilson, *Subliminal Seduction* (New York: Signet Books, 1973–1974)

Klein, Naomi, *No Logo* (London: Flamingo, 2001)

Koons, Jeff, *The Jeff Koons Handbook* (London: Thames and Hudson, 1992)

Krentzman, Jackie, 'The Force Behind the Nike Empire', *Stanford Magazine*, January–February 1997

Labaume, Vincent, 'Bruce Nauman, Are You Roman or Italic?', in *Bruce Nauman*, exhibition catalogue (London: Hayward Gallery, 1998)

Lash, Scott, *Sociology of Postmodernism* (London and New York: Routledge, 1990)

Lefebvre, Henri, *The Production of Space* (1974), trans. Donald Nicholson-Smith (Oxford: Basil Blackwell, 1984)

Leiss, William, Stephen Kline, and Sut Jhally, *Social Communication in Advertising: Persons, Products and Images of Well Being* (London: Routledge, 1990)

Lewis, Richard W., *Absolut Book: The Absolut Vodka Advertising Story* (Boston, Mass.: Journey Editions, 1996)

Lodder, Christina, *Russian Constructivism* (New Haven and London: Yale University Press, 1983)

Lodge, David, *Nice Work* (London: Secker and Warburg, 1988)

Lupton, Ellen, 'The Academy of Deconstructed Design', *Eye*, 1991, 44–52

Lury, Celia, *Consumer Culture* (Cambridge: Polity Press, 1996)

Lyotard, Jean-François, *The Postmodern Condition: A Report on Knowledge* (Minneapolis: University of Minnesota Press, 1984)

Lyotard, Jean-François, 'The Sublime and the Avant-Garde', *Artforum*, April 1984

Maciunas, George, 'Neo-Dada in Music, Theatre, Poetry, Art', text presented for the Little Summer Festival: After John Cage, Wuppertal, 1962

MacCabe, Colin, *James Joyce and the Revolution of the Word* (London and Basingstoke: Macmillan, 1978)

McCoy, Katherine, and Michael and Hugh Aldersley-Williams et al., *The New Cranbrook Design Discourse* (New York: Rizzoli, 1990)

McGrath, Melanie, 'Something's Wrong: Melanie McGrath on Tracey Emin', www.tate.org.uk/magazine/issue1/something.htm

McIntosh, Alistair, 'From Eros to Thanatos: Cigarette Advertising's Imagery of Violation as an Icon into British Cultural Psychotherapy', www.alastairmcintosh.com/articles/1996-eros-thanatos.htm, first published as an occasional paper for Human Ecology, Faculty of Science and Engineering, University of Edinburgh, 1996

McLuhan, Marshall, *The Medium is the Massage* (Harmondsworth: Penguin, 1967)

McShine, Kynaston, 'Introduction', in *Andy Warhol: A Retrospective*, exhibition catalogue (New York: Museum of Modern Art, 1989)

Miller, J. Abbott, 'Word Art', *Eye*, 1993

Moholy-Nagy, László, 'The Future of the Photographic Process' (1929), in *Creative Camera*, June 1986

Moore, Topaz, 'Benetton Defiant over its Images of Reality: A Clothing Firm Rejects Allegations of Exploitation in its Advertising', *The Independent*, 20 February 1992

Moore, Topaz and Ian Katz, 'AIDS Victim's Family Approves Poster', *The Guardian*, 25 January 1992

Morley, Simon, *Writing on the Wall: Word and Image in Modern Art* (London: Thames and Hudson, 2003)

Morris, William, 'The Lesser Arts', in Asa Briggs (ed.), *William Morris, 1834–1896* (Harmondsworth: Penguin, 1962)

Mort, Frank, *Cultures of Consumption: Masculinities and Social Practice in Late Twentieth-Century Britain* (London and New York: Routledge, 1996)

Muir, Kate, 'On the Banned Wagon: Life and Times', *The Times*, 6 June 1991

Myerson, Jeremy and Graham Vickers, *Rewind: Forty Years of Design and Advertising* (London: Phaidon Press, 2003)

Nagy, Peter, 'From Criticism to Complicity', *Flash Art*, 129 (Summer 1986)

Nairne, Sandy, *State of the Art: Ideas and Images in the 1980s* (London: Chatto and Windus in association with Channel 4 Television, 1987)

'The New Honda Accord – isn't it nice when things just... work?', *The Guardian*, 9 May 2003

Newman, Michael, 'The Demotic Art of Gillian Wearing', *Parachute*, 102 (2001)

Newman, Michael, 'Revising Modernism, Representing Postmodernism: Critical Discourses of the Visual Arts', in Lisa Appignanesi (ed.), *Postmodernism: ICA Documents* (London: Institute of Contemporary Arts, 1989)

Nixon, Sean, *Hard Looks: Masculinities, Spectatorship and Contemporary Consumption* (London: UCL Press, 1997)

Packard, Vance, *The Hidden Persuaders* (1957; Harmondsworth: Pelican, 1962)

Pécoil, Vincent, 'Brand Art', *Art Monthly*, 265 (April 2003)

Phillips, Lisa, *The American Century: Art and Culture, 1950–2000* (New York and London: Whitney Museum of Art in association with W.W. Norton, 2000)

Phillips, Lisa, 'Image World: Art and Media Culture', *Art and Design*, 6 (January–February 1996)

Pompidou Centre, *Art et Publicité*, exhibition catalogue (Paris: MNAM, 1990–1991)

Poyner, Rick, 'Information', *Eye*, 1994

Poyner, Rick, *Obey the Giant: Life in the Image World* (London: August Media, 2001)

Princenthal, Nancy, 'Gillian Wearing at Jay Gorney', *Art in America*, January 1998

'Profile: Not with a Bomb, but a Jumper: Luciano Benetton, Salesman Extraordinary', *The Independent*, 4 April 1992

Roberts, John, 'Mad For It! Philistinism, the Everyday and the New British Art', *Third Text*, 35 (Summer 1996)

Rojek, Chris, *Celebrity* (London: Reaktion Books, 2001)

Rubin, William S., *Dada, Surrealism and their Heritage* (New York: Museum of Modern Art, 1968)

Sadler, Simon, *The Situationist City* (Cambridge, Mass.: MIT Press, 1999)

Salvemini, Lorella Pagnucco, *United Colors: The Benetton Campaigns* (London: Thames and Hudson, 2002)

Salvioni, Daniela, 'Jeff Koons's Poetics of Class', in *Jeff Koons* (San Francisco: San Francisco Museum of Modern Art, 1992–1993)

Salvioni, Daniela, 'McCollum and Koons', *Flash Art*, 131 (December 1986–January 1987)

Schudson, Michael, *Advertising, the Uneasy Persuasion: Its Dubious Impact on American Society* (1984; London and New York: Routledge, 1993)

Searle, Adrian, 'Me, Me, Me, Me', *The Guardian*, 22 April 1997

Searle, Adrian, 'Ouch! Tracey Emin's New Show is Full of Trauma. But There's More to Art than Pain', *The Guardian*, 12 November 2002

Seigel, Jeanne (ed.), *Art Talk: The Early 80s* (New York: Da Capo Press, 1988)

Sewell, Brian, *The Reviews that Caused the Rumpus and Other Pieces* (London: Bloomsbury, 1994)

Sontag, Susan, *Illness as Metaphor* (Harmondsworth: Penguin, 1991)

Spector, Nancy, *Felix Gonzales-Torres* (New York: Solomon R. Guggenheim Museum, 1995)

Squiers, Carol, 'Diversionary (Syn) Tactics', *ARTnews*, February 1986

Squiers, Carol, 'Who Laughs Last? The Photographs of Barbara Kruger', in *Barbara Kruger: Thinking of You* (Los Angeles: Museum of Contemporary Art, 1999–2000)

Stallabrass, Julian, *High Art Lite: British Art in the 1990s* (London and New York: Verso, 1999)

Stallabrass, Julian, 'Shop until you Stop', in Christoph Grunenberg and Max Hollein (eds.), *Shopping: A Century of Art and Consumer Culture* (Frankfurt and Liverpool: Hatje Cantz and Tate Liverpool, 2002)

Storr, Robert, 'Beyond Words', in Joan Simon (ed.), *Bruce Nauman* (Minneapolis: Walker Art Centre, 1994)

Storr, Robert, *Gerhard Richter: Forty Years of Painting* (New York: Museum of Modern Art, 2002)

Sutton, Tiffany, *The Classification of Visual Art: A Philosophical Myth and its History* (Cambridge: Cambridge University Press, 2000)

Tate Gallery, *Rites of Passage: Art for the End of the Century* (London: Tate Gallery, 1995)

Thompson, Mark (ed.), *Social Work: Saatchi & Saatchi's Cause-Related Ideas* (London: 2000)

Tomato, *Process: A Tomato Project* (London: Thames and Hudson, 1996)

Travis, Daryl, *Emotional Branding: How Successful Brands Gain the Irrational Edge* (Roseville, California: Prima Publishing, 2000)

Tregaskis, Kate, 'Creative Britain Inc', *Art Monthly*, 246 (May 2001)

Varnedoe, Kirk and Adam Gopnik, *High and Low: Modern Art, Popular Culture* (New York: Museum of Modern Art, 1990–1991)

Verzotti, Giorgio, 'Object, Sign, Community: On the Art of Haim Steinbach', in *Haim Steinbach*, exhibition catalogue (Castello di Rivoli Museo d'Arte Contemporanea, Milan: Edizioni Charta, 1995)

Waldman, Diane, *Jenny Holzer* (New York: Guggenheim Museum Publications, 1989)

Walker, John A., *Art and Celebrity* (London: Pluto Press, 2003)

Walker, John A., *Art in the Age of Mass Media* (London: Pluto Press, 2001)

Walker Art Centre, press release for *Peter Fischli and David Weiss: In a Restless World* (Minneapolis: Walker Art Centre, April 1996)

Warhol, Andy, *The Philosophy of Andy Warhol (From A to B and Back Again)* (New York: Harcourt Brace Janovich, 1975)

Watney, Simon, 'Photography and AIDS', in Carol Squiers (ed.), *The Critical Image: Essays in Contemporary Photography* (London: Laurence Wishart, 1990)

Weeks, Jeffrey, 'Post-modern AIDS?', in Tessa Boffin and Sunil Gupta (eds.), *Ecstatic Antibodies: Resisting the AIDS Mythology* (London: Rivers Oram, 1990)

Whitney Museum of American Art, The, *Abject Art: Repulsion and Desire in American Art* (New York: Whitney Museum of American Art, 1993)

Wicke, Jennifer A., *Advertising Fictions: Literature Advertisement and Social Readings* (New York and Guildford, Surrey: Columbia University Press, 1988)

Williams, Raymond, 'Advertising: The Magic System' (1962), in *Problems in Materialism and Culture* (London: New Left Books, 1980)

Williamson, Judith, *Consuming Passions* (London and New York: Marion Boyers, 1986)

Williamson, Judith, *Decoding Advertisements: Ideology and Meaning in Advertising* (London and New York: Marion Boyers, 1978)

Wittgenstein, Ludwig, *Philosophical Investigations* (3rd rev. edn., Oxford: Blackwell, 2001)

Wittstock, Melinda, 'Protests Double over Tasteless Adverts: Consumers Quick to Complain', *The Times*, 9 March 1992

Wollen, Peter, 'London Swings', in David Burrows (ed.), *Who's Afraid of the Red, White and Blue?* (Birmingham: Article Press, 1998)

Wood, Paul (ed.), *The Challenge of the Avant-Garde* (New Haven and London: Yale University Press in association with Open University, 1999)

Wu, Chin-Tao, *Privatising Culture: Corporate Art Intervention since the 1980s* (London and New York: Verso, 2002)

Yagi, Tamotsu, Emiko Kaji and Hiroshi Shogi, *Global Vision: United Colors of Benetton* (Tokyo: Robundo Press, 1993)

Index